Reviewed
2089-05

The Antebellum Crisis and
America's First Bohemians

CIVIL WAR IN THE NORTH

Series Editor, Lesley J. Gordon, University of Akron

ADVISORY BOARD

William Blair, *Pennsylvania State University*

Peter S. Carmichael, *West Virginia University*

Stephen D. Engle, *Florida Atlantic University*

J. Matthew Gallman, *University of Florida*

Elizabeth Leonard, *Colby College*

Elizabeth Varon, *Temple University*

Joan Waugh, *University of California Los Angeles*

The Antebellum Crisis America's First Bohemians

Mark A. Lause

The Kent State
University Press
Kent, Ohio

© 2009 by The Kent State University Press, Kent, Ohio 44242
All rights reserved
Library of Congress Catalog Card Number 2009021363
ISBN 978-1-60635-033-1
Manufactured in the United States of America

Library of Congress Cataloging-in-Publication Data
Lause, Mark A.
The antebellum crisis and America's first bohemians / Mark A. Lause.
p. cm. — (Civil War in the North)
Includes bibliographical references and index.
ISBN 978-1-60635-033-1 (hardcover : alk. paper)
1. New York (N.Y.)—History—1775–1865.
2. New York (N.Y.)—Intellectual life—19th century.
3. New York (N.Y.)—Social conditions—19th century.
4. Bohemianism—New York (State)—New York—History—19th century.
5. Art and society—United States—History—19th century.
6. Social movements in art.
7. Social movements in literature.
I. Title.
F128.44.L38 2009
306'.1—dc22
2009021363
British Library Cataloging-in-Publication data are available.
13 12 11 10 09 5 4 3 2 1

Contents

Introduction · vii

1 The King of Bohemia:
Henry Clapp, American Cosmopolite · 1

2 A Scandal in Bohemia:
Free Love and the Antebellum American Culture Wars · 21

3 Utopia on Broadway:
Charles Pfaff's Saloon and the Power of the Pen · 44

4 Liberty and Coercion:
Red Republicans, Black Republicans, and the Republic of Letters · 64

5 Representing Alienation:
The Republican Civilization and Its Discontents · 85

Conclusion:
Iconoclasts in Iconic Times · 104

Notes · 127

Bibliography · 163

Index · 175

Introduction

Just back from Paris, the Yankee writer Henry Clapp proposed to experience an American metropolis with his newly honed European sensibilities. His "New Portrait of Paris" began with his observation of Broadway's "immense tide of people . . . from every quarter of the globe. The scene carried me back to Paris, where, during the previous three years, I had so often been amazed with the variegated current of human life coursing down the broad beautiful Boulevards, and spreading itself in phosphorescent waves over the Elysian Fields." Clapp's vision and his aspirations—and those who scoured New York streets with him in their iconoclastic search of European quality coffee, wines, and cuisine—reveled in their cultural innovativeness that constituted the first self-described and self-conscious "bohemian" circles in the United States.[1] Such an embrace of a Parisian bohemianism seems strangely removed from the political crises afflicting the antebellum metropolis, itself unfolding within the lengthening shadow of sectional tensions threatening the very survival of the nation. That Clapp and his circle often took such pains to distinguish their personal, creative concerns from the electoral politics seems to emphasize this distinction.

Yet, no coincidence inspired the emergence of bohemianism in the United States alongside the political crisis that created a new Republican Party. Slavery had existed for decades with little political cost, but the expansion of technology, transportation, and communication shaped a civic culture that made the institution an issue perceived by people of the non-slaveholding states; the bohemians represented the cultural vanguard of those creative arts that built that culture and structured those perceptions. Clearly, political history requires looking beyond the crises of the parties and the soul-searching among officeholders and office seekers. So, too, the more radical currents in—and at the fringes of—the Republican insurgency, which defined the new

party and shaped much of its early history, was particularly and inexorably intertwined with the personnel, practice, and persuasion of bohemian life.

This work rests heavily on the scholarly study of bohemianism abroad and hopes to expand that understanding into a more Transatlantic context. The current emerged as an international phenomena in the mid-nineteenth century. As the transient and young aspirants to success in literature, art and music settled in various Parisian neighborhoods, they came to be identified as bohemians, after the misidentified homeland of the gypsies. The identification spread to similar circles in London, New York, and other cities where it constituted what a Philadelphia writer described as a "a mythic empire, à la Paris, inhabited by poets, actors, essayists, artistes, magazine scribblers, newspaper reporters, et al."[2] In deference to the nationality, our purposes will avoid capitalization of the term applied to that "mythic empire."

Bohemianism had a tremendous—and often neglected—impact on American cultural history. Further popularized by the itinerant newspapermen who covered the Civil War, it became virtually synonymous with a literary romanticism. In theater, the appearance of bohemian women on stage coincided with the introduction of the erotic as an element of respectable commercial entertainment. The cosmopolitanism of the group made it open to the experience of new worlds, and this includes some of the earliest Orientalists in the United States and some pioneers in the recreational uses of psychoactive substances. Those readers most familiar with the subject will find a considerable amount of information new to them.

Innately cosmopolitan and internationalist, bohemianism broadened into a distinct identifiable current in most cities of the western world by the end of the nineteenth century. The scholarship rightly established the essential premises for bohemianism. The expansion of culture-making enterprises, particularly through the written word, created new opportunities and made bohemianism possible.

In a related sense, participation in bohemianism tends to be seen, as any cultural experience, from the top down. For the wellborn and wealthy—or their children—bohemianism seemed to be a matter of choice, a voluntary and frequently transitory condition. Thus, one scholar could write, "Despite the air of romance which surrounded America's first Bohemia, those who sampled and later abandoned that life did far better than those who tasted and stayed."[3]

As a broader phenomena, bohemianism in America did not constitute an innately distinctive group, nor was membership a question of individual choice of

any permanence. Certainly, it owed less to expanding opportunity and individual aspirations than to the frustration of those opportunities. While class standards may have discouraged the participation of young men—or women—of elite origins from following their bliss into these expanding creative arts, those of more plebeian background could find earning a living in this way much more precarious. The cases of individual bohemians involve impressive personal struggles to overcome the obstacles barring the entry of women into such fields as newspaper work, as well as of workingmen attempting a transition from manual labor. For them, the decision to pursue the dream of social mobility through cultural labor represented a great gamble, personally chosen as the best of the available alternatives. In the United States, no less than in European countries, these people experienced a booming business of culture, the frustration of mobility within it, and a looming crisis of national proportions.

Viewed from the inside, then, bohemianism could scarcely fail to have a political dimension. Indeed, its apparent disassociation from politics owed something to its emergence in the wake of the 1848–49 revolutionary upheavals, in which the bayonets of power prevailed over the republican strivings of ordinary people and their advocates. The American context of such responses, however, surely defined the current as implicitly internationalist and cosmopolitan. Indeed, those Americans drawn to bohemian standards were already inspired by European thinkers such as Charles Fourier and other socialists. Many bohemians shared a special affinity with the most radical "Red Republican" associations of European émigrés in the city, including revolutionary societies fostering new ideas, such as those of Karl Marx and his European rivals and critics.

This deeper political impact of bohemianism lies beneath electoral considerations. Bohemian standards crystallized among men of letters just as women were entering fields like literature, and this doubtlessly eased the process. Fourierists and other radicals always held "advanced" views of women's rights and marriage. However, it also quite clear that bohemians explored new areas of sex and gender relations that had sweeping implications, over time, for the wider society.

Bohemianism shared a deep kinship with the ideology of "free labor" so central to the Republican insurgency. Indeed, contemporary bohemians understood the term, embracing not only writers but theatrical workers, musicians, visual artists, and others. They celebrated the substance of creativity rather than its form, viewing it as the freest kind of labor.

This work owes its quality to the editorial staff at Kent State University Press, particularly Joyce Harrison and Mary Young. I hope it reflects my frequent discussions of the subject with some of the many people more knowledgeable than I on aspects of this problem. These include Paul Buhle, Janine Hartman, whose familiarity with the European side of the subject has been very helpful, and Edward Whitley, to whom, with Robert Weidman, all future scholars will be in debt for the Lehigh University Web site, The Vault at Pfaff's: An Archive of Art and Literature by New York City's Nineteenth-Century Bohemians (http://digital.lib.lehigh.edu/pfaffs/). This masterfully done site includes biographies of many of the Pfaffians, commentaries, bibliographical sources, and a complete, searchable run of the *Saturday Press*. It is a model of what the Internet can provide in terms of accessible scholarship.

As this book is going to press, I received word that one of them, Franklin Rosemont has unexpectedly passed away at the early age of 65. Though I had not spoken with Franklin in many years, I believe my own interest in the politics of culture benefited tremendously from the short time I worked in particularly close association with him and members of the Chicago surrealist group. It is fitting that it be dedicated to his memory.

CHAPTER I

The King of Bohemia

HENRY CLAPP, AMERICAN COSMOPOLITE

The Bohemian is by nature, if not by habit, a cosmopolite, with a general sympathy for the fine arts, and for all things above and beyond convention. The Bohemian is not, like the creature of society, a victim of rules and customs; he steps over them with an easy, graceful, joyous unconsciousness, guided by the principles of good taste and feeling. Above all others, essentially, the Bohemian must not be narrow minded; if he be, he is degraded back to the position of mere worlding.

—Jane McElhenney, aka "Ada Clare"

"No man was better known in the newspaper and artistic world a few years ago than the eccentric and gifted King of the Bohemians—Henry Clapp, Jr." So began his obituary in the *New York Times*. The first consciously bohemian figure in American life offered Old World standards to the New, inspiring many of the city's most creative minds "to drop in after theatre hours at Pfaff's lager beer saloon, in Broadway, near Bleecker Street, and there, in a large vault under the sidewalk, enjoy the luxuries of pipes, beer, lunch, songs and free conversation until the late hours of morning." It was a measure of the times that his own obituaries blamed his influence for having drawn others to waste their lives under the Broadway sidewalk and blatantly used this as a morality lesson on the dangers of drink.[1]

Understanding early bohemianism requires an assessment of the remarkable individual who combined his unique experiences overseas with

deeply rooted American concerns. With legions of his pious New England contemporaries, Henry Clapp rejected the devil and his works—drink, slavery, injustice—and decided to come out of the institutions that sustained those works—not just the saloon and the gambling house but the church, political parties, and the state. However, Clapp's experiences persuaded him that alternative ideas could inspire coercive institutions as well. He became a cosmopolite not just by his own choice but by choosing to experience that choice overseas. While there, he encountered, admired, and, again by choice, assimilated the values of bohemian Paris and London.

Shortly before Clapp died, someone—probably George S. McWatters or Ned Underhill—coaxed him into giving an autobiographical narrative, transcribed in shorthand and much later appearing in a Brooklyn newspaper. In December 1812, Rebecca Coffin of Nantucket married Henry Clapp Sr., a former bookseller and bookbinder from Hartford, Connecticut, left a widower with an infant daughter the previous year. His new wife delivered "four children born within the space of one year." One set of twins born on November 17, 1813, died within a few weeks, but another set, born on November 11, 1814, were Rebecca and Henry Jr. Five more children followed over the next fourteen years.[2]

The product of this crowded household, Henry Jr. also found Nantucket claustrophobic. He recalled it as having "several reading clubs, which I believe they call insurance offices." It was the sort of small town that became easily focused on "the spectacle of two or more citizens convening together, or a stranger is visible in the streets."[3]

Clapp obtained a unique education through his mother's family. He later referred to "the spare-the-Rod-spoil-the-Child Academy of my boyhood," but he left the common school at age sixteen to enter the Coffin School, established at Nantucket by Sir Isaac Coffin, formerly of the Royal Navy. Sir Isaac had attended the Boston Latin School before joining the British Navy and rising quickly to command of a seventy-four-gun ship of the line at the age of twenty-two, but he returned in 1827 to establish a training center named for the pioneering family on the island. "Nobody was allowed in that school who was not a descendant of the Coffins," recalled Clapp, adding, "I was one." Coffin had soon bought the brig "Clio" from Boston and gotten the U.S. Navy to loan an officer to command her crew. With twenty other students, he helped sail the ship from Boston to Quebec and, over his parents objections, became one of the nine who went from Boston to Rio de Janeiro. "I got terribly sea sick and had quite enough of sea life," said Clapp.[4]

Clapp's father "wanted to make me a tailor," but the son resisted and the compromise landed him in mercantile pursuits at Boston. In 1831, he entered a good year's service at the State Street business of a true eccentric stationer and bookseller, who "had a room over his store in which he had a model railroad before there was a railroad built in this country." After a year, Clapp lost the job for verbally sparring with a customer over the price of a pencil set. He then went into the wholesale oil and candle house to sweep the store and run errands but found himself keeping its books a year later at an annual salary of $600 and gaining the experience that allowed him to get another job at $800 a year. Then, about 1838, Clapp went into the oil and candle business himself, supplying job experience as a "counter jumper," while his partner provided the capital.[5]

Given what his family did, Clapp's success in maritime and mercantile employment hardly entailed a rebellion, and he might have remained a "counter jumper," had it not been for two areas of experience that opened to him, starting when he was a nineteen-year-old. At about that time, a lady with whom he boarded in Boston had an idea that he had some literary talent and persuaded him to write an obituary of a friend who had just died, Captain Carter. As he explained, there then existed no distribution system other than subscription, so he had to go around buying copies of the *Boston Transcript* from those he knew to have subscribed.[6]

Then, when he was roughly the age of twenty-one, the climate of Boston brought him down with bronchitis, at a point where he had saved enough to do something about it. Starting in 1836—and continuing for the next four years—he wintered in warmer climes, three in New Orleans and one in Cuba. "I did nothing in Havana, but endeavor to recuperate," he recalled. New Orleans left a lifelong impression on him, as it did on Thomas Low Nichols, who remembered "the cafés were filled with visitors, smoking and drinking, and playing billiards and dominoes." There, Clapp encountered the institution of slavery firsthand and probably began to discover his own knack for the French language. Certainly, he relished the varieties of people and the polyglot nature of the city. Much later, he verbally catalogued the various ethnic groups in the city, adding the punch line that Jews completed the Mosaic.[7]

There, too, the young clerk likely became familiar with "the stranger's church" conducted by the Reverend Theodore Clapp, a possible relative, also from Massachusetts. Recruited as pastor of a Presbyterian parish at New Orleans, the reverend came to reject the gloomier prognostications of Calvinism and the literal interpretations of the Bible. Only a few years

before, Reverend Clapp had organized what became a Unitarian church in New Orleans, and he had faced trial by the Mississippi Presbytery the following year. Interested in phrenology and as enamored as any of the resident Yankees with the diversity of New Orleans society, he would be a fixture in the community for more than thirty years.[8] In his rebellion against the family's Puritanism, young Clapp shared strikingly similar predispositions.

Despite New Orleans—or, perhaps, because of it—Henry Clapp returned to New England ready to embrace what he could of his Puritan roots. By his mid-twenties, he began teaching Sunday school and working for temperance, as both a speaker and a writer for the *Nantucket Enquirer*, of which he became the editor. Soon after, he moved to New Bedford and began working for the *New Bedford Bulletin*, the editor of which, Charles T. Congdon, recalled, "I found him not without value; whatever he could do at all he could do readily." From these early essays on slavery, demon rum, and industrial exploitation, "gradually he drifted into that profession." Later, friends in New York knew that Clapp had "associated himself with the church, espoused, as a lecturer and writer, the cause of temperance, and actively labored for the anti-slavery movement."[9]

From the beginning, Clapp in his abolitionism proved less eager to condemn people than William Lloyd Garrison, the Boston editor who insisted that there be no compromise with wrong and fostered a purist idea of what it was to be an abolitionist. In August 1842, Clapp attended the Nantucket antislavery convention, dominated by Garrisonians, who proposed adopting their usual pro forma institutional denunciation of the clergy's negligence, but Clapp took the floor and defended the antislavery activism of Nantucket's ministers. He served as secretary of another such Nantucket convention in June 1843, where he had become sufficiently integrated into the movement to address "at some length" the guilt of the church, but he did not make a sweeping denunciation of the clergy.[10] Clapp simply saw no good purpose in maligning individuals whose antislavery credentials were otherwise quite in order.

In a larger sense, Garrison's approach clashed directly with that of Nathaniel Peabody Rogers. The former had little good to say about socialism or the labor movement and opposed the efforts of other abolitionists to launch the Liberty Party, which tended to embrace a "broad platform" reaching beyond antislavery, while the latter sympathized with both. A Dartmouth graduate, Rogers had a successful law career in New Hampshire, though he began writing in 1835 for the Concord antislavery paper, the *Herald of Freedom*. Three years later, he left the law and moved to Concord to become an editor,

with much of his work also appearing under the pseudonym "Old Man of the Mountain" in the *New York Tribune* and other antislavery papers. Rogers became a particular champion of a broader idea of equal rights in 1840, when he went to London for the World's Anti-Slavery Convention, which refused to seat several American women, leading to Rogers's protest and resignation. Thereafter, he expressed sympathy for the labor movement and spoke regularly on temperance and women's rights as well as slavery.[11] Rogers—rather than Garrison—provided Clapp with a political and moral compass.

Garrison and Rogers did not abandon their faith in existing institutions in quite the same way. Garrison denounced the Liberty Party for its confidence in electoral politics and, at that point, any abolitionists willing to discuss questions other than slavery. Rogers, however, saw no reason to believe that Garrison's petitioning of the existing authorities could accomplish any serious change. From this perspective, Rogers—and Clapp—remained far more skeptical of the moral foundations of American institutions than Garrison.

As early as December 1843, Clapp attended a socialist convention in Boston's Tremont Temple. While abolitionists participated, the followers of Charles Fourier predominated. Like the British socialist Robert Owen, Fourier advocated the establishment of communitarian societies that would grow beyond the competitiveness and repressiveness of capitalism. Unlike Owen, Fourier nested this social program in a millenarian worldview that saw human social progress related to advance of the physical world through stages. With the establishment of a Fourierist community, the phalanx would hasten all these processes. While Americans never organized one on the scale of Fourier's blueprint, they launched scores of usually ill-fated communities, including Brook Farm, which was near Roxbury, just outside of Boston, some of whose residents attended the convention.[12]

The patrician abolitionist Thomas Wentworth Higginson remembered these gatherings. He particularly recalled how a local capitalist turned up and asserted "that individuality was better promoted by the existing method of competition." Afterward, reported Higginson, Clapp rose in response, as "a young radical mechanic." "I have never heard a speech so thrilling and effective," wrote Higginson half a century later, adding "That speech did more than anything else to make me at least a half-way socialist for life."[13]

As persuasive as their arguments were, the Fourierists confronted their own version of the problems the Liberty Party faced. The failure of their own strategy of organizing socialist communities disillusioned many of their

ranks, who urged the formation of cooperatives as a more creative application of socialist ideas. These would both directly assist working people in population centers and demonstrate the practical value of collective action. Fourierists also became increasingly drawn to the electoral project of the new National Reform Association, which emerged from the political experience of New York City workingmen and advocated political action for a more democratic land redistribution.[14] The land reformers, in turn, increasingly cooperated to encourage the Liberty Party to discuss social reconstruction, along with the abolition of slavery.

Clapp and Rogers also shared a flair for the dramatic, defying what was expected. A future employer—who did not particularly like Clapp—said that Clapp preferred "to say startling things, and did not always exhibit the best taste." He enjoyed getting hissed at, to which he would respond, "'There is always that sound when the waters of truth drop into the fires of hell,'—a remark which secured quiet and good order for at least fifteen minutes."[15] This confrontational style often moved audiences quickly to think about issues but scarcely made for personal popularity.

Clapp also earned a certain notoriety for defying the municipal authorities. When a local justice of the peace named Lummus—referred to as "lummox" in the town—dropped charges against a man "because he was rich, whereas if he had been poor he would have been sent to prison," Clapp reported it in the *Pioneer* and faced a second indictment. Lummus charged him with libel, and Clapp "defended my own case." When he referred to the justice as a "lummox," the judge objected. In the end, the court put him in the Salem jail for sixty days. While there, he continued to edit the *Pioneer*, reporting on why he had been imprisoned. The district attorney warned him that he could be prosecuted again for the offense, and Clapp asked if the law prohibited a jailed editor from explaining why he was jailed.[16] As did Henry David Thoreau over his war tax, Clapp gained through his deed a certain prominence independent of his more well-known friends.

When Clapp launched his own paper at Lynn, just outside of Garrison's stronghold, he did so as an ally of Rogers. Sometimes as editor and other times as correspondent, Clapp developed his talents to buoy the Lynn's *Essex County Washingtonian*, which became the *Pioneer*, and later, in clear homage to Roger's old paper, the *Pioneer and Herald of Freedom*. In 1846, Clapp issued a collection of his essays under the title of *The Pioneer; or, Leaves from an Editor's Portfolio*. Clapp's essay "Modern Christianity," published in the *Liberty Bell*, further established his credentials as a comprehensive social reformer.[17]

Clapp's alignment with Rogers rather than Garrison created a serious source of tension. In late 1844, Garrison had written a mutual acquaintance that he hoped Clapp and Rogers would attend an upcoming convention, but by March 1845, he complained that Clapp had the "considerable talent, and the zeal of a new convert; but lacks judgment and good sense—is impulsive and vain."[18]

In early 1846, Clapp criticized the disinterest of Garrison and the *Liberator* in the New England Workingmen's Association. Clapp admitted that he had "little patience with the Northern laborer, who is grumbling about his hard lot, and yet doing all in his power to fasten the manacles and chains still tighter upon the limbs of the slave," but he also had "little faith in that man's Anti-Slavery" who "feels no sympathy for the Northern slave." Ultimately, the workers' movement and the abolitionists sought "the same thing." Once the working people of the North realized this, they would demolish the institution, and "the work of Anti-Slavery is accomplished." Both abolition and labor reform "should be composed of the same persons. They should be one and the same thing. When this is the case, they will work successfully together, but until then, neither can expect to accomplish much."[19]

Garrison responded with what can only be characterized as a series of viciously personal attacks. When Clapp attended the Liberty Party convention in Providence, Garrison ascribed it to the "vanity and self-conceit," of a man "bankrupt in business, and we believe equally so in moral reputation." When Clapp replied, Garrison published it in the "Refuge of Oppression" column of the *Liberator* reserved in for proslavery editorials and arguments. Soon, the "liberator" complained that Clapp had gotten off easily in his brush with the Salem authorities.[20]

The more Clapp protested such treatment, the more adamantly Garrison assaulted his character. In Garrison's mind, Clapp's defense of clergymen and his support for the Liberty Party amounted to a backhanded support for "a pro-slavery church and clergy, a blood-stained government, and *the old betrayers of the anti-slavery enterprise.*" When the *Pioneer* replied to these attacks, Garrison filled three columns of his *Liberator* with circular arguments, essentially acknowledging that he did not know Clapp to be quite so low a character as he had asserted but also that he had no evidence that Clapp deserved better.[21]

Clapp's brushes with Garrison probably enhanced his reputation for independent thinking and a "brilliant advocacy of Freedom of Speech." By June 1846, Clapp had become one of many abolitionists who complained that the movement's growth and success had bypassed the merits of Garrison's

"cold-blooded intrigue—and love of manage; apish, swelling—wool-eyed Aristocracy, not quite solid enough in character for the family ambition; and a swelling—distended—boasting self-reverence—and egotistical devotion—tolerable and even excusable in a pioneer reformer—almost justifiable, and I don't know but useful and becoming, in the onset of down-trodden Reform,—but altogether disgusting and intolerable in a pioneer after he has been the tool of a Board." Garrison rather proved their point by again consigning the article to the proslavery pieces in his "Refuge of Oppression."[22] Repeatedly, Garrison equated his authority and abolitionist purism, and opposition to him with proslavery and sin.

Undismayed by Garrison's disapproval, the Massachusetts "Washingtonian" clubs selected Clapp to represent them at the World Temperance Convention that summer in London. There at the same time, Garrison seems to have convinced himself of the slander that Clapp could not have been an abolitionist and grumbled about his presence in the English antislavery meeting "notwithstanding his horror of an organized meeting on our side of the Atlantic." When a friend sent Garrison a copy of Clapp's letter to the *Pioneer* praising Garrison's work in England, and mutual acquaintances informed Garrison that Clapp still spoke fondly of Garrison's role, Garrison reported this to his wife, complaining of Clapp's "affected magnimity." By December 1846, one of Garrison's supporters told him that Clapp's lecture at Exeter had been very positive but marred by his "Liberty party predilections."[23]

Meanwhile, events at home carried the antislavery issue beyond anyone's management. Nathaniel P. Rogers, before his death in October 1846, sharply criticized Garrison for trying to control the movement, but Garrison's real concern was to focus abolitionism morally on the sin of slavery and the nation that sustained it. He remained oblivious to the way the U.S. War on Mexico created the opportunity for abolitionists to build a still broader radical coalition to redirect the course of the nation. When Clapp subsequently criticized Garrison's call for the secession of Massachusetts from the Union, the latter characteristically dismissed him as "a vile creature, with considerable talent, but not to be trusted or encouraged. No one is more bitterly opposed to us than he is, in design and spirit."[24] Of course, the intensity of Garrison's hostility may have faded with Clapp overseas and Rogers dead, but the course of events left him increasingly isolated.

In Britain, Clapp began a close collaboration with Elihu Burritt, the "Learned Blacksmith." Beyond the forge, Burritt had a lifelong love of learning,

especially languages. Although employed for translating and related work, he publicly continued to regard himself as a workingman and advocated social reforms like abolition, free labor, and world peace. Clapp joined Burritt at Aylesbury, declaring war to be "a system of organized hate, to which heroism, courage and philanthropy were all opposed." He "maintained that, with all his hatred to slavery, he could not conceive anything more destructive of human freedom than the system which they that night condemned." Together they addressed the London Peace Society in late 1847.[25]

However, while making some money as a writer in the city, Clapp spent much of his time touring the British Isles. Garrison noted that Clapp attended his own talk at in Finsbury Chapel in London and his address to the Emancipation Society in Glasgow. Burritt and Clapp both visited Ireland, the former writing *Four Months in Skibbereen* on the potato famine. A generation before Henry George's tour, Clapp made much the same observation: "Not a little of the blame must be charged upon the monopoly of the soil," adding, though, that even radical land distribution "will not withstand the blight of an oppressive and unmeaning religion."[26]

After eleven months abroad, Clapp returned briefly to the States. He reoccupied the editorial chair at the *Pioneer*, and Horace Greeley's *New York Tribune* picked up his articles on the Anti-Corn Law agitation in Britain. Clapp also attended and reported on abolitionist meetings in New York City, addressed a socialist convention at Boston in May 1848, and apparently irritated some abolitionists by making comments against "priestcraft" that appeared in the freethinkers' newspaper, the *Boston Investigator*. Nevertheless, Burritt's League of Universal Brotherhood sent Clapp and Burritt as American delegates to a series of international meetings overseas. By September 21–22, 1848, the two attended the World Convention of the Friends of Universal Peace at Brussels, with Clapp serving as secretary.[27]

Clapp spent another year of touring, writing, and lecturing before attending the Second General Peace Congress assembled at the Salle de la Sainte Cecile on August 22–24, 1849. He wrote on the event for both the *Pioneer* and Greeley's *Tribune* and mingled with such luminaries as Victor Hugo, Alexis de Tocqueville, Alphonse de Lamartine, and Pierre Jean Béranger, as well as striking up acquaintanceships with John Bright and Richard Cobden. Among the Americans, a white South Carolinian, William Henry Hurlbert, sat alongside two former slaves. Reverend James William Charles Pennington added that slaves wanted justice rather than any violent retaliation against their captors,

while William Wells Brown likened the institution to a war waged on blacks, insisting that "to demand the abolition of slavery was to work for the maintenance of peace." Significantly, when Boston radicals held a ratification meeting of its resolutions November 22, Clapp was conspicuous by his absence.[28] He had opted to remain behind rather than return to the United States

By this point in his career, Clapp had come thoroughly to mistrust conventional behavior as an essential bulwark of oppression and exploitation. Decades before, a character in an ever-popular English play responded to any suggestion of the unconventional by asking "What will Mrs. Grundy say?" Clapp and other iconoclasts regularly used this figment of their transatlantic imagination to personify the tyranny of convention through the medium of the self-righteous opinions of others. Garrison's position, argued Clapp, "if carried to its legitimate consequences would result in the gloomiest dogmas of ancient theology" sewing the "seeds of bigotry and superstition." While he remained sympathetic to the radicalism of Garrison and Rogers, his experiences led him to distinguish between the legitimate arguments and goals of social movements and those of "moral and religious corporations generally, which sought unquestioned authority under the motto: *Our party, right or wrong.*"[29] What good could come by appealing to the instincts of Mrs. Grundy?

The Old World offered Clapp wonders unimaginable in the U.S. London not only promised a metropolitan experience new to any American, but the residents themselves moved through an urban landscape unprecedented in their own experience.[30] The 2,363,000 souls who lived along the Thames River choked on the miasma from the raw sewage that had contributed to recent outbreaks of cholera. Commerce had so completely outgrown the old wharves that the city had begun four major new docks downriver, and the railroads expanded so quickly across the country they required new stations at Euston, Paddington, Fenchurch, Waterloo, and King's Cross. The redesigning of broad spaces like Regent Street, Piccadilly Circus, Carlton House Terrace, and Oxford Circus opened the city, even as the royal stables gave way to Trafalgar Square and its new National Gallery. Likewise, Buckingham grew into a palace, and mock-Gothic Houses of Parliament rose on the river. Prince Albert, consort of Queen Victoria, was taking the initiative for the Great Exhibition of 1851, held in Hyde Park around the iron and glass Crystal Palace.

London's people, like its products, came from all over the empire. Large numbers of Irish had clustered along the crowded riverfront districts for a cen-

tury, but those who worked in the filthiest of the new industries or could afford only minimal rents drained into the East End. As Clapp saw it, over 100,000 refugees of the Irish potato famine crowed into the city. Moreover, some 20,000 Jews gave the city a cosmopolitan air, and large numbers of Chinese people were starting to settle in the Limehouse district. Social critics and writers of conscience like Charles Dickens complained of seeing children as young as five begging in the streets or soliciting work like sweeping chimneys.

In these same years, the bright glow of gaslight enfolded the city itself in the shadows and enclaves of a new metropolis. An asylum from the tensions and chaos of the daily working life, the night offered a vibrant new field of unmanaged activity among individual urbanites less familiar with each other than they could have ever been in the past. Crime and antisocial activities of all sorts grew into every habitable corner of the night, and Sir Robert Peel's Metropolitan Police—the "bobbies" and "peelers"—did not suppress these experiences as much as they pushed them farther into the less visible nooks and crannies.

Artists and writers in this new, artificially enlightened cavernous world claimed its geography as a new Bohemia. By longstanding usage, the term "Bohemia" erroneously referred to the assumed origins of the roving bands of European Romany, commonly called "gypsies," tribes depicted to be as romantic as they were rootless. The closed circles responsible for producing the written word, theater, music, and the fine arts could not have met the rapidly expanding demand for these things in nineteenth-century western cities, so large numbers of newspapermen, actors, musicians, and artists worked under contract for modest salaries or as freelance pieceworkers. With their quarter of the social structure in flux, these often diverse kinds of workers functioned like a coherent déclassé group of artisans.

In England, the demand for the written word grew exponentially with expanding leisure time for some and growing literacy in general. It required a small army of anonymous literary pieceworkers like Clapp. Paid by the word, they usually got no byline. Such writers were "proletarianized" in the most classically Marxist sense, but they adhered to an ideal of craftsmanship and got sufficient recompense to regard themselves usually as middle class, however impoverished. So, too, British painters had studied on the continent, in Bruges, Ghent, Antwerp, and Rome, where expatriate German painters, who called themselves Nazarenes, sought to restore religious and cultural themes to the medium.

By 1848, veterans of the Grand Tour concluded that the drive for beauty should have greater claims on the artists than expressions of truth evident in Nature. The London-born son of Italian refugees, Dante Gabriel Rossetti inspired a new Pre-Raphaelite Brotherhood proposed to restore that truth, in part, by exploring what they believed to be the underlying unity of painting and poetry. This artistic perspective inspired both established English writers and the newspaper scribblers who hoped to elevate their craft to an art, including John Ruskin, William Morris, and other radicals clustered around the Working Men's College on Great Ormond Street.[31] While in London, Clapp lived an anonymous life on the fringes of these circles.

We get few glimpses of Clapp in London. An English writer recognized him from an antislavery speech "heard years before holding forth at antislavery meetings in Boston." Another chanced upon him in a "a little chocolate house in Oxford Street, kept by an Italian, who had been a pastry cook for Louis Philippe. Then accompanied by James Hannay, Clapp formed part "of the London literary Bohemia of that day."[32]

Another observer noticed Clapp with William North at "an eating-house in the Strand," where they had just ordered a meal. One of them scribbled furiously to finish an article, while the other waited, poised "to take the manuscript to the publisher, or editor, to procure the means of paying for the dinner they had ordered." A "man of eccentric vision, physical and mental," North was the son of a prominent barrister and had attended the University of Bonn as a step toward a legal career, but he refused to occupy the chambers his father took for him at the Inns of Court. With "no allowance from the paternal purse," North took small literary jobs and became Clapp's "great chum" in London.[33]

In 1849—after several years in England—Clapp moved to Paris, which had only about half the population of London but offered much broader fields for exploration. Clapp recalled arriving as "a green and ungallicized Yankee," settling into the Hôtel Corneille, next to the Théâtre de l'Odéon. English guidebooks and essays regularly recommended the quarters there, populated by French medical students and named for the seventeenth-century writer Pierre Corneille. Shortly before Clapp arrived, William Makepeace Thackeray had suggested that one could live well at the Hôtel Corneille on four francs a day and wrote, "If by any strange chance you are desirous for a while to get rid of your countrymen, you will find that they scarcely ever

penetrate." Shortly after, James McNeill Whistler lived there, and, much later, James Joyce chose it as his residence.[34]

The six-story Hôtel Corneille loomed over the street as "dingy, mean-looking, and dirty, inside and out," populated by "a noisy crew," continually singing and shouting from open windows to friends in the street below. Honoré de Balzac described it as "one of those large houses where there is a winding staircase quite at the back lighted below from the street, higher up by borrowed lights, and at the top by a skylight. There were forty furnished rooms—furnished as students' rooms are!" His character shared a room

> a little over seven feet high, . . . hung with a vile cheap paper sprigged with blue. The floor was painted, and knew nothing of the polish given by the frotteur's brush. By our beds there was only a scrap of thin carpet. The chimney opened immediately to the roof, and smoked so abominably that we were obliged to provide a stove at our own expense. Our beds were mere painted wooden cribs like those in schools; on the chimney shelf there were but two brass candlesticks, with or without tallow candles in them, and our two pipes with some tobacco in a pouch or strewn abroad, also the little piles of cigar-ash left there by our visitors or ourselves.

The student residents actually spent as much time as possible elsewhere, "in the cafés, the theatre, the Luxembourg gardens, in grisettes' rooms, even in the law schools—anywhere rather than in their horrible rooms—horrible for purposes of study, delightful as soon as they were used for gossiping and smoking in."[35]

In Paris, Clapp continued to spend time with those English Pre-Raphaelites continuing their inspirational excursions to the continent. Henry Mayhew, the author of *London Labour and the London Poor* visited the Hôtel Corneille with his brother Augustus. Watching the English and the French interact entertained Clapp, particularly their tendency toward "detesting each other with a heartiness which is in itself more amusing than any comedy." He wrote that London "had bewildered me with its immensity, and oppressed me in its magnificence" and compared it to Paris: "With the one you deliberate, with the other you flirt." "The American traveler spends a week in London and a month in Paris, and returns home thinking of the one and dreaming

of the other; resolved all the while to revisit France before he dies, but to go by the way of England." Clapp found the French "more ready, more genial, more witty" than English or Americans. "Their weakness is a passion for generalization and paradox. But even this is a charm. A Frenchman's mind is like a lightly charged electric battery, from which you are constantly receiving the most agreeable shocks."[36]

The written word had been essential to the creation of this world. From the eighteenth century, almost as soon as a few people demonstrated the possibility of making a living by the pen, without any alternate income, people desperate for a better and more respectable life threw themselves into an unprepared market. On the eve of the French Revolution, an estimated three hundred writers were trying to eke out some existence in a city that could not support more than a fraction of that. One observer described a city of young clerks, accountants, lawyers, soldiers, and others trying to turn themselves into authors only to "die of hunger, even beg, and turn out pamphlets." Politics became central to their experience. One historian believes that the verb "to politic"—*politiquer*—likely came from the cafés of the Palais Royale.[37]

Paris was yet recovering from the revolutionary upheavals of 1848–49. The raising of the Luxor Obelisk at the Place de la Concorde and the Arc de Triomphe recalled the classical world. The historic Île de la Cité retained many of the ancient streets, mansions and churches, though most of the medieval city fell before the construction projects of Napoléon Bonaparte, that heir of the eighteenth century revolution. In 1830, another revolution had overthrown Charles X the Bourbon and established the new July Monarchy of Louis Philippe of the house of Orléans. Although the construction of new canals and the removal of burials from the central city improved sanitation and the water supply, the triumphant market economy jammed still greater populations into these already new broad avenues and deepened, rather than alleviated the extreme poverty that fostered desperate rebellion. In February 1848, the people established the Second Republic, which socialists and other radicals sought to coax the revolution into ever more radical channels. However, the respectable bourgeois republicans arranged for the bloody repression of the workers' movements in "the June Days." Although the authorities suppressed, arrested, proscribed, and deported the intransigent, an uneasy peace had settled over the bloodied cobblestones. Clapp later wrote that, while he was there, Parisians "dare not allude to politics," while drinking their coffee in public cafés.[38]

Yet, none of this distracted Clapp from his joy at exploring the French metropolis and interacting with its people. He found the students in his "hotel" countrified in origins, but often overpolished by urban life, to the point where the loss of the enamel might be compensated by "artificial brightness." "Not that I am an admirer of rusticity. The gods forbid!" Through them, he met female *éstudiantes*, so called "not because of their devotion to study, but because of their devotion to students." With these, he learned of "at least fifty coffee concerts in Paris," that which he most frequented held four to five hundred people. A particular coffeehouse became "my favorite resort for years, alternating with the lattice work inclosure [*sic*]" in the northwest corner of the Jardins de Luxembourg, where he became well known. (He shared this preference with Balzac's fictional residents of the Hôtel Corneille.) This café or coffeehouse culture—literally but one step from the streets—democratized access to what had previously been the exclusive province of the salon, more exclusive locations open only by invitation.[39]

It became the realm of the bohemians, who courted success, but often on their own terms. They preferred to create in a temporary poverty, rather than do what they deemed to be less important, but more lucrative work. Balzac's *Prince of Bohemia* emphasized this free-spirited scorn for the conventional middle-class deference to the marketplace, but Henri Mürger used this iron cage of necessity to frame his 1846 serially published *Scènes de la Vie de Bohème*, a tragedy of art and love in tension with social convention and wealth. At the time of Clapp's 1849 arrival in Paris, Mürger brought the story to the stage as *La Vie de Bohème*, in collaboration with Théodore Barrière.[40]

These new bohemians came from a full range of class origins, but most came from the lower classes. Very few would ever achieve real financial security, much less success in their chosen fields, and many probably knew that they would never do so. They were either willing to gamble that they would eventually be able to improve their lot or were so obsessed with the work that they were willing to gamble. So it was that Alphonse de Calonne, in *Voyage au pays de Bohème* described his metaphorical Bohemia as "a sad country, bounded on the North by need, on the South by poverty, on the East by illusion, and on the West by the hospital. It is irrigated by two inexhaustible streams: imprudence and shame."[41]

All of this transformed Clapp, the product of a New England reform tradition that almost always denounced sex, alcohol, tobacco, and coffee as physically harmful and spiritually sinful. He later quipped, "I ought to have

died a quarter of a century ago at least; and if I had sufficient reverence for their melancholy science, I should have done so, if only for the 'good of the cause.' The man who wouldn't willingly die that such a noble race might live, is as bad as the reprobate who didn't relish the idea of being damned that other folk might be saved. But mankind is so selfish!" Clapp seemed to demonstrate the generalization of Thomas Low Nichols that "as the Yankees go to extremes in everything, when they do break the Sabbath they break it into very small pieces."[42]

In embracing the bohemian life, the Yankee Puritan took up smoking in earnest, although he had apparently started as a young man in New Orleans, later quipping that his extensive use of tobacco "killed me, according to the physiologists, before I was one-and-twenty." In the Paris cafés, where "nearly all the men were smoking pipes" and the others "the milder luxury of cigarettes," he enjoyed the habit without the reproof or guilt imposed by his Yankee neighbors. Not only did he never apologize for the habit, but he espoused the fundamentals of the smoking culture. "Your first pipe with a man is an event," he wrote. "It transforms him into a friend." At one point, he suggested that the tobacco plant, rather than an olive branch, should have been the symbol of peace.[43]

Clapp also developed a taste for strong coffee. "I admit that the delicious Mocha is a 'slow poison'—perhaps one of the slowest poisons in the world—but that is one of its charms." Although he initially found the French coffee too strong, a diner at the next table demonstrated to him how to pour a small amount into the cup, fill it with "boiling milk," add four or five sugars, quarter the bread "longitudinally" and dunk it. Their habit also had Clapp "'dying by inches' for sixty years."[44]

The former temperance lecturer also began drinking alcohol on a regular basis. He recounted an anecdote about how one of Horace Greeley's compositors, when offered a drink, replied "No, I thank you; I never drink; but I chew and swear." Clapp added, "It was only by indulging in a few such weaknesses myself, that I established my claim to common humanity." He almost surely had imbibed as a young man at sea and probably indulged in New Orleans as well. Perhaps he may be forgiven for having taken up the habit more seriously in Europe, at the height of his difficulties with Garrison. After a trip, probably in 1849, he likely recalled his own equipage in noting that "each of the males moreover was armed with a 'pocket-pistol,' loaded in the muzzle with the best cogniac [sic]." Temperance, wrote Clapp, "secured for us all the right *not* to drink. Meanwhile it left the right to drink intact."[45]

Clapp also hinted that he began spending time with women, without marriage as a goal. There had long been the *filles galantes* (streetwalkers) or the higher class *lorette* (courtesan), but café life blurred the *femmes des boulevard*, who picked up men on the street, with the *filles de joie* ("fun girls") who met men in these new places of business. Outsiders may not have distinguished from prostitutes the young working-class *grisette*, many of whom simply did not share the middle-class sexual taboos.[46]

Not viewing such things from the outside, Clapp came to know many of these "studentesses." He found them "not so remarkable for their knowledge as for their smartness" and having "more good sense than could be distilled out of a dozen libraries. Your mere scholar was a fool to them." He recalled that had it not been for his experience with one, he "should never, perhaps, have known how vastly superior is a nature developed by experience and having all its instincts and emotions." There were also older, unmarried but sexually active women to whom he saw "the mass of working-men in all respects her inferiors; while the most intelligent of them adopt her own mode of reasoning, and remain bachelor." These easygoing and charming women provided a stark contrast to the rigidly structured relations of middle-class New Englanders. At one point, Clapp confessed that he had come to see marriage as "the upshot and catastrophe of civilization; and I'm no civilizationist. I do not care to have my likes and dislikes circumscribed."[47]

In 1851, Clapp had the experience of trying to introduce his beloved Paris to Horace Greeley, his fellow Yankee and old Fourierist comrade. Greeley's *New York Tribune* had become an unprecedented publishing success back in the United States, and the editor sought to broaden his horizons by crossing over for the World's Exposition in London and spending the summer touring France. Clapp welcomed him warmly and took him to have his first tailored European clothes "but could not dissuade him from wearing a favorite pair of bright green slippers with it." Exasperated by Greeley's Yankee self-satisfaction, Clapp later echoed John Bright on Benjamin Disraeli, to say that the editor of the *Tribune* "was a self-made man and worshipped his creator."[48] For Clapp, this judgment may have been less about Greeley than about how Paris had remade Clapp.

Clapp finally returned from Europe in the winter of 1853–54 no less an ardent radical than when he left. He frankly confessed himself an admirer of Fourier, who "hopes for nothing more ardently than some day to see the ideas of that greatest of Socialists fairly and fully tested, come what may." In the public eye, he remained primarily "a prominent spokesman for the Socialists."[49]

However, while Clapp brought his radicalism back intact from Europe, he also returned with a world-weary impatience with easy answers.

Although Clapp would later be largely forgotten, he became an important figure in New York letters. The newspaperman Junius Henri Browne attributed his prestige to his time abroad. However, many Americans had been abroad and many foreign literati lived in New York. Clapp did return speaking the French language "with extraordinary fluency, and natives of France acknowledged that he spoke it with a perfect accent."[50]

More tangibly, Clapp became "one of the first to introduce the personal style of Paris feuilleton into the literary weeklies." Of course, however much contemporaries appreciated his work, most of it appeared unsigned in newspapers and magazines or under pseudonyms, the only one we know to be associated with him being "Figaro." For what it must be worth, Walt Whitman thought Clapp's "abilities way out of the common."[51] A reasonable judgment of his literary skills probably depends on such indirect sources.

Whitman also spoke of Clapp's physical presence, which seemed "somewhat suggestive of the portrait of Voltaire." He surely looked "more of a Frenchman than an American." He sported what was, initially, "a reddish beard, and smoked a black clay pipe," but his beard began graying so early that William Winter and other of his younger friends joked that he was the "oldest man," rumored to be 101 years old. The exaggeration influenced Browne to describe Clapp as "nearly twice as old as most of his companions." Winter described Clapp as "an original character" and "a man of slight, seemingly fragile but really wiry figure; bearded; gray; with keen, light blue eyes, a haggard visage, a vivacious manner, and a thin, incisive voice."[52] There were many younger men and women around him, but those close to his age also shared the table.

Clapp also had "a certain kind of magnetism that drew and held men, though he was neither in person nor manner, what would be called attractive." Another thought him "contemptuous of most folks and his wit had a sting to it." A newcomer to the table got "scant courtesy until he had won a position by an intellectual tilt." An artist—probably Albert L. Rawson himself—took a seat at the table uninvited, "for he supposed it was like other public restaurants, and accidentally favored with a goodly company, and ventured a reply to one of Clapp's criticisms of a recent painting shown in the gallery of the American Art Union." Clapp "looked as if he would like to annihilate the artist," until "one of the coterie introduced him as Mr. Oddie," after which

Clapp beamed, declaring: "Oh yes; I know you; you come of an ancient line of Italian poets, doctors, and painters, and make the oddest pictures in the Art Union." With others, Clapp might remain "churlish," and even later, he "would be friends with some, with others never, and with no evident reason for either conduct, except capricious fancy. Even in the coterie he regarded one as his own and another as indifferent."[53]

With the benefits (and disadvantages) of distance, Winter further acknowledged Clapp's "mercurial character and his vicissitudinous career." In hindsight, he thought his mentor "brilliant and buoyant in mind; impatient of the commonplace; intolerant of smug, ponderous, empty, obstructive respectability; prone to sarcasm." "He delighted to shock the commonplace mind and to sting the hide of the Pharisee with the barb of satire. He had met with crosses, disappointment, and sorrow, and he was wayward and erratic; but he possessed both the faculty of taste and the instinctive love of beauty, and, essentially, he was the apostle of the freedom of thought." Conversely, this "continuous, bitter conflict with conventionality" made him "reckless of public opinion." As well, "his views on almost all subjects, were of a radical kind, and accordingly, he excited venomous antagonism." Winter summarized Clapp's career as "in material results, more or less, a failure, as all careers are, or are likely to be, that inveterately run counter to the tide of mediocrity. Such as he was,—withered, bitter, grotesque, seemingly ancient, a good fighter, a kind heart,—he was the Prince of our Bohemian circle."[54]

Clapp saw himself in a much lighter vein. He later confessed that nothing gave him so high an idea of Charles Dickens's genius than his creation of Wilkins Micawber "without being acquainted with himself [Clapp]." In *David Copperfield*, the comic figure of Micawber brought to light the villainous doings of Uriah Heep, an unscrupulous man on the make. Clapp always remained a man with a mission, but it was no longer the direct radical appeal to rational arguments in order to persuade the masses of something. As Clapp counseled a despondent Whitman, it was "better to have people stirred against you if they cannot be stirred for you—better that than not to stir them at all."[55] Bohemianism in America represented a complex and easily misrepresented force.

Very fundamentally, Clapp had shed the kind of political naiveté characteristic of many of his old comrades. Fourierists still spoke of persuading the human race to abandon capitalism through the compelling power of distinct socialist communities, and abolitionists prattled about using "moral suasion"

to inspire slaveholders to end slavery. The former editor of the *Pioneer* had simply spent years in places where people had grappled with changing society for a longer time than had Americans. In discussing the bureaucratic morass of paperwork connected with passports, Clapp noted with some humor that "very Red Republicans were cursing Louis Napoleon for not abolishing a system which the Provisional Government itself did not have the courage to reform."[56]

For Henry Clapp, the status quo rested securely not just on the material self-interest of the ruling class but on unexamined conventional thinking in general. As the revolutions of 1848–49 seemed to indicate, the people could militantly challenge and even overturn the former, but unless they eradicated the latter the same old ruling circles or a facsimile would wind up in power. No parochial solution, rooted in conventional thinking, would unseat, transform or transcend the present civilization.

In the New York to which Clapp returned, art and life had already developed an uncanny ability to imitate each other. News of riots in the French capital had reached New York, and the Bowery Theatre brought *The Insurrection of Paris* to the stage. Inspired by Edwin Forrest's depiction of the people such as themselves, the Bowery B'hoys expressed their theatrical criticism of his rival, William Macready in the Astor Place Opera House Riot of May 10, 1849. Even in so arcane a field as opera, when Bernard Ullmann tried to cut advertising costs, a mob supportive of George Wilkes's *Spirit of the Times* invaded the Academy of Music and refused to allow the performance to begin without a formal apology.[57] As Clapp settled into the city, the politics of the street had become theatrical, and the theatrical adopted the politics of the street.

CHAPTER 2

A Scandal in Bohemia

Free Love and the Antebellum American Culture Wars

―――∞―――

It ain't so much the things we don't know that get us in trouble.
It's the things we know that ain't so. —*Artemus Ward*

In 1855, the horrified *New York Times* exposed the existence of "a Secret Society, or League" among the local radicals. On their behalf, Henry Clapp acknowledged the presence of "a complicated secret institution ... composed of reformatory men and women in various parts of the world, whose collective aim is the 'examination of all questions within the scope of human concern.'" With a literary straight face, he added—and the paper printed—that the organization had "no corporate existence, in the common sense of that term, since its members assume no joint responsibility; are not governed by the ballot; cannot, in the nature of things, have a creed; have no officers who are not self-elected to their functions; have no common fund." Yet, that League had "numerous branches or 'Orders,'" that uncovered by the *Times* being its "Grand Order of Recreation."[1] Novel fears, the newfound power of the press, and the politics of the social imagination contributed to Clapp's suggestion

that, beyond the trustworthy scrutiny of the respectable, lurked a secret society of people insidiously pursuing fun.

As dangerous radical conspiracies go, twice-weekly lectures amounted to very little, but the ongoing political party crisis in the city, the state, and the nation frayed nerves all around. In the teeth of an organized Nativist hostility, veterans of the 1848–49 revolutions in France, Italy, Germany, and elsewhere sought to influence politics in New York. Although lacking such a revolutionary experience, American radicals—who had been building utopian communities or dabbling in independent politics for a generation—found themselves participants in an electoral coalition with some genuine prospects of success and began forming flexible new kinds of communities, grounded in a respect for radical individualism, including questions of sexual love. In their attempts to inject such issues into the public venue with the same frankness they used in addressing economics, they struck a particularly sensitive nerve with the new municipal administration. New York had reached a size and level of anonymity where a burgeoning sex industry emerged and compromised the integrity of city officialdom. The subsequent "Free Love" scandal of October 1855 contributed materially to the collapse of that administration and the emergence of a viable new Republican opposition. It also became the first great public debut of a group that Clapp transformed into a bohemian subculture.

The hope of universal freedom had helped inspire revolts across the western world in 1848–49, and their defeat drove thousands of refugees across the Atlantic, where Americans faced a national crisis of their own. The so-called second-political-party system, in which Democrats and Whigs vied for power, had begun to unravel. The abolitionist Liberty Party, with which Clapp had been associated, had ignored William Lloyd Garrison's objections and captured a limited but strategic base. About the time Clapp had left for Europe, the Mexican-American War moved the Pennsylvania Democratic congressman David Wilmot to propose barring slavery from any territory acquired in the war. The Southern Democratic administration of James K. Polk rejected the Wilmot Proviso, after which former president Martin Van Buren and many Northern Democrats bolted to form an independent Free Soil Party that included abolitionists, land reformers, and "Conscience Whigs." More than one in ten voters in the national election of 1848 opted for the Free Soil version of Wilmot's attempt to prevent the expansion of slavery into the west.

Although the most prominent of the professional politicians subsequently returned to the major parties, those who remained had reorganized a Free Democratic Party, the kind of a fusion of overt abolitionism and land reform that Clapp had advocated. Free Democrats ran candidates such as the socialist Warren B. Chase for governor of Wisconsin and ceded great authority to the veteran abolitionist and Libertyman Gerrit Smith. Smith's minority report to the 1852 national convention declared "our fraternal sympathies to the oppressed, not only of our own land, but of every other land" and calling for the party's reorganization as a "Democratic League" to be "organized in every part of the world."[2] So rang an American echo of the attempts by British Chartists to establish an international society of "Fraternal Democrats."

When veterans of these European revolutions began organizing themselves into a common association at New York, they hosted an address by Senator John P. Hale, the recent presidential candidate of the Free Democrats. This originated in a common effort to get a medal for U.S. naval commander Duncan N. Ingraham, who had forced an Austrian ship at Smyrna to release Martin Koszta, a Hungarian who had lived in America and declared his intention of becoming a U.S. citizen. In September, Hale spoke to a New York rally under "the flags of Hungary, America, Cuba, France, Poland, and the Roman Republic," as well as "the French Red Republican flag" with its "Union Socialiste" label. Over the next few weeks, they established a permanent organization, to be called "the Society of Universal Democracy."[3]

European radicals at New York came out of just the kind of societies that terrified the *Times*. Based on the Masonic order, their model evolved through a succession of political secret societies, starting with Filippe Michele Buonarotti, a long-lived Italian participant in the French Revolution. In the 1830s, what remained of Buonarotti's orders recruited Louis Auguste Blanqui, whose Société des Saisons persisted, in one form or another, into the 1870s. Blanqui's society urged an ongoing revolutionary overthrow of ruling classes until the process left the working class alone to exercise power, sympathetic the German émigrés in Paris launched their own Bund der Geächteten (the League of the Proscribed), followed by a Bund der Gerechten (the League of the Just), and, then, the Kommunist Bund of Karl Marx and Friedrich Engels, who described their goals "the same as those of the other Parisian secret societies of the period."[4]

The Germans in America eventually attained the reputation as the most radical of the émigré groups. Thomas Low Nichols described them as

particularly "of the Protestant or Rationalist class, led by Mr. Greeley and their own socialist or Red Republican leaders," adding that they later "joined the Republican party, from a sympathy with its Abolition and ultra views." As early as the mid-1840s, veterans of the old Communist League established a Social Reform Association, and its European founder, Wilhelm Weitling, arrived and launched a new Arbeiterbund in 1850. Three years later, Joseph Weydemeyer—a Prussian artillerist-turned-carpenter with particularly close ties to Marx and Engels—revived the name with his General German Workers' Association, and, in 1857, the New York émigrés founded their own Communist Club.[5]

At the time, the more neglected French radicals seemed to have far more extensive and complex associations. Their groups ran the political spectrum, including groups as far left as the Blanquistes, who had organized in New York as well as London. Some also held membership, with radicals of all sorts, in l'Ordre Maçonnique de Memphis, which Jacques Etienne Marconis brought to New York in 1856, offering the allegedly ancient Egyptian mysteries. At least one American, William Batchelder Greene—the translator of Proudhon—had joined the order in France. By the mid-1850s, the order had headquarters in London, where it recruited large numbers of British laboring men unable to afford membership in orthodox freemasonry.[6]

The most prominent French association in New York—"the Mountain"— invited its allies to the February 1854 celebration of the anniversary of the Paris risings. The gathering took place not only under the stars and stripes, but under "the *Drapeau Rouge*, or red flag of the Universal Democracy, the staff surmounted by a crimson and bronze liberty cap, and a large golden triangle in the centre of the banner." One speaker called it "the symbol of the solidarity and fraternity of nations. The Carpenter of Nazareth had been clothed with ignominy for having protested against the yoke of the Caesars, and for preaching universal Justice, Liberty and Fraternity against iniquity and despotisms; and as a barrage of ignominy they had placed on him a red mantle. It was the banner which had often been with the people against the power of feudality." In Champs de Mars, he recalled, "the Tri-color had colored red in the blood of the slaughtered citizens," though this flag was "not symbolic of blood and carnage, but of the republican spirit of France." An American participant, William J. Rose, added that he "had trod the soil of Revolutionary Europe, where true men, worthy of all that was glorious in the next, and to the destination of the future," and had stood on the barricades

of the Roman Republic, where "Frenchmen, Italians, Poles, Englishmen, Spaniards and Americans fought together."[7]

The collaboration continued from the Ingraham Committee, through Universal Democratic Republican Societies of United States of North America, to a Convention of Liberal Societies. This not only extended this heritage of radical European fraternalism but aspired to influence in America by comparing "the platforms and candidates of all parties, without being the slave of any; it was therefore highly gratifying to find this already in a fair way to be carried out." In halls decorated by "hung escutcheons bearing the names of various localities" associated with the recent upheavals mingled members of groups such as "Italian Democratic Society, Polish Democratic society, German Democratic League, Union for Social Reform, German American Workingmen's League, French Society *Le Montagne*, Cuban Athenaeum, and several others," including individual Spaniards and Russians. American speakers addressed these meetings, with the U.S. flag "mingling its folds with those of Republican France and Italy," as well as the red flag of revolution.[8]

The most persistent leader in these efforts, "Colonel" Hugh Forbes attended meetings alongside Stephen Pearl Andrews and other Americans, while encouraging immigrants to address issues in their new country. A veteran of Britain's Coldstream Guards, Forbes entered the silk business and fought in the revolution with Giuseppe Garibaldi, penning his insurrectionary *Manual for the Patriotic Volunteer*. Although captured by the Austrians, Forbes won his release and turned up in the United States by 1850. He turned to lecturing and newspaper work in an effort to get funds to bring his wife and children to the United States, but he found these fields hardly lucrative. Living and working along Broadway, he moved the émigrés toward a common organization to assist other refugees to address American concerns such as protesting the Nebraska and Kansas Act.[9]

A platform shared by Forbes, the romantic radical scribbler and Senator Hale embodied the convergence of concerns between the immigrant radicals and the Free Democracy. "Every extension of Slavery," insisted Forbes, "is perilous to Republican Liberty—which danger to the community, the free settler, it deprived of his vote is unable to avert." On July 5, 1854, he chaired a general meeting of these émigré associations on American affairs hosted by the French. They discussed the "considerable interest in the action of certain organizations at Boston and elsewhere, with a view to aid emigrants from the Northern States to Kansas and Nebraska, that a society is now forming in

Philadelphia for similar purposes." When Poles predisposed to the Democrats objected, Forbes "deemed it not only the right but the duty of every good citizen to take a share in the politics of his country, whether he claimed it as a native or adopted citizen," and "opposition to despotic measures and men on this side of the Atlantic, was a service rendered to the cause of freedom universally." A few weeks later, a committee of the group agreed that "the catechism for the patriotic volunteers, as it exists in Forbes's *Military Manual*" applied to American institutions. Significantly, Kansas preoccupied many radicals, and Forbes and others, after "a protracted discussion" won an almost unanimous vote "to give the priority to the question of Slavery."[10] This brought these international associations on—or just off—Broadway onto the stage of American politics and injected a new cosmopolitanism into the projects of the land reformers, Brothers of the Union, and Free Democrats.

The expected convergence of European societies with homegrown radicals laid the foundations for the paranoia that gripped the premier American metropolis and its *Times*. The Free Soil split among the Democrats allowed the opposition to take power nationally, but the victory had broken the Whig Party. Rattled by the national debate over slavery and terrified at the prospect of large numbers of hard-drinking Catholics and uncontrollable secularism, they formed a new nativist "American Party" that instructed members to say that they "know nothing" of its workings. One such exposé described horrific conditions at New York, "the most un-American city in the United States." The sheer number of immigrants seemed to put on the agenda "Fourierism, agrarianism, and that particular form of red republicanism, which consists in overturning the foundations of society, and dividing the property acquired by the industrious among the idle and dissolute." All of this entailed a conspiracy of horrific proportions, expressing "foreign impudence imposing upon American forbearance," for "*Americans should rule America.*"[11] To such a climate Clapp returned, wherein he quickly reestablished his ties to the socialist movement, particularly through his friend Albert Brisbane.

American radicals distanced themselves from the kind of utopian experiments they had been building for years. For a generation, the most radical social critics had advocated social transformation by the power of example through the establishment of socialist communities, an option not readily available in the Old World. At this point, though, they began thinking of pursuing their goals in less self-insolating ways. By midcentury, American socialists involved themselves in the politics of land reform and Free Democratic

politics or in cooperative Protective Unions. Another Massachusetts-born Fourierist, Ira B. Davis, became one of the most persistent advocates of both, maintaining a network of Protective Union cooperative stores and a bakery by 1853. Although disinterested in the Free Democratic project, he became a public leader of the Brotherhood of the Union, an American fraternal order. Impressed by the waves of émigrés in New York, Davis's Nazarene Circle of the Brotherhood renamed itself the Ouvrier Circle.[12]

So, too, the kinds of communities American radicals formed proved very different from their predecessors. In 1853, some of the leading lights of the American movement launched one of the oddest in the history of socialism: the Modern Times colony, which likely never drew more than a hundred members to its location near Thompson's station, at what would become Brentwood on Long Island. Nichols, who joined the community, wrote, "It seemed very odd to find one's self, two hours from New York, among people who had deliberately discarded the common restraints and regulations of society, and where the leading spirits—the persons most admired and respected—were those who had the most completely acted upon their theories."[13]

Despite its tiny size, probably no single socialist community ever enlisted more original contributors to American radical thought. Stephen Pearl Andrews had been a Yankee pioneer of abolitionism in Louisiana and Texas, before having been driven out by a Houston mob. As a corollary of his own philosophical Universology and Pantarchy, Andrews adopted the economics of Josiah Warren's *Equitable Commerce* (later *True Civilization*). Warren had spent a quarter century in New Harmony, Utopia, and Cincinnati forming Time Stores, where "Labor Notes," representing time engaged at one's calling purchased merchandise sold at the cost of production with a small markup to cover overhead and the clerk's time. Edward N. Kellogg advocated greater economic equality through a socially controlled monetary system, a body of ideas that became foundational to what became Greenbackism after the Civil War. Henry and Millicent Edgar—founders of positivism in the United States—came from the North American Phalanx, as well as Charles Codman and a contingent of Brook Farmers. National Reformers such as Dr. Edward Newberry and James A. Clay, the advocate of women's rights and critic of marriage moved to Modern Times. Present in spirit was Greene of the l'Ordre Maçonnique de Memphis, an advocate of a cooperative mutualism that theoretically transformed Warren's Labor Notes and Kellogg's paper currency into a political agitation for "a mutual currency" and "mutual banking," but he was then in Paris.[14]

Yet, the ranks of the colony were often just as interesting. A native Scot and a friend of Clapp, George S. McWatters had worked as a mechanic in Northern Ireland and London. A prominent English radical later visiting America recognized McWatters as "an old friend of mine," indicating his likely involvement with the Chartists and other radicals. McWatters's experience brought him a less flattering sense of the idea that America's streets were paved with gold. After taking his family to Philadelphia, he studied law, but work on debt collection disgusted him, so he went to California, where he found himself alienated by the gold fever. Upon returning east, he joined the Individuals Sovereigns engaged in Equitable Commerce at the Modern Times community. In the city, McWatters found work as a booking agent for Laura Keene and others in theater. Just as paradoxically, perhaps, the revolutionist's client list included Lola Montez, the émigré celebrity whose liaison with royalty had so scandalized Vienna that it sparked the 1848 revolutions. After he solved some minor mysteries associated with the theatrical community, a mercantile house in New York commissioned him to solve a forgery "to the amount of about fifty thousand dollars," giving him a virtual blank check to go to St. Louis and "anywhere else thereafter on the two continents" to find the culprit.[15] As a private detective—and later a policeman—Officer Mac was more institutionally connected and philosophically alienated from those institutions than most people in these radical circles would have been.

Some of these radicals scoffed at social conventions with regard to sex, love, and marriage. Consistently advocating individual sovereignty, Andrews had long declared his views on marriage. Dr. Marx E. Lazarus wrote *Love vs. Marriage*, which kicked off the discussion of "free love" by criticizing marriage as disharmonious, and advocated a kind of cooperative anarchy as means to ends of Fourierism.[16]

The landlady at Lazarus's boardinghouse was the former Mary Sargent Neal. Always a rebellious spirit, she had rejected the Jeffersonian free thought of her rural New Hampshire family to join the Quakers on her own. She later wrote an autobiographical novel, *Mary Lyndon*, on her experience locked into a loveless ten-year marriage to Hiram Gove. More immediately, though, she turned to self-education, which led to her opening a school for girls in Lowell. In defiance of community standards and the disapproval of her co-religionists, Mary Gove took to the platform on her own to lecture on medical and sexual subjects. An avid supporter of the water cure, she became closely associated in the 1840s with Lazarus, whom she followed into Fourierism after moving to

New York. A regular at Brisbane's soirée at 261 Tenth Street, she met Edgar Allan Poe, Herman Melville, Horace Greeley, and other local luminaries. In turn, when she and her sister leased a house of their own, they hosted gatherings of reformers, where she met Nichols, an aspiring and somewhat younger medical student, and married him in a Swedenborgian ceremony.[17]

Nichols had already established a long history in sexualized politics, much of which had become public knowledge. A minor figure in the emergence of the semipornographic "flash press" of the early 1840s, he made no secret of his affinity for prostitutes and, uniquely, refused to be blackmailed by his rivals. As a result, they published notices of his affairs, referring to him as Ego Nichols, Handsome Tom and, in lower case, "t. l. niggles."[18] Nichols clearly demonstrated just how far one could push the envelope of respectability.

Although a physician, Nichols worked as the assistant editor of James Gordon Bennett's *New York Herald* and boasted that readers failed to distinguish a difference between what he and his employer wrote. By 1850, he had earned his medical degree, married Mary Gove and with her, began opening a series of water-cure institutes. He also wrote *Woman, in All Ages and Nations* and *Esoteric Anthropology* and coauthored with Mary *Marriage: Its History, Character, and Results*. The Nicholses understood that women's rights did not mean, as was generally thought, "amelioration, more scope to labor, a better education, less offensive laws—but freedom and equality with man, social, religious, and political." Such "would be a revolution." Together, they had defied convention to foster an unprecedented discussion of human sexuality in the United States. In 1853, they moved to Modern Times and launched a new educational and cultural project, Desarollo. At Modern Times, wrote Nichols, "marriage existed or was dissolved at the choice of the parties."[19] Already famed for an anarchist focus on individual will, Modern Times soon developed a reputation for nudism and free love.

Believing that the public needed to be educated to the new standards, the radicals made no secret of their views. Edward F. "Ned" Underhill declared "that I am a free lover, and not a slave lover—that I believe the institution of civilized marriage to be at variance with instincts of human nature, which rebel against all systems of slavery." He described himself as "a young man, successively a factory operative, an actor and a journalist—and certainly an enthusiast." A native of upstate New York, he had mangled a hand in an industrial accident and learned stenography from the Fourierist Theron C. Leland. Among the handful of male signers of the Declaration of Sentiments

and Resolutions at the 1848 Woman's Rights Convention in Seneca Falls, he also became directly involved in radical language and spelling reform. "For many years I have been identified with the cause of constructive socialism," he added, "and ... others have lost faith in the immediate prospect of a realization of a condition of society better than exists on the plane of civilization, because of the failure of numerous attempts at social reorganization." In particular, he believed in "the full fruition of social harmony, which, to me, is the second advent of Christ upon earth." Underhill served on a committee elected at a mass meeting of the unemployed to evaluate Kellogg's proposal for government paper currency, but he also participated in the Free Democratic Party.[20]

With news and rumors of Modern Times in the air, Clapp, Andrews, Underhill and others undertook the task of building "an effective organization in this City." Andrews "opened his house—invited his friends of kindred sympathies—prepared refreshments for the intellectual whose 'attractions' drew them towards him—his lady, a woman of elegant manners, presided at these *soirées*, with grace and dignity—it was a select circle." They aimed initially at the formation of a political association, even with clergymen attending. What emerged was that "Secret Society, or League" that so horrified the *Times*.[21]

Municipal politics in 1854–55 provided the radicals a much needed opening. In response, to the crisis in the two-party system, local voters had elected a Know-Nothing administration that soon earned a reputation as being just as corrupt as its predecessors. When reformers and immigrants mobilized behind Fernando Wood, a wealthy businessman, to turn out the Know-Nothings, Davis, Andrews, and other radicals participated. Wood's combination of conservative machine politics, populist rhetoric, and assiduous sensitivity to public opinion created a temporarily successful but very brittle Democratic coalition. Wood took office as Andrews and the radicals resumed their work in the city.[22] However, through 1855 his first administration began to unravel.

The year started when the radicals who had helped elect Mayor Wood began confronting him over the issue of unemployment. Starting with "only a few hundred," Davis and his comrades began mobilizing "thousands" whose representatives confronted the local authorities, initially urging the city to authorize the jobless to occupy unimproved lots as squatters. The prospect horrified Wood, who promised "a plan of my own for the relief

of the unemployed workingmen." By midyear, the émigrés, led by Forbes, began to discuss their involvement in the effort. Reorganized as Practical Democrats, the unemployed built what the Democratic *Herald* conceded to be "an organization of some importance." By September 1855, Davis and other radicals moved a meeting of "about 300 persons" to call for a new "American Democracy" to promote more egalitarian election laws, cooperative protective unions, and a city housing project to rent cheaply to the landless. They also opposed prohibition and favored criminalizing attempts by employers "to defraud working people out of their just wages for labor performed."[23] By this point, the discontented had lost patience with Mayor Wood.

What followed in October 1855 was the public debut of the two-year-old league for which Clapp became a spokesman. Andrews served "the League" as their "self-appointed chief, who exercises unlimited authority, and is irremovable." Among other things, it formed a "Grand Order of Recreation" that sought "to organize the amusements of the people upon a basis of cheapness and of accommodations for the vast numbers, which will bring them within the reach of the whole people and, by their frequency, variety and moderation prevent them from degenerating into dissipations." The club included radicals of all sorts—on all sorts of questions—including "several of the disciples of JOSIAH WARREN, the apostle of 'Individual Sovereignty.'"[24] In part, the League represented an extension of Modern Times back into Gotham.

The League enlisted the aid of Clapp's friend Albert Brisbane. The longtime leader among the American followers of Charles Fourier, Brisbane headed the American Union of Associationists, aimed at demonstrating the value of Fourier's blueprint for changing the world. He had seen the upheavals of 1848–49, heard Pierre-Joseph Proudhon, Karl Marx, and others, and had serious reservations about the recreational arm of the League. Clapp later wrote that Brisbane "has always been opposed to the Club, on the ground of its being a mere place of amusement, and not a company of propagandists." A "most meteoric talker who could enchant a roomful on any subject," he disliked "addressing promiscuous audiences with whom there is no unity of opinion" and sympathized with the goals of the club but said "they do not, it seems to me, break up the basis of social injustice; as a radical reform in the relations of labor and capital only can do this." Brisbane believed "the great reforms to be effected in society relate to political economy, that is to credit, the currency, commerce and banking. We must strike down the privileges of capital and elevate labor."[25]

Nevertheless, these recreational activities of this informal club quickly transcended the narrow circles of the original group by issuing select invitations for growing numbers to attend. They leased "a bare, unpromising suite of apartments" at the corner of Bowery and Great Jones Streets but, by February, got more spacious quarters in the interior of Taylor's, in the heart of the theater and entertainment district. As one writer recalled, "Every old New Yorker remembers with pride and pleasure the magnificent establishment on the northwest corner of Broadway and Franklin Street. Nothing like it in size or appointments has ever been seen in this country, even to this day." Undesirable for permanent occupation, owing to its "want of ventilation, a very considerable altitude, unpainted panels and some other things," the space suited "weekly social gatherings, for lectures, music, dancing, &c., . . . attended by hundreds of persons of both sexes." Although gatherings were by invitation only, attendance crept up to between 60 and 200, averaging 150, and supported a move to twice weekly meetings, Mondays and Thursdays, beginning at 8 P.M. and ending around 11 P.M.[26]

Radicals had already claimed this space as their own. Andrews, Davis, and others knew Taylor's as the site used by the local spiritualists, who had founded an organization there in June of the previous year. The Fourierists also met there, sponsoring a meeting addressed by Warren B. Chase of the "*Ceresco* Union, which occupies the site of a defunct 'Phalasterie' in Wisconsin." Chase's community, renamed Ripon, had taken such a decisive initiative to launch a new Republican Party in the Upper Midwest. The Fourierists continued to meet well into 1856 with Clapp's active participation.[27]

The story of the "Free Love League," "Free Love Union" or the "Free Love Club" has become somewhat iconic in the narrow prehistory of American "Culture Wars." One newspaper account reflected the illicit fascination of penetrating the scandalous secrets of the Grand Order of Recreation. "Up three pairs of dingy staircases. Through torturous passage-ways. In and out of a great receptacle of useless timber. Past three doors of offices. Up—up—up,—till the last landing is reached." If you had an introduction in the form of a password—"passional attraction" at the time of this visit—you could pay the admission at a small table. Through trial and error, the group had adjusted the fee to cover expenses and to encourage couples and single women to attend. Beyond the table, you could check your hat or cloak for a two-cent ticket at a partitioned area. Red drapes divided off an outer chamber as "the retiring room for the ladies," and a long uncarpeted, unfurnished room led

to an "inner temple," carpeted and furnished with a desk raised on a platform and a seating area for lectures. After the lecture, participants used the two tables in this room for playing cards and returned to the larger room for dancing.[28]

In reality, Clapp rightly pointed out that this Grand Order of Recreation had "no more to do with Free Love than with Free Trade, though both of these topics are within the competency of the league, the former belonging to the 'Grand Order of the Social Relations,' the latter to the 'Grand Order of Justice.'" Such subjects had long fallen under the monopoly of the churches and patriarchal authority, but the most objectionable feature of these public meetings was the radical attempt to involve women in these discussions. The schoolteacher Marie Stevens later admitted to having been "several times at the Club 555 Broadway." A native of Lebanon, New Hampshire, she had worked in and around the mills of Manchester and Lowell, until, as an autodidactic seventeen-year-old, she had turned up in Boston, as a student of phrenology and "phonography," a system of shorthand. Two years later, she turned up in New York City working a day job at the Five Point Mission school and trying to break into theater. She recalled open discussions of sexual love, that divided participants broadly into "exclusionists" and "varietiests." At one of these, she likely met Lyman Whiting Case, who had become involved with the land reform while a student. A lawyer, after his wife's death in 1853, Case had moved to New York and taken up with Stevens.[29] Both became regulars in Clapp's circle.

Circumstances made the public discussion of sex more timely and marketable but also rendered it particularly disruptive and unwelcome. Urban growth had created a large transient male population, changed in the structure of the traditional family, and radically modified courtship standards. The 1855 city census identified about a third of the population as adult males to whom catered between 20,000 and 30,000 prostitutes, according to contemporary estimates. As in every other industry subject to market forces, those in the best position to corner demand did so, giving rise to a "whoreocracy"—running from the high-priced houses of assignation in the best neighborhoods, down through the cheaper brothels scattered through the city, and finally to the streetwalkers. To a great extent, of course, working-class people—women and men—did not fully share the middle-class stigmatization of illicit sex, which, in turn, sanctioned their objectification in the unprincipled and mercenary pursuit of sex by the "sporting" young men.[30] Perhaps the most distinguishing

feature of the fictional *Elephant Club* of Underhill and Mortimer Thomson was the complete absence of such obsessions.

The association of the sex trade and the theater district became notorious, with the largest concentration of high-class brothels on Mercer Street, just behind the theater district on Broadway. Not surprisingly, solicitation and sex became particularly associated with the upper tiers of respectable theaters. Then, too, in these years, ambitious sex workers began experimenting with theatrical performances of nude tableaux, dance, and even the sex act itself.[31]

As in the industrialization of handicrafts, market-driven considerations increasingly eclipsed older practices in the sex industry. The intervention of government authority contributed much to reshaping this trade, as others. Wood had led the Democrats back to power, promising to clean the city's image, and his new police force made well-publicized roundups of streetwalkers and raids of the less well-connected "disorderly houses." At that end of the trade, the additional threat of police violence created a function for the male protector, the pimp, who could better negotiate a space for the business with the neighborhood and municipal authorities. In turn, the system incorporated official tolerance and the police collection of payoffs. At the higher and more successful end of the trade was that open and lucrative sex industry on Mercer Street.[32] In short, as with most unworkable prohibitions, police involvement had the effect of encouraging the emergence and dominance of the more well-heeled high-end businesses—those brothels catering to the city's wealthiest and most powerful clients, to Mrs. Grundy's errant spouse.

Certainly, the contradictions interested local radicals. One native of London's East End, Emma Hardinge, had taken up residence with her mother at the Modern Times colony. As her fame as a spiritualist grew, she would propose a cooperative for "homeless and outcast females" that would allow those women wishing to leave prostitution to learn a trade and make a living without it.[33] Certainly, such a practical radicalism was widespread among her neighbors at Modern Times and its well-wishers, including those who continued to work in the city.

Nevertheless, there was never a hint of evidence that the so-called Free Love Club was anything but a chat shop. "Want of finish is often found among reformers; vulgarity, rarely, or never," wrote Clapp. "They leave that attribute to the so-called 'higher class,' who look sarcastically down upon them, and whose often innately vulgar natures, are thinly veiled by a gloss of dress and conventionality." The veteran land-reform leader Joshua King Ingalls, who knew these "and others, who affected great latitude in the 'freedom of the affections,'"

found the meetings on Broadway "never indecent or vulgar," and the conduct as "orderly and respectful, and I saw no actions surpassing the improprieties of the kissing and romping games, I have often witnessed at Sectarian sociables, where dancing and cards were religiously prohibited." Even a later exposé acknowledged that nothing "of an improper character has occurred, or can occur, elsewhere than in the immediate precincts of the Club" and acknowledged "that there is nothing to repel the most delicate observer."[34]

The scandal had less to do with what actually happened than with the rivalries within the New York City press. Democratic papers, like the *New York Herald*, regularly blasted the Republican Party as a threat to the sanctity of private property, but of particular importance in this case were the tensions between Henry Raymond's *Times* and Horace Greeley's *Tribune*. The former, who wanted a party led by former Whigs and Nativists, continued to fret over "the course of the Red Republicans" and feared that the conflict might find "the revolutionary ball put in motion." The *Times* directly attacked the radicals' adopted patron among the Founding Fathers, Thomas Paine, denouncing him for his "Red Republican Jacobinism": "Utopian extremes cannot long live upon the soil of this Republic. Those of PAINE died before he did, and have been succeeded by myriads of others, each of which has been equally short-lived."[35]

The *Times* had actually helped elect Wood but wanted a large role in shaping the character of the emerging new Republican Party, offering itself as a less radical rival of the *Tribune*. At one point, Clapp wrote about this match for "the Championship of the Republican Party" like a boxing match:

> GREELEY, owing to his superior weight and wind, is likely to win, although thus far he has received by far the greater amount of punishment of the two, and is already so blind that he cannot read even his own letters, and so confused as to have entirely lost his memory. Moreover, RAYMOND appears to have some secret objection to winning,—probably because, if he should gain the Belt, he would be in as awkward a position as the man who drew an elephant in a lottery, and didn't know for the life of him what to do with it.[36]

As part of this, the *Times* published an extensive piece entitled "The Free Love System." "The championship of Socialism, or of universal Libertinism and Adultery, which is but another name for the same thing—is carried forward under various disguises," it warned. Under these disguises, "the principles

of Socialism were never more ardently and zealously advocated" and "never had anything like so strong a hold on the sympathies and sentiments of a large portion of our society" as the present. Specifically, the *Times* blamed the erosion of Christian marriage on Fourier—and the popularity of Fourier on Greeley and the *Tribune*. The latter added its own denunciations of the "Free Love League" or the "Progressive Union Club," which both made a battle for their moral superiority over both each other and Wood's police force. One letter writer to the *Times* recalled a dinner "when Mr. BRISBANE united in one toast the names of JESUS CHRIST, CHARLES FOURIER, and HORACE GREELEY!" Despite his fundamental decency, Greeley had an abiding faith in the ability of government to foster a more moral society. As Nichols wrote, he "would have shut up or banished every prostitute, and made every breach of the seventh commandment a State prison offence." When the *Times* charged that a threat to marriage existed, for which Greeley was partly responsible, his *Tribune* entered into the extensive debate it had wanted to avoid over reforming marriage law, particularly to permit easier divorces. There followed something of a literary argument over *Love, Marriage, and Divorce and the Sovereignty of the Individual*, in which Andrews, Greeley, Henry James, and Marx Edgeworth Lazarus participated.[37]

Even a supportive participant in the meetings, such as Ingalls, acknowledged that the nature of the meetings changed with the unwanted publicity. As the female members of the households left the city, the organizers decided "to charge single men not only the same admission fee as for a couple, but double the price. While this considerably reduced the number of single tickets sold, it reduced also the disparity between the numbers of the respective sexes." Then, too, the cost of admission was so high for single men that some may have begun "to invite any woman they could induce to go without reference to character. Some even went to the street and picked up a companion from the demimondes." The police "supposed they had discovered a place where they could levy blackmail, or gain some cheap notoriety by posing as guardians of the public morals."[38] The latter became particularly important, given the proximity of the open sex trade on Mercer Street.

On Thursday, October 18, 1855, everything came to a head. With all of the publicity, attendance promised to be booming, although not among those eager to hear lectures on mutual banking. That evening, Brisbane found Andrews suffering "with a hemorrhage of the lungs" and agreed to stand in

for him at the meeting. Andrews urged him to convey his apologies and "to state briefly the objects which he had in view in organizing the club."[39]

The *Times* reporter—likely the same writer responsible for the earlier coverage—described how Clapp, "a prominent spokesman for the Socialists," charged the press with misrepresenting the club. It had "no prospectus, had published no bills," and "had not sought publicity; but publicity had been thrust upon it." Sounding like a good Pre-Raphaelite, Clapp condemned the one-sided misrepresentation of what peaceful citizens were doing by the press as typical of "this cowardly Nineteenth Century." The papers, he complained,

> *with ever-eager eyes—fixed upon anything that promises to pander to a prurient curiosity*—ready to do anything and everything to add to its lust of gain—ready to *fall down and lick up the very mire in the streets*—looks down our chimneys, seeks to invade our domestic circles; misrepresents us in every possible way. Through its influence you have come here tonight, gentleman! And what have you found here? Are we men and women, who meet here day by day for social intercourse, or are we a pack of idiots, *as we have been told by that greater idiot, the Press?* JAMES GORDON BENNETT, HORACE GREELEY, HENRY J. RAYMOND, *par nobile fratrum*, are the glorious Triumvirate to whose agency we are indebted for these favors.

When Clapp's audience greeted his remarks with "great sensation—hisses—cheers, &c.," Raymond's employee described it as a "violent speech," given by a speaker who "became very violent" in its delivery.[40]

After being "loudly called for," Brisbane climbed up to sit on the back of a chair "with right leg extended upon the baize-covered table before him, and spoke rapidly for half an hour." He recited the purposes of the club to provide "amusement and instruction" to those who "cannot find these at home, being too poor to invite and not fashionable enough to be invited." The *Times* reporter also wrote that Brisbane had declared New York to be

> nothing else than a Great Free-Love Club! Men came here from abroad because it is so. *Mercer street is full of Free Love Clubs*; without them New York would not be what it is. It is they which attract such crowds of strangers hither, and if any man then present could say he had never

been in that locality, and had found what he went to seek,—in short, if there was one purely moral man in the room,—Mr. B. Wanted him to step forward where he could be seen. (Here there was observed a general shrinkage.)

"Suppose all this were blotted out—What would New York become?" Brisbane asked, adding that it would become "dull and stupid—nothing but a congregation of merchants!"[41]

The purposes of Clapp and Brisbane had been to discourage those drawn to the meeting by the lurid promises implicit in the press. In response, the *Times* complained that Clapp and Brisbane had given "the very incautious, injudicious and grossly offensive addresses" that they would have "suffered a violent interruption" had the police not been present.[42]

In fact, of all their listeners, Captains Charles S. Turnbull and David Kissner of the Eighth and Fourteenth Ward stations had the greatest reasons to be furious. Though conceding that it was all a matter of "rumor," the *Times* said the police were present because of complaints that the gatherings had been "disorderly in their character." The police also later said they were present to protect the meeting from attempts at "interfering with the performances up stairs." Two uniformed captains were turned away but Turnbull and Kissner paid their twenty-five cents each and entered. While it is not a matter of record whether they had to whisper something like "passional attraction" as well, Brisbane's description of Mercer Street as one of "New-York's chief institution[s]" scandalized the uniformed watchmen over that institution.[43]

Shortly after 9 P.M., everything fell apart. Another municipal functionary, Isaac Cockefair, turned up, but Thomas Harland, the doorkeeper, stopped him in the foyer. Cockefair created a disturbance, complaining that he had already given someone money downstairs, so the police arrested Harland. When the brothers John and Benjamin Henderson protested Harland's treatment, the police arrested them "for the interference with the officers in the discharge of their duties." Unable to be heard, Brisbane went to the back and asked Officer Turnbull "whether he could not induce the people to leave quietly," after which Trumbull claimed he had been "accosted," and, said Brisbane, "immediately seized me in a brutal manner, seeking evidently a chance to show his zeal, forced me down stairs, and conducted me to the Eighth Ward Station-house."[44]

The press reported that "several highly respectable gentlemen, well known

in the literary world and in politics, sought to make a speedy exit." As the police carted Brisbane, Harland, and the Hendersons off to jail, Underhill "made a bee-line for a Magistrate." When he failed to find one, the four prisoners "remained in prison during the night." However, the city was in for trouble, because, as one freethinker recalled decades later, "the reformers didn't take it lying down so much then as they are inclined to do now."[45]

The next morning, Mayor Wood woke up to find the arrests "the talk of the town."[46] Sensing a public relations disaster, he quietly moved the preliminary hearing from the Market Police Court to City Hall, "where his Honor himself would attend to their cases." The four prisoners arrived in a carriage, and representatives of the press hovered about. When the only police charge against Brisbane was "uttering inflammatory and seditious language, inciting to riot," Wood's eyes must have rolled. The mayor immediately dismissed Brisbane, who had a "brisk conversation" with Captain Turnbull on the way out.

At this point, Police Chief George W. Matsell arrived at City Hall "and went direct to the Mayor." Determined to prevent the further embarrassment of his beleaguered force, Matsell exchanged hurried and unreported words with the mayor, who then announced to all present that he had just authorized Matsell to place the club "under strict Police surveillance." Thereafter, said the *Times*, Mayor Wood

> turned to the few reporters who were present, and remarked, for publication, that the Club was an institution of immoral tendency— that it was his opinion that it should be broken up—that it was his opinion that there was already vice and iniquity enough in the City— and that summary measures would be taken with this organization in case of any further disturbance of the public peace. His Honor was very strong in the expression of his sentiments, and was distinctly understood to be anything but a Free Lover.

After thus double-reversing himself, Wood dropped the matter into the lap of one Justice Osborne and hurried from the scene. Osborne took the remaining three prisoners into the adjacent outer room. Without the groundless charge of incitement to riot, Officer Turnbull charged Harland with assaulting Cockefair and the Hendersons with an attempt to prevent Harland's arrest. The prisoners got a bail hearing, while Underhill and others raised what they needed to secure their freedom.

The court reconvened on Saturday morning to hear testimony about the assault on Cockefair. Ever one step behind the process, Captain Kissner tried to revive the idea that Brisbane had incited the room to riot, and then he "wished to know whether one of the charges in this case was that the house was disorderly," adding that pursuing the case without that charge would only be "half the story." However, neither Kissner nor any other policeman had any evidence indicating this to have been the case. To make matters worse, the alleged victim of the assault, Cockefair, was not present.[47]

The writing was on the wall. On Monday, Cockefair testified, but without any supporting witnesses, leaving the mayor's police holding the bag. On Tuesday, Captain Turnbull's testimony resulted in the immediate dropping of changes against Harland, Cockefair's alleged assailant. That made the charges against the Hendersons unsustainable. When Turnbull told the judge in the presence of reporters that Brisbane's remarks had "in his opinion, an immoral tendency." The *New York Times* revised its position to state: "Now it appears that a citizen of this commonwealth can be seized by the police, and dragged to a loathsome station-house and incarcerated all night, because one of the members of the said police considers that he made remarks which did not accord *with his views of morality!!*"[48]

The *Times*—which had been a major force in creating the problem—had little choice but to take a position identical to that of the radicals. "We doubt if the history of this country affords any parallel to that proceeding." "A gathering of two or three hundred people, assembled in a private room,—guilty of no disorder,—preserving all the decorum ever required at a public ball or even in a private party, is invaded by the Police who create a disturbance and under that pretext break up the meeting, and drag off to prison two or three gentlemen who venture to question the propriety and legality of their conduct." It recalled "some of the worst governed nations of Europe" wherein a citizen "runs the risk of finding himself arrested and set to mediate in a dungeon, on the laws of morality and the blessings of a Government which knows how to defend it." Declaring that Turnbull had "exceeded his duty, the *Times* reported that the mayor "ostentatiously proclaims his purpose to put the Club under police *surveillance*, because he believes the *doctrines* it promulgates to be of an immoral tendency! Is there anything more flagrant than this, in the worst despotisms of Europe?"[49]

On Sunday, the gloating radicals dropped responsibility for the entire incident directly on the head of the mayor. Coming on the heels of police

boasts that they had closed a dangerous function, Underhill quoted Turnbull's assertion that he had rather randomly come upon the meeting, adding, "Our Police Officers have a convenient way of shirking or assuming responsibility, as best suits their purposes and inclinations." Clapp added, "The storm is over, and nobody is killed but Mayor WOOD, who received his death-stroke in this morning's TIMES'. The bubble has burst—the bomb has spent itself; Sebastapol is taken (over the left;) the Press has 'saved Society.' ... In a word, all is tranquil—New-York draws a long breath, and—the country is safe!" That evening, the "Club met as usual."[50] In one form or another, it survived for many years.

The entire affair had become a major embarrassment for the Municipal Police and Mayor Wood. Denounced for not repressing the free love menace, Wood found that doing so placed him and his police at odds with the most basic precepts of American liberty, as expressed by the emergent Republicans. The event dealt the administration of Wood's temporarily successful Democratic coalition a great blow, through its most vulnerable feature, the police.

The importance of this Free Love Club incident is easily misunderstood, although the incident has gotten some notoriety as a kind of antebellum clash in "the culture war." Wood's biographer ascribes some importance to the free love episode, treating it "as an exercise in self-deception." Lost in this has been the bait-and-switch maneuver of the press, which pushed the administration to do something for which it subsequently condemned it.[51] Those who see only the activities of the prominent and powerful may suggest that Raymond and Greeley somehow overcame their rivalry to cooperate in crippling the Wood administration; however, not only is there no evidence supporting this, and what evidence we have indicates just the opposite.

The most realistic, if subtle, explanation lies outside the offices of the mayor and the editors of the major newspapers. The Yankee-born Franklin J. Ottarson held a seat not only on the city's central committee of the new Republican Party but on the city council. He held office in the New York printers' union, the Odd Fellows, and the temperance movement, and remained close to Clapp, Brisbane, Underhill, and the other radicals, being also described as Greeley's "trusted assistant and friend." Similar associations influenced much of the corps reportorial. Nichols had a direct hand in the management of the *New York Herald*. Charles B. Seymour and Joseph Howard Jr. had longstanding connections to the *New York Times*. John Russell Young later described

Clapp's circle as "resolute, brilliant, capable, irresponsible, intolerant—not above setting things on fire for the fun of seeing them burn."[52] There was more than gratuitous mischief in the case of the free love imbroglio.

Not only did the disintegration of Wood's coalition permit a more thorough redefinition of the party system in New York along antislavery lines, but Wood's handling of the police force pushed the legislature toward reform on that point. In the winter of 1856–57, the state authorities established a new Metropolitan police district with power vested in the state. Wood ignored the law and tried to retain the Municipal police, though it dwindled to only about 800, and both sides built up rival police forces into 1857. McWatters—the socialist theatrical agent-turned-detective—espoused ardently Republican politics and joined the new Metropolitans. Missing the point, as often he did, Nichols wrote, "One most enthusiastic advocate of the principles of Warren and Andrews got an appointment in the New York police force, and became a humble instrument of the power he had long denounced."[53] The tension between the police forces erupted into a pitched battle that ultimately could only have ended in a Republican victory.

By assigning priority to the free love issue, the working members of the press had made it important, creating a scandal that became real enough to help bring down a municipal administration and might well do more. In a later exchange, Clapp noted the failure of the old Enlightenment faith in reasoned discourse: "In these days, and in this country, you can't preach down anything. The thing has been tried and failed." Not surprisingly, the realization first struck the owners, publishers, and editors as well as the reporters, printers, and freelance writers. Concerns over patronage, advertising, and other very material considerations would increasingly eclipse the idea of journalistic mission and assure the owners and their managers an exclusive control that made the press look progressively similar and bland. When the large dailies later boasted that their pages were now stereotyped, Clapp commented that "this fact has been patent from the beginning."[54] In the 1850s, however, writers had a hand in assigning the priorities to a story.

No coincidence made free love the touchstone of this initial outrage. The first self-conscious bohemians on this side of the Atlantic shared with their peers in London and Paris that characteristic scorn of "the commonplace" and its "smug, ponderous, empty obstructive respectability." No accident clustered them about an acerbic iconoclast, impatient with the unthinking repetition

of tropes that bolstered the status quo. Even that minority of Americans who rightly heaped scorn on the hypocrisy of the nation's slaveholding or the open corruption of its electoral politics, even the more enlightened and aware of the respectable middle class balked at attacking the standards governing sex, gender, and the family. Almost nobody would have flouted it publicly, as did Thomas L. Nichols, but the bohemians found a way to make their point with a cultural statement that trumped all appeals to the mandates of municipal standards. In the process, they began a cultural transformation of politics that, like the active abolitionist resistance to the return of fugitive slaves, helped to carry the term far beyond the mere electoral contests between rival cliques of officeholders and office seekers.

CHAPTER 3

Utopia on Broadway

Charles Pfaff's Saloon and the Power of the Pen

GO TO PFAFF'S!—At Pfaff's Restaurant and Lager Beer Saloon, No. 647 Broadway, New York, you will find the best Viands, the best Lager Bier, the best Coffee and Tea, the best Wines and Liquors, the best Havana Cigars—in fine, the best of everything, at Moderate Prices. N.B.—You will also find at Pfaff's the best German, French, Italian, English, and American papers.

—*advertisement*, Saturday Press

Frank S. Chanfrau, one of the regulars at Charlie Pfaff's saloon had been born in a wooden tenement on the Bowery, worked his way west as a ship carpenter, and discovered his remarkable gifts of mimicry. In 1848, in "A Glance at New York," he brought to life the character of "Mose," who swaggered onto the stage and delivered lines in the distinctive language of the Bowery "b'hoys" and "g'hals," to the delight of the distinctively working-class crowd. Based on this success, Chanfrau turned to developing *Our American Cousin* and its spinoffs for Laura Keene, aided by Charles Gayler, author of *Out of the Streets: A Story of New York Life*.[1] An emergent urban life not only inspired the career of a worker-turned-actor-portraying-a-worker, but that life helped make the pen its main fulcrum of antebellum creativity.

A well-connected visitor to Charles Pfaff's cellar on Broadway could have met virtually all of those newspapermen eager to distinguish themselves through essays, fiction, or poetry. The expansion of these creative pursuits

opened the way for a remarkably talented group of women who provided a catalyst for the emergence of bohemianism. Moreover, Pfaff's was the gathering spot for the musical and theatrical talent that worked nearby and for the painters, sculptors, and engravers expanding the republican vision to the wide world beyond the likenesses of the rich and well born. Certainly, printers' ink had become the life's blood of this new subculture, but Pfaff's liquid refreshments became quite important, if only as an excuse for being overwhelmed by the introductions.

New York's seat of power rested, with varying degrees of comfort, at City Hall on lower Broadway. Mayor Fernando Wood, a wealthy Democratic merchant, built a temporarily successful coalition around his combination of pragmatism, corruption, and cheap appeals to traditional values. There, amid the seemingly chaotic activities of the nearly million souls living and working on Manhattan Island, several thousand local government officials scrambled to formulate and present a simplified and sanitized version of their accomplishments.

Across the street on Park Row, large buildings housed the city's major newspapers. Popular acceptance, rather than birth, defined political legitimacy, and in a literate population this made government reliant on legions of newspapermen, some of whom had proved themselves quite ready to rattle the mayor's administration over issues such as individual management of expanding leisure time. The owners there understood and shared so many concerns with rulers of the city that they often functioned as attentive stenographers for the government authorities, filtering information essential to an orderly metropolis, and leaving chronicles that framed the efforts of those later seeking an orderly understanding of history. The press also had distinct interests at the time, shaped by the competition for circulation, directly related to their profits on advertising and announcements. Media interest encouraged, supported, and inspired factional rivalries within the government and assisted in their resolution. The success of the Wood administration turned largely on the competition and rivalry between Horace Greeley's *New York Tribune* and Henry J. Raymond's *New York Times*, the former hostile and the latter friendly to the mayor, and both eager to surpass the other to become the voice of an emerging Republican Party.[2]

The legions of printers, reporters, and freelance writers employed on Newspaper Row had concerns of their own that both overlapped and conflicted with their employers. While unions of printers had formed and fallen many times over the decades, the 1850s saw the emergence of a new local with

hundreds of members that helped to anchor the recently formed National Typographical Union. Every individual working in the industry pursued diverse interests of their own, beyond "the point of production." Over time, as their workdays tended to shrink a bit, they enjoyed the leisure to explore a city that offered ever more diversions expanding into all avenues.

This general expansion of leisure and wealth, however inequitably distributed, fertilized the growth of a large entertainment district up Broadway—only a fifteen- or twenty-minute walk from Newspaper Row. Thirsty, hungry, or just plain bored newspapermen would simply follow Broadway north of Chambers Street, past the offices of minor, more periodic publications along the way. The *Educational Herald*, *New Jerusalem Messenger*, *U.S. Democratic Review*, George Wilkes's *Spirit of the Times*, *Young Men's Christian Journal*, and *Booksellers' Medium* shared the same complex at 346 and 348 Broadway. Within a few doors were the *Musical World*, the *Carrier Dove*, and *Brownson's Quarterly*, as well as the offices of Fowler and Wells with the *Phrenological Journal*, and *Water Cure Journal*. Crossing Canal Street, to the north, you passed the *American Journal of Photography*, and Dan Sickles's *Masonic Chronicle* on the right.[3]

The character of Broadway became more mixed further north. The pedestrian passed the City Hotel on the left and on the right, the Odd Fellow's Opera House, home to Campbell's Minstrels, with the Coliseum and City Assembly Rooms, which hosted meetings of politicians and citizen-reformers. A few doors away, at 452 Broadway, was the furniture shop of one of the latter, Charles C. Commerford—the son of John Commerford, who had helped to lead just about every radical labor movement in the city since 1830—who would open correspondence in a few years with Karl Marx.[4]

The farther north from city hall, the entertainment establishments and hotels became numerous and obvious. Crossing Greene Street, one passed on the left, the old Mechanics Hall, now housing Bryant Minstrels and, at Broome Street, Wallack's Theatre loomed to the right side. Crossing Spring Street, large hotels, catering to traveling businessmen and tourists loomed on either side. The Metropolitan Hotel towered to the right, with Niblo's Garden Theatre, next to the Olympic, the home of Laura Keene's Varieties just beyond Houston. To the left sprawled the site of the Free Love scandal at Taylor's Saloon and Hotel, a gigantic structure at 555 Broadway. After negotiating "a madness of omnibuses and targetshooters, and men, women, and children who are too late for something," one reached a point still on "Broadway—but

far enough removed to catch only the hoarse echoes of its multitudinous thunder; seldom penetrated by the waifs, the organ-grinders', poor girls, that want pennies." Then, as one reporter noted, "there is a saloon."[5]

At some point in 1856, Henry Clapp and Fitz-James O'Brien entered Charles Pfaff's on the left side of Broadway just a few doors south of Bleecker Street. Once through the door, they descended uneven stairs into "a small, casual room, undefined in proportions, embracing a round table and some chairs, and a gallant row of wine-casks, prepared, all of them, for any bibulous emergency, attracts the querulous attention of the uninitiated, who do things at bars in the common way." Others, perhaps visiting a later space, described a vaulted ceiling in the rafters of which dense smoke nightly gathered, a new underworld of a gaslit nightlife that had only recently been created.[6] In this American version of a German *Ratskeller*, the elements for a distinctive bohemianism began to take form.

More than physical directions were required to find Clapp's psychological replication of a Continental life, and the route of aspiring literati from the newspaper craft left the clearest tracks of the roughly two hundred identifiable "Pfaffians." Writers for the periodical press had had their favorite haunts since the days when Edgar Allan Poe slaked his prodigious thirst at Alexander "Sandy" Welsh's on Ann and Nassau.

By the mid-1850s, a number of transplanted Britons had become regulars at the Ornithorhyncus restaurant down the island. Born in India to the family of a British officer, Francis "Frank" Henry Temple Bellew had come to America at the start of the decade and made a decent living as a painter. He took an immediate, if eccentric, liking to the recently catalogued duck-billed platypus, the unlikely marsupial that seemed to have been designed by committee, with flat feet, a beaver's body, and what looks like the bill of a duck or goose. The animal seemed to defy conventional reason, as if nature itself wished to demonstrate the inadequacy of the human imagination. Bellew persuaded the owner a new restaurant on Spring Street to name it after the platypus, the zoological name of which is the *Ornithorhynchus paradoxus*. Gathering regularly there, he and his friends "talked, sang, joked, drank beer, and smoked church-warden pipes."[7] While Bellew's politics may have been unexceptional, his way of looking at the world was rarely simplistic.

Fitz-James O'Brien joined them. Born to a well-off family, he had come to the United States as the assistant of Hezekiah Linthicum Bateman and

soon moved from Boston to New York. Sometimes called a quick-fisted rowdy, O'Brien was also described as a generous, gifted Irishman, who became "one of the cardinals in the high church of Bohemia." Although he thought of himself mostly as a poet, O'Brien wrote short stories on macabre and fantastic themes that rivaled Poe's, and his work at *Putnam's Monthly Magazine* earned him a burgeoning reputation by 1859. Rawson thought it "a rare treat" when the group at Pfaff's persuaded him to read some of his work "for he felt and expressed so clearly every sentiment in choice terms."[8]

Two Londoners participated in this circle. William North—one of Clapp's friends from his days in England—had worked with O'Brien on *Putnam's*, impressing his friends as wildly impulsive: "full of brilliant projects, hating routine, and bent on reforming mankind on the instant." His work culminated in the *Slave of the Lamp*. Charles B. Seymour, a former teacher, became a music and drama critic for the *New York Times* and attained a certain fame in 1858 with his *Self-Made Men*, a collection of short biographies of British and American subjects that included Clapp's old mentor, Elihu Burritt. Seymour later broke the news to Bellew that North had poisoned himself over a love affair, adding that North had no friends but himself and Ned Underhill, the working-class socialist who insisted on helping Seymour with the funeral arrangements.[9]

Another self-exiled Briton was Henry W. Herbert. The son of the Dean of Manchester, the grandson of the Earl of Pembroke, and a cousin to the Earl of Carnarvon, Herbert had crossed the Atlantic to take up teaching at a school on Beaver Street, near Whitehall. While there, he wrote his historical romance *Cromwell* and planned more. He had married, but his wife died, leaving him alone with his dogs after 1848, in which year he wrote *Pierre, the Partisan: A Tale of the Mexican Marches*. As "Frank Forester," he also wrote *American Game in Its Season*, and *The Horse and Horsemanship in North America*, "the first to introduce sports of the field into fiction in America." After his second wife filed for a divorce after only a few weeks of marriage, he invited his literary friends to a banquet at his rooms in the Stevens Hotel in May 1858. When only one came, Herbert slipped into a depression and closed the day by shooting himself through the heart.[10]

Underhill's collaborator in writing *The History and Records of the Elephant Club* was Mortimer Thomson, "Q.K. Philander Doesticks, P.B.," who explained his pen name as "Queer Kritter, Philander Doesticks, Perfect Brick." Thomson had gained fame by going to Niagara and writing self-deprecating letters back to the *Tribune*, the first in what he called "a series of unpre-

meditated extravagances." There followed: *Doesticks—What He Says* (1855); *Plu-Ri-Bus-tah: A Song That's by No Author* (1856), a spoof of Longfellow's "Hiawatha" that also burlesqued the American eagle; and *Nothing to Say: Being a Satire on Snobbery* (1857). He already enjoyed a reputation as a popular humorist when he collaborated with Underhill on the *Elephant Club*.[11]

Thomson and Underhill's *Elephant Club* recounted the serendipitous meeting of a gaggle of young blades united around the goal of "seeing the elephant," experiencing New York City. Although not all pursued literary or creative occupations, they did share the financial wherewithal to pursue drink, smoke, and good food across the city. Age and marriage gradually predisposed many of them to abandon youthful pub crawls for more regular and comfortable nesting someplace like Sandy Welsh's or the Ornithorhyncus.

At this crucial point, Clapp and O'Brien began introducing other writers to the exotic world of Pfaff's beneath the familiar streets of the city. Bellew, Seymour, Underhill, Thomson, and the rest simply followed the affable O'Brien from the old Ornithorhyncus to a new watering hole up Broadway, picking up others, such as Franklin J. Ottarson. Clapp's background made it likely that some of the radicals, such as Stephen Pearl Andrews and Albert Brisbane, followed him. What they found at Pfaff's was a heady brew.

A German Catholic from Baden, Charles Pfaff offered as much as the Ornithorhyncus and more. Shortly after emigrating, he opened a place on Broadway near Amity in 1853, but soon moved to a new place at 645–47 Broadway, and later to No. 653. These moves kept him near his preferred clientele of theatrical managers, actors, actresses, and, particularly, the foreign-born musicians.[12]

Pfaff knew how to present his discerning customers with a quality product. He immediately delighted Clapp and O'Brien with his beer. Years later, Whitman remembered Pfaff greeting him after an absence by disappearing into his cellar and retrieving "from his cobwebs a bottle of choice champagne—the best. Cobwebs are no discount for champagne!" Added Whitman, "What a judge of wines that fellow was! He made no misses." Others added that Pfaff also served "a dinner worthy of a more celebrated cuisine," and Ed James thought "no finer restaurant catering to the theatrical trade has ever existed." In addition, Pfaff allowed his odd customers to carry a tab, exercising a generosity that went beyond that of the canny businessman aware that "his" bohemians drew others into his place.[13]

Once Clapp and O'Brien had begun to bring their literary friends into Pfaff's, they favored the street side of the cellar, specifically an alcove dug out under the sidewalk and occupied with a long table. At "about five o'clock in the dimming day," it became the home of "King Devilmaycare," although "the splendors of aristocracy are wanting." What happened regularly there inspired Whitman's homage to "The Two Vaults."

The vault at Pfaff's where drinkers &
 laughers meet to eat and carouse;
While on the walk immediately
 overhead was the myriad feet of Broadway.

Less romantically, John Swinton recalled its placement "by Pfaff's privy," adding, after a later visit, that "the place smelt as atrociously as ever."[14]

A new group of regulars joined them at the table. An eager young ally was George Arnold, the son of a Unitarian minister turned socialist. In the spring of 1853, the elder Arnold, though the president of the North American Phalanx, left with thirty others to found the Raritan Bay Union. His brother-in-law—the uncle of the younger George—was Marcus Spring, an abolitionist in the community, who had befriended John Brown. The young man proved to be "a very clever writer . . . remarkable for his versatility." Painfully aware of social ills from an early age, Arnold sought escape in a new kind of community made coherent by a common taste for aesthetics and alcohol. Friends remembered him as having celebrated "in a careless way the pleasures and the pains of love, the joys of wine, the charm of indolence, the gayety and worthlessness of existence in the true Anacreontic vein." As a result, "he trifled life away in pointed phrases and tuneful numbers; but gained a large circle of devoted friends."[15]

Scottish-born William Swinton, a professor at the Mount Washington Collegiate Institute on Washington Square, had been educated in Canada and at Amherst College in hopes of becoming a Presbyterian minister. In 1853, he married and began preaching, but he left to teach ancient and modern languages. He worked at the Edgeworth Female Seminary in North Carolina before coming to New York. In 1858, he joined the staff of the *New York Times*, and in the following year, his pieces for *Putnam's Monthly* were published in 1859 as *Rambles among Words: Their Poetry and Wisdom*.[16]

John Swinton—William's older brother—had already learned the printer's trade in Illinois. He supported himself through a course of classical instruction at Williston seminary in Easthampton, Massachusetts, and traveled extensively and lived briefly in Charleston, South Carolina, before going west to take an active part in the free-state movement in Kansas. He returned to New York City in 1857 and, while studying medicine, wrote for the *Times*. Walt Whitman later quipped that the elder Swinton had been "always a bit sarcastic about Pfaff's" as "a quick blade—crossed swords with many a man there."[17]

With the resources to hone such a genuinely cosmopolitan career, Bayard Taylor went to Europe and the Middle East in 1851. He lectured when he returned, though he again left the country in the summer of 1856, returning in the fall of 1858. However, he became integral enough to the group that when he finished his country home, "Cedarcroft," outside the city, in the summer of 1860, friends showed up and performed a play.[18]

Richard Henry Stoddard, only a few months Taylor's junior, met him when both were poetry-struck teenagers. With Taylor working at the *Tribune* and Stoddard at a local foundry, they spent many evenings in Taylor's two rooms in a Murray Street boardinghouse, just off Broadway. There, Taylor introduced Stoddard to cigars before and after they slipped off for oysters. In 1852, while Taylor was abroad, Stoddard wrote his way out of the foundry and married the genial Elizabeth Drew Barstow, resuming his association with Taylor upon his return. Another guest of the Stoddards, O'Brien, joined them in playing games like drawing themes for poems from a hat.[19]

The appearance of two other writers at Pfaff's underscored the cosmopolitanism of the culture developing in New York. The son of a leader of the 1794 rebellion in Poland, Count Adam Gurowski had himself "fought in three revolutions for the independence of Poland, and after all that, was received at the court of Czar Nicholas as a friend." Clapp had earlier brought back Gurowski's books from Paris, some of the coterie having read them, the best being *Thoughts on the Future of Poland* and *Russia and Civilization*. Whitman found Gurowski "one of the clearest headed most remarkable men I ever came in contact with," someone as "keen, candid, happy, as men rarely are," though "very irascible" at times. The count once told him, "Walt—you here in America—you are vulgar, but magnificent!" Others thought Gurowski came to Pfaff's "when he had a fresh supply of wrath in his literary vials, which he poured out on the heads of the ignoramuses and pretenders—asses—

who deluge the journals with inane trash ... a rare bird, and the boys were delighted to hear him sing, and never were really angry at his singing out of tune." When William D. O'Connor later described Gurowski as "a madman with lucid intervals," Whitman agreed that their friend was "no doubt, very crazy but also very sane."[20]

An Armenian resident of the Ottoman Empire, Christopher Oscanyan had come to America for an education, but decided to remain. Briefly in early 1855, he opened a Turkish Coffee House at 625 Broadway, but it apparently failed, and he became one of the "occasional callers" at Pfaff's. At the time of the free love threat to western civilization, the press described Oscanyan's lectures on "the Mysteries of the Turkish Harem" as "Free Love in the East." The author of *The Sultan and His People*, Oscanyan continued to foster a rare cosmopolitanism, even after his 1860 appointment as the Ottoman consul-general to the United States.[21]

Arnold, Stoddard, the Swintons, the Taylors, and the less regular customers lived and labored in the shadow of Edgar Allan Poe, already on his way to becoming an iconic martyr to one's own creativity. Although a southerner and a West Pointer, Poe had cast away the respectable profession of the sword for a more precarious one with the pen. In 1844, he had moved permanently to New York to work for the *Mirror* at Ann and Nassau and became a habitué of Alexander "Sandy" Welsh's beer cellar on that corner, along with other newspapermen. Literary publications then clustered nearby along Nassau included the *American Review* and the *Broadway Journal*, of which Poe and Charles F. Briggs acquired the latter and moved to Broadway. Briggs, who wrote under the names "Henry Franco" or "Ferdinand Mendoza Pinto," had tried to elevate tastes in the city for years before joining the crowd at Pfaff's. Significantly, Mary Gove Nichols also knew Poe, who also had great admirers in O'Brien, Taylor, and the Stoddards.[22]

Though long eclipsed by Poe, his friend the Philadelphian George Lippard had been one of the most popular writers of the 1840s, as well as a prominent radical. After his wife's death, he had wandered off into the west. The Pfaffians knew of him through Charles Demerais Gardette, a Philadelphian, who became "only an occasional comet in that brilliant sky of the Pfaffian zodiac." There, he told Whitman that Lippard had been "handsome, Byronic," but "drank—drank—drank—died mysteriously either of suicide or *mania a potu* at 25—or 6—a perfect wreck,—was ragged, drunk, beggarly—." Other Philadelphia writers who visited Pfaff's when in town were Charles Godfrey

Leland, the author of Hans Breitman stories, who had witnessed the French Revolution of 1848 and would become the editor of *Vanity Fair*; Harry Neal; and another associate of Lippard's, John S. DuSolle of the *Sunday Times*.[23]

However, Walt Whitman embodied the importance of Pfaff's for the future of American letters. At some point in 1857, the nearly forty-year-old native of Long Island began making his way into Pfaff's regularly. Steeped in the freethought radical traditions of the 1820s and '30s, he had served an apprenticeship as a printer, taught school, and worked on various local newspapers before becoming the editor in of the *Brooklyn Daily Eagle* in 1845. After a few months on the *New Orleans Crescent*, he had returned to take charge of the pro–Free Soil *Brooklyn Freeman*, then the *Brooklyn Times*. In 1855, the same year his father died, Whitman had published a dozen long, untitled poems and a preface as *Leaves of Grass*. It attained enough acclaim that a second edition of some thirty-three poems was issued in 1856.[24] By the time he showed up at Pfaff's, Whitman enjoyed a reputation sufficient to inspire considerable jealousy as well as respect.

When Whitman turned up in Clapp's circle, he had just suffered what was possibly a minor cerebral hemorrhage, a failed love affair, and a falling-out with the owner of the *Brooklyn Times* over his editorial support for decriminalization of prostitution. His very success discomforted some of the younger poets. Stoddard was particularly hostile to Whitman, but Arnold, E. C. Stedman, William Winter, and others were quite willing to join in tormenting him. At one point, Ned Wilkins, whom Whitman had met—"I think it was at Ada Clare's"—told him that some of them had been sitting around at the *Saturday Press* mocking *Leaves of Grass* while waiting for their pay. Decades later, the memory could still produce an outburst: "The devil with Willie Winter! What does he know? He knows nothing. He is one of the fellows possessed of the old armor, costumes, what not—but of the spirit that inhabited them—the beating heart, the pulsing blood, he knows nothing—cannot even dream!"[25]

Despite it all, Whitman, as an old man, repeatedly told his young protégé Horace Traubel of how important Pfaff's had been to him: "I want to talk with you at length some day about Henry Clapp.... You will have to know something about Henry Clapp if you want to know all about me." Clapp "stepped out from the crowd of hooters—was my friend; a much needed ally." Whitman found Clapp "literary but he was not shackled (except by debts)," which meant that he became "always loyal—always very close to me."[26]

At the time, Charles Farrar Browne may have been the most generally famous. While editing the *Cleveland Plain Dealer*, he had created the persona of "Artemus Ward." He subsequently came "to the Metropolis, where clever men naturally tend, worked to advantage his droll vein for the *Saturday Press*, *Vanity Fair* and Mrs. Grundy. He was a pure Bohemian, thoroughly good-natured, incapable of malice towards any one, with a capacity for gentleness and tenderness, like a woman's openhanded, imprudent, seeing everything at a queer angle, and always wondering at his own success." Artemus Ward always belonged to "the knights of the quill," regardless of the fame he attained on the lecture circuit.[27]

Albert L. Rawson remembered how Browne contested the unfamiliar benevolence of Gardette, who regularly paid the bill for the entire table when he visited New York. Gardette replied by calling Pfaff to the table and, in "a cyclone of a stage whisper," told him to "look out for that solemn man over there; his money is all counterfeit—every red cent." Pfaff "chuckled and rubbed his fat hands together and squeezed his eyes into thin lines with glee." Embarrassed, the self-deprecating Browne drawled about "more than one good thing disguised as a humbug" and made the entire table roar with laughter by turning his napkin into a puppet that danced up and down by the coffee cup.[28] So it was that the self-conscious Artemus Ward entertained a friend of George Lippard, at a table he sometimes shared with Walt Whitman and the former partner of Edgar Allan Poe.

Perhaps the most interesting feature of the long table was the presence at it of a remarkable circle of talented women. Literary pursuits tended to confine female writers to a specialized niche for maudlin and sentimental fiction, but increasing numbers of women had begun to take advantage of an expanding market to challenge the "old boys" who ran the major publications. Ever scornful of the commonplace, Clapp mocked the chauvinism of his field and quipped about the absence of female bylines in the *Nation*, suggesting that a better title for the publication would have been the *Stag-Nation*.[29]

When the Yankee Clapp launched his war on the conventional, he found a counterpart in a beautiful South Carolina belle, later crowned "the Queen of Bohemia." Jane McElhenney's wealthy parents had both died before she reached twelve years of age, and she had been taken in by relatives at Charleston. The poet Paul H. Hayne was her cousin and one of her uncles was Robert Y. Hayne, the oratorical advocate of South Carolina's nullifica-

tion. She was only eighteen when first she saw New York; by some accounts, after her first visit she returned to Charleston to make arrangements, and by others, she just took a room in the Union Place Hotel and had her trust-fund payments forwarded to her. By 1855, she began writing love poems and sketches for the *Atlas* under the pseudonym of "Clare" and "Ada Clare," after the character from Charles Dickens's *Bleak House*. Ever confident, she also cherished aspirations of a stage career.[30]

What happened next is even more muddled. At some point, McElhenney met the pianist and composer Louis Marie Gottschalk at Saratoga. The son of an émigré London Jew and a New Orleans Creole belle, Gottschalk had studied in France from the age of twelve, developing a genuinely cosmopolitan taste. Although McElhenney was said to have fallen in love with him, it was apparently "the pianist's brother" who left her to have a child out of wedlock. In 1857, she pursued Gottschalk to Paris, where he denied any responsibility. While there, though, she continued to write, as "Ada Clare" for New York papers like the *Atlas* and George Wilkes's *Spirit of the Times*. Her prolific work included a confessional account of the affair, which made Gottschalk decide not to return to the States for years.[31]

In a sense, Jane McElhenney went to France, and Ada Clare came back. She wrote much and well, including two novels, of which "Benjamin Massett, a true friend, persuaded her to print one and destroy the other," but, as with Clapp, her personality helped galvanize the circle. An attractive blond, she impressed her companions not only with good looks, Southern accent, and genuine charm but because she was "jolly, rollicking, fun-loving," "a bright, handsome girl, liking good dress," and even "dashing in her appearance." Stephen Pearl Andrews called her "a spark from the divine fire, the over soul." In these circles, Ada—with her son Aubrey—found the kind of acceptance denied her in conventional society.[32] Any broader social sanctions against the presence of respectable women in a saloon had no such weight at Pfaff's.

Ada Clare did not obtain the high regard of her peers by pandering to male sensibilities. She had strong opinions about timeworn conventions and no qualms about expressing her disapproval if they crawled onto the table at Pfaff's. She scorned "the popular joke" as a "worm-eaten witticism, this feeble two-pence worth of grin-making, out to the public eye," a "tyrant and the slayer of conversation. It tramples upon anecdote, slaughters argument, and sets its foot upon the neck of narrative." She also hated the puns ever-popular among printers and newspaper writers, declaring them "mere

superficial, unmeaning play upon words." They made her so "disgusted and sore" that she would either "practice voluntary dumbness, or to sail upon the soft streams of garment and dress-general, which I thank thee, Jove! The punsters are too lofty to mutilate." She threatened to compile "a handbook of punning. Or an encyclopedia, or an almanac, or a dictionary of the pun general," as they "vary very little, follow arbitrary rules, and like strict conservatives, cling tenderly to the precedence of the past."[33]

Like other writers, Ada Clare remained fascinated by the theater. She personally ventured on stage in *Antony and Cleopatra* in March 1859, and the "Queen of Bohemia" regularly held "her court, in a private box at Anderson's 'Psychomantheum' in Niblo's Winter Garden. She also had a house over on Union Square and later on Forty-second Street," and her "handsome establishment" became "the rendezvous of wits and artistes." Frequently, when Pfaff's was closed on Sunday, she invited the crowd over to her house, where she had a table that was "really round, and in an English basement dining room, lighted by the sun, moon, and the brilliant stars of her galaxy of men and women."[34]

More importantly, Ada Clare's quiet defiance of social standards helped create a safe place for unconventional women of all sorts. Even before going to Europe, she had befriended another aspiring actress, the schoolteacher Marie Stevens, who had been on the fringes of the free love scandal. Stevens joined Ada Clare's "very choice circle of friends." In her old age—after a long life of advocating temperance—Stevens would admit to but one visit to Pfaff's, allegedly when she persuaded her companion Lyman Case to take her, but she vividly remembered the "informal, unconventional literary receptions" on Sundays at Ada Clare's. Marie would go over to the big house Saturday evenings to help the hostess prepare, and "shared her room & bed."[35]

The women drawn to Ada Clare were creative individuals in their own right, who blazed their own distinctive trails in a man's world. The novelist Mrs. Emma Dorothy Eliza Nevitte Southworth had turned to the pen back in Prairie du Chien, Wisconsin, after her husband deserted her and their children. While working as a schoolteacher, she placed her first major piece in 1846 with Baltimore's antislavery *Sunday Visitor*, and in 1849 sold her first novel to the abolitionist *National Era*. In 1856, she signed an exclusive contract with the *New York Ledger* for her fiction, and the first of many novels appeared in book form the following year.[36]

Precious little is known of numerous others. Anna Ballard later got regular work on the *New York Sun* and had a groundbreaking interview with the

founder of theosophy, Madame Helena Petrovich Blavetsky, before taking her own tour of the Orient. The daughter of an Indianapolis clergyman, Dora Shaw won her reputation as Camille on the American stage, and her "unsuccessful dramatic career and claim to the authorship of Beautiful Snow,' will be remembered as also among the gathered." Another "wild, impulsive Western woman" called herself "Jenny Danforth," the witty and beautiful "estranged wife, it was said, of a naval officer of high rank, but whose name was not Danforth"; she led a "precarious but now wholly unhappy life" from writing before falling "into misfortune and poverty," finally vanishing without anyone knowing what had become of her. Little more than names survive of others, such as Daisy Sheppard.[37]

Most of these women, like some male writers, had an interest in the stage, though the theatrical crowd already brought many women into Pfaff's. In 1857, the Georgia-born Anne Deland turned up as Desdemona in *Othello* at Newark, and Laura Keene recruited her into New York City for the next two seasons. Deland became a regular at Pfaff's before her tours to Cincinnati and New Orleans, and an 1860 marriage that took her off the stage. The presence of Mary Fox and other actresses were so commonplace that little information on them survives.[38]

In contrast, Adah Isaacs Menken begun turning up at Pfaff's in 1859. Inquiring minds alternatively found the obscure actress fresh from Cincinnati silent or totally misleading about who she actually was, which has left scholars to cherry-pick among the conflicting and contradictory yarns she spun. The consensus is that she was raised, if not born, in the New Orleans area and that her periodic claims to Jewish, Spanish, or Irish backgrounds lacked evidence, while claims that she had some French and African American blood may have been more likely. At the time of her arrival in the city, she had been leaving a documentary trail for only about four years. In February 1855, an "Adda Thedore" married an itinerant musician named Kneass in Galveston County, but that fall saw her living as "Ada Bertha Théodore" at Washington on the Brazos and sending her poems to the local *Literary Gazette*. She married the Cincinnati musician Alexander Isaacs Menken in April 1856 and spent almost two years with him touring theaters from east Texas to Tennessee before returning with him to his family, where she converted to Judaism. Determined to be taken seriously as an actress, she persuaded her husband to take her to New York City, where he became increasingly sullen, returning to Ohio after she began to attain some modest successes.[39]

While her strikingly good looks got her onto the stage, they left her with a defensive obsession to demonstrate genuine talent.

Menken won what could only be called celebrity with news of her September 1859 marriage to the prizefighter John C. Heenan. Previously a foreman at the federal arsenal in Troy, New York, Heenan had punched his way to within striking distance of the first international heavyweight boxing championship. As rumors of the marriage surfaced, George Wilkes of the *Spirit of the Times* grumbled that Heenan could not have married without his knowing of it, which led to spreading press speculation with Frank Queens of the *Clipper* defending the marriage. In February 1860, the attention exploded in the publication of a letter from Alexander Isaacs Menken, noting that they had not yet been divorced, although in fact, the marriage to Menken may actually not have been legal, because her previous marriage to Kneass may not have been dissolved. As suited her personality, Menken ended the matter by writing Wilkes a public letter appealing to fair play and asking for some respect for her privacy.

Other women came in Menken's wake, including Emily Page, a Vermont poetess, who feared for Menken's life because of Heenan, and Ethel Lynn Beers, a regular at Pfaff's while on a "prolonged visit to New York in 1859 and 1860." Mary Freeman not only wrote but became "a genius in water-color miniatures" and later became a Mrs. Goldbeck. As noted, Richard Stoddard's wife, Elizabeth, had studied at Wheaton Seminary and not only assisted his literary work but regularly wrote poems, stories, and essays for the periodical press and, eventually, three novels. Hannah James and her husband, Ed James, the editor of the *Clipper*, also befriended "the Menken." Participants remembered "a pretty little creature, known as Getty Gay, probably an assumed name," who had been an actress; her "lithe and petite figure and sweetly sad face" remained memorable after her apparent disappearance, but she had become the wife of Charles Gayler as the group dissolved. The real name of the actress known as "Ada Clifton" was Ernestina Katherine Louise Marie Ritter, who later divorced her first husband to marry Edouard Mollenhauer.[40] That so many wives and future wives of male Pfaffians had been involved in the circle speaks to the modernity of the experience.

A visitor to Clapp's table would probably meet a number of those talented persons clustered elsewhere in the room or passing by the alcove on their way to or from the privy. In the case of theatrical figures, one or another of the people at the table would have been able to provide introductions to almost

anyone. Managers of conventional theater close to Clapp's circle at Pfaff's included Hezekiah Linthicum Bateman.[41]

As an aside, Pfaff's became the informal birthplace of opera in the United States. A Moravian from Austria-Hungary, the aggressive and unorthodox Max Maretzek later described this process in terms of "the rivalry then existing" among himself, Bernard Ullmann, and Maurice Strakosch. Ole Bull, the Norwegian violinist and socialist, recruited Maretzek and Strakosch to establish a regular opera company at New York's Academy of Music, but Bull's plans folded in February 1854, opening the way for Ullmann, Maretzek, and Strakosch to continue on their own. When the trio fell out in 1857, Jacob Grau, a fourth operatic manager, entered the scene to moderate the differences. Despite their ongoing rivalries, the four shared what Maretzek called the "revels at Pfaff's," the hectic life of touring musicians and "the bee-line which the German fiddlers and blowers made for Pfaff's Hotel to moisten their quivering lips and parched tongues."[42]

Yet, even in so arcane an area, when the demand for fresh material exploded, newspaper and other writers turned their talents to the stage, expanding the fellowship of Pfaff's cellar. While regularly turning up at labor and socialist meetings, William Henry Fry, a French-educated musician, Fourierist, and critic for the *Tribune*, wrote and brought to the stage his "Aurelia the Vestal," "Leonora," and "Notre-Dame of Paris," pioneering works of home-grown American opera.[43] At any point, one could probably not have made it across Pfaff's without rubbing elbows with a newspaperman who planned to do something for the stage or someone from the stage planning a literary work.

More directly and personally involved in writing were figures such as John Brougham, the Irish American editor of the *Lantern*, whose pen danced from editorials to plays and beyond. He ran Brougham's Lyceum and, later, Wallack's, the Bowery, and Burton's. Another Pfaffian, Dr. D. Wadsworth Wainwright won success when his *Wheat and Chaff* became a hit play at Wallack's in 1858–59. The newspaperman Frank Wood persisted with little such achievement until his 1863 *Leah the Forsook*, with the lead role going to Kate Josephine Bateman, the daughter of his friend Hezekiah L. Bateman.[44]

Quite a number of Pfaffian scribblers enjoyed such associations with the stage. Walt Whitman fondly remembered Edward "Ned" G. P. Wilkins as "courageous," as well as "noble, slim, sickish, dressy, Frenchy—consumptive in look, in gait, weak-voiced: oh! I think he had the weakest voice I ever knew in a man." Although "perhaps the most abrupt" of the critics, he was

"a pungent and strong writer, at the same time correct and graceful, and had the requisite amount of dogmatism and self-consciousness to render him acceptable to his guild and satisfactory to himself." Charles Dawson Shanly proved "modest, silent, patient, reticent—everything that is meant by the name of gentleman." At one point, Shanly ran into William Winter in the lobby of a play in which Kate Bateman was performing. Her father caught them slipping out and began grilling them, after which Shanly raised a hand like a schoolboy and asked, "Please, Mr. Bateman, may we go out for a drink?" Friends thought Shanly was "absolutely careless of literary reputation" and Willkins "promised far better things than he had ever performed . . . leaving no other record than the file of newspapers—the silent history of countless unremembered men of genius."[45]

By virtue of their own work, Broughton, Chanfrau, O'Brien, Shanley, Wainwright, Wilkins, and Wood bridged Newspaper Row and the stage, as did Ada Clare, Getty Gay, Marie Howland, and Elizabeth Stoddard. Actors and actresses present at Pfaff's included the famous Joseph Jefferson, William H. Reynolds, Thomas Blades De Walden, Larry Brannigan (known as Lawrence P. Barrett), and London-born Charles Fisher, as well as Ada Clifton, Anne Deland, Mary Fox, Adah Isaacs Menken, and Dora Shaw. Among the most colorful was Adolphus Davenport Hoyt—the Connecticut Yankee known as Dolly Davenport—who had left the stage for the law, until his marriage to a vivacious actress and daughter of a theater manager drew him back to Wallack's Old Theatre. At one point, his friends at the New York's Academy of Music read in the Louisiana press that he had died in New Orleans and sent a telegraph: "Please send body of A. H. Davenport, deceased, by steamer, to his mother." The answer came immediately, "I will try and bring my body myself—never was better able to do so in my life."[46]

Less flamboyant but more representative, perhaps, was William Pleater Davidge. A veteran of the English stage before coming to New York in 1850, he helped bring a transatlantic expertise and sophistication to the American stage. A genial, middle-aged Londoner with many friends, he became "one of the best of the old line of comedians, and his work in Shakespearean and old English comedies was already of rare excellence. He was never a star, but sustained leading comedy roles in many companies and in many cities."[47]

Pfaff's initial clientele had been the performers in the nearby theaters. Most characteristically, of course, were the foreign musicians, such as the violinist Edouard Mollenhauer. Increasingly, though, the place had become a mecca for performers of all sorts, including the English-born acrobats the

Hanlon brothers. From their September 1858 American debut in a circus—when Thomas, George, William, Alfred, and Edward ranged in age from twelve to twenty-two—the older ones became regulars at Pfaff's. They also participated with Brougham and Keene in a benefit, underscoring the fact that their associations extended beyond its doors.[48]

In many respects, Edward Howard House personified the bohemian ideal as a practicing musician, journalist, and theatrical agent. Born near Boston to the family of a bank-note engraver and a talented female pianist, House quickly became a musical prodigy under his mother's tutelage, but her early death turned him to take up his father's trade. Through hard work, he moved into writing for the *Boston Courier*, and, by his early twenties, he had enough standing in the competitive world of the Boston literati to persuade James Russell Lowell of the *Atlantic Monthly* to publish Whitman. House came to New York with a taste for good drink and a love for theater, in which he could now indulge as the drama critic of the *Tribune*. Eventually, he "made a good deal of money, it is said, by sharing the authorship of some, and being the agent in this country of all . . . Dion Boucicault's plays." Friends remember him as "a good fellow, handsome, well-bred, winning in manners." He was "still a bachelor" who had "done little work and gets a good deal for it; and enjoys himself as a man of the world ought."[49]

Beyond music and the theater, Clapp described painting and sculpture, with poetry as "a kind of Trinity of Imagination." Some in the visual arts had literary associates, as did Mary Freeman, but engravers had particularly close ties to publishing. The talented and imaginative Yankee Albert Leighton Rawson provided much of the information available on his own background himself. This included his education at the Ludlow Academy in Vermont as well as his study of law under William Henry Seward, of theology under "Elder" Joseph Muzzey Graves, and of medicine under Professor John W. Webster of Massachusetts Medical College. At seventeen, Rawson produced his first book, *The Divine Origins of the Holy Bible*, following it with several novels. He claimed to have visited the Middle East four times, encountering Blavetsky in Cairo in 1851 and joining her in a caravan on an annual pilgrimage to Mecca disguised as a Muslim medical student. Duly noting these petitions, it should be added that no publishing record can be found on most of the books he was said to have written, and one researcher pointed out that Rawson was in prison for theft in New Jersey from September 1851 through June 1852, when he was supposed to have been in the Mideast. His claim that he spent 1854–55 exploring the mounds of the Mississippi Valley

is more plausible, since his parents had gone to Chicago, but less so is that he visited the ruins of Central America and Yucatan or toured the Hudson Bay. By 1858, the National Academy of Design in New York displayed his work, and he later married the daughter of Laura Keene.[50]

A handful of other caricaturists and cartoonists at Pfaff's illustrated the connection between the artistic world and the expanding market for the written word. These included not only Edward F. "Ned" Mullen, but a Philadelphian "of original and deeply interesting character," Sol Eytinge, who had "a fine imagination and great warmth of feeling" and had started as a book illustrator before going to the *New York Illustrated News*, which Thomas Bailey Aldrich edited. Mortimer Thomson served as the groomsman at Eytinge's wedding, and his younger sister, Rose Eytinge, married George H. Butler and pursued an acting career, in which she was periodically associated with Keene. Eytinge's young protégé on the *Illustrated News*, also a visitor to Pfaff's, was Thomas Nast, destined for fame as the political cartoonist who brought down the Tweed Ring after the war.[51]

Rawson, Mullen, Eytinge, and young Nast could have introduced a visitor to some of the most original American artists who enjoyed Pfaff's. While the smart money remained in painting the portraits of the high and mighty, natural or exotic themes moved the artists at Pfaff's, who included some of the pioneering landscape painters of the Hudson River School. George Henry Boughton, James H. Cafferty, Jerome B. Thompson, Charles Baker, Homer Dodge Martin, Aaron Draper Shattuck, and the young Winslow Homer explored the appearance of the Hudson Valley, the Berkshire and White Mountains, animal life, and the West, when not lingering in the city.[52]

Social themes moved them. William James Stillman turned to stunning photographic work on scenes such as the Acropolis in Athens. As one critic wrote of the Swedenborgian George Inness, "Nobody surely would care for a painting by Inness with the soul of Inness left out of it." Albert Bierstadt also took his European training west in search of subjects. After doing portraits of the rich and famous, Eastman Johnson turned to such themes as Indians in Wisconsin and painted an acclaimed series on "Negro Life at the South." One of his students, the Yankee-born George Henry Hall, went overseas and preferred North African and Italian themes, while Albert Van Beest did Moorish street scenes as well as royal families.[53]

Some of the artists at Pfaff's chafed under the market preferences for portraiture. Described as "the best portrait painter of that time," Charles L. Elliott had been a pupil of Gilbert Stuart but eventually found portraits

boring, at least more so than drink. When patrons sent him to paint the aged Daniel Webster, Elliott celebrated by getting drunk. Friends got him sober and packed him off to Massachusetts, but he later returned to tell the group in Ada Clare's parlor that he "went to Marshfield, saw Webster, went fishing with him, got blind drunk every day with him for three weeks, and came home without saying a word about the portrait."[54] The exercise of power was not so conspicuously insulated from the creative process.

At least two sculptors of note graced Pfaff's cellar with their presence. An upstate New York carpenter and joiner, Erastus Dow Palmer had reached nearly thirty years of age before turning to making cameo portraits and then to sculpture, and he never went abroad until his career was well established. Palmer's 1857 *The Landing of the Pilgrims* involved a group of sixteen figures fifteen inches high, to occupy the pediment on the south wing of the capitol, but the southern Democratic officials at Washington found even statues of Yankees that close to power threatening, so they refused payment, keeping the pediment remained vacant. Palmer's Irish-born and Albany-raised student Launt Thompson had studied anatomy in the office of a physician before turning to sculpture.[55]

Any intelligent newcomer to Pfaff's would have found the introductions daunting. The numbers alone tended to overwhelm, but more daunting was the quality of those with whom they were rubbing elbows. While contemporaries would not have understood the judgments of posterity on this talent, anyone aware of the world around them knew that they shuffled across the dirt floor at Pfaff's with some of the best and most creative minds in the country's largest city. It scarcely mattered that one might be discussing opera, while another sought to master a particularly difficult piece of music, and yet another grumbled about the trouble of getting paid for freelance newspaper work.

At Pfaff's, such bohemians dwelt, by choice, in a republic of the creative. Their participation required little collective agreement beyond the common assent to place their comfort in the hands of a friendly presiding host. Within this self-chosen population, all sat where they chose, ordered what they wanted to order, and generally regarded each other not merely with tolerance but a mutually amused respect, including covering the bills for those who might be "short" on a given day. Nevertheless, the practical translation of such standards into the wider world proved no less problematic than it had for Charles Fourier.

CHAPTER 4

Liberty and Coercion

RED REPUBLICANS, BLACK REPUBLICANS,
AND THE REPUBLIC OF LETTERS

―⊗⊗―

> We boast of progress, and prate of this age—marvelous, indeed, by its *mechanical* contrivances; but the true philosopher has daily to deplore the prevalence of folly, the glorification of error, the travesty of truth, and the general idolatry of shams, and apostasy from the real and the beautiful. —*Ada Clare*

The *New York Tribune* printed a dramatic account of the execution of John Brown. As the old man went to the gallows, he saw a slave woman along the route, lifting her baby to witness his passage. Touched, the old man stopped and tenderly kissed the infant. Fearful about sending any of its regular representatives, who might be recognized and arrested in Virginia, the *Tribune* had sent its drama critic, Edward H. House, who invented a fictional incident to convey the truth of Brown's scorn for the racism of his countrymen.[1]

The old socialist impulse in the hands of Henry Clapp and his colleagues inspired not only new kinds of social experiments such as Modern Times but also intentional communities that did not require removal to a pastoral utopia. In addition to the regular social activities associated with their "grand order" and the loose association of the regulars at Pfaff's, they launched a pioneering housing cooperative. In part, Clapp and his circle started their own

thoroughly independent and iconoclastic newspaper, the *Saturday Press*, as an expression of discomfort along the more radical margins of an increasingly successful Republican Party. In a very fundamental sense, in the bohemian mind, Republican electoral successes seemed to distill radical rhetoric into what looked to become a lackluster Whiggish rivalry to the Democrats. Certainly, the ongoing Democratic Party threat to silence the discussions about labor, slavery, or the meaning of freedom provided an American analogy to the brutal reactionary repression of the European republicans and provided radical Americans with a justification to take up the language and practice of armed struggle themselves. Alongside—and somewhat as a part of—bohemianism, the 1858 attempted assassination of Napoleon III provided some of the language used to justify events in Kansas and John Brown's decision to take up the gun. This required bohemians to reconcile their radical roots with their iconoclastic predispositions.

Veterans of the old "League," including numerous Bohemians, continued to meet after the free love scandal. In August 1857, the New York office of the Ohio Life Insurance and Trust Company failed. The Panic that followed metaphorically toppled business after business like a row of dominoes up Broadway toward Pfaff's. Its spread pulled currency from circulation, and the depressed economy corkscrewed unemployment to unprecedented levels. By February 1858, the dramatic jumps in the cost of living convinced Ned Underhill "that many families living in one household can secure more home comforts, and at less price, than if each family were living in an isolated household. He embarks all his little worldly means in the experiment, and without experience, without encouragement of his friends, and with nothing but faith in the correctness of his conclusions to sustain him in his efforts, he boldly determines to make the trial. He does so, and two years' experience proves that he was right and others wrongs." Initially, Underhill and his companions leased a private house on Twenty-third Street and hosted social events there, "averaging seventy persons, on every Saturday evening through the Winter."[2]

On Saturday, May 1, a traditional moving day in the city, Underhill leased "a large brick house, four stories high, on Stuyvesant-street. It lies close under the shadow of St. Mark's Church, is not far removed from the great City Libraries,—the Astor, Historical, and Mercantile—is within whispering distance of the Bible-House, and altogether occupies a position nearly

as central as though located on Broadway." He then sublet its apartments among twenty to twenty-five persons. Underhill described them as "personal friends of myself and family," some socialists and others not. Although they "divided into separate families" in their rooms, they constituted a "Unitary Household" through a shared living space.[3]

Residents shared the first floor, with "two handsome parlors, lighted by gas, furnished with taste, adorned with pictures, and provided with such musical instruments as a harp, piano and guitar." To the rear, "an extension, in which is the general dining-room. One table is set for all the inhabitants of four floors." They hired servants and laundresses at "good pay." Still, they had cut the cost of living in the city to a third. At their new location, their weekly gatherings drew "an average attendance of eighty to ninety persons."[4] Various sources mention the presence of Henry Clapp, Albert Brisbane, Stephen Pearl Andrews, Marx Edgeworth Lazarus, Marie Stevens, Edward Howland, and others.

By the summer of 1858, the fate of the Wood administration forced the *New York Times* to abandon any hopes for a new governing coalition other than the Republicans. Under its influence and urgings, elite critics of the Kansas-Nebraska Act in New York had simply voted to merge with the old Whig Party rather than to build a new coalition. They also embraced that Maine law prohibiting alcoholic drink, a cultural slap to the Germans, Irish, French, Italians, and other groups. Moreover, the *Times* continued to take swipes at the Fourierists and editorially rejected land reform on the grounds of cost, essentially echoing the Democratic argument. Even with the *Tribune* in support, the local Republican Party never shared the enthusiasm of the midwestern Republicans for various radical reforms.[5]

For such conservative participants in the new coalition, the Republican Party had to do not with society in New York but in Kansas and the West. The opening of the Kansas Territory had become an ongoing, bleeding national scandal. Politically hostage to the Southern faction, the Democratic administrations of Franklin Pierce and, later, James Buchanan ignored the armed intimidation by proslavery paramilitary associations of settlers from the non-slaveholding states and sanctioned fraudulent elections that returned a proslavery territorial government. Opponents of slavery in Kansas took up arms and those elsewhere responded with a sectional political outlook that mirrored those who had shaped Southern politics for a generation. The result fueled an insurgent Republican coalition.

Back east, the *New York Times* renewed its own ongoing attempt to seize the leadership of the new coalition. It greeted news of the Unitary Household by resurrecting the issue of three years earlier and placed the responsibility for "that flourishing crop of Woman's right-ism, Free-Love-ism, and Unitary Household-ism, with which society is infested" at the door of Horace Greeley's *Tribune*. Later, the *Times* acknowledged that it based its position on stories that "may have come to us in an exaggerated form, and that isolated instances of misconduct may have been regarded and presented as characteristic of a system."[6] Still, the paper would not let the facts get in the way of another attempt to discredit the *Tribune*.

The radicals replied through Underhill. He described the steamboat *New World* as "a magnificent unitary traveling apparatus" and wrote that the facilities of the St. Nicholas Hotel "with its unitary parlors, its unitary dining-halls, its unitary theatre and its machinery for economizing labor, are infinitely better for five hundred families than are five hundred cramped houses." Choosing to live in this fashion, he wrote "constitutes the half of constructive socialism, which is the only phase that exists in this country possessing any vitality."[7]

The first year of the experiment proved so successful that Underhill "leased four houses on East Fourteenth-street," opposite the Academy of Music, for $1,740 a month. These filled quickly enough to bring down the costs to $5 per week per person. Underhill wrote that if the numbers grew as large as the clientele of the St. Nicholas Hotel, expenses would be down to $2.50. Brisbane, meanwhile, applied what they learned from the Unitary Household to western colonization.[8]

Participants saw this as a new urban extension of Modern Times, or a less naive and more practical version of Brook Farm or New Harmony. Over the Fourth of July weekend of 1859, residents visited Arnold's former home, which was described as "the New Jersey Phalanx." Two of the younger residents got into a serious altercation over the attentions of a young woman at the Phalanx. The aggrieved party, though "laboring under a consciousness of physical infirmity, but thinking that he could pull a trigger as hard as any man," issued the other a challenge to a duel. The challenged party accepted but made arrangements to have their seconds load the pistols "with powder only." The challenger melodramatically contemplated a daguerreotype before handing it to his second. After claiming to hear a bullet whiz past his ear in the second exchange, he declared "his honor" was "satisfied and his courage

vindicated." Such experiences led the Bohemians to take their distance from a utopianism that did not actually escape the values of the prevailing social world and discuss them as "mere theories of no consequence."[9]

Sex within the group tended to be much less generally Victorian. After Marie Stevens's 1857 marriage to Lyman W. Case, the couple moved into the Unitary Household. One Monday, Clapp brought Edward Howland, the twenty-five-year-old Charleston-born Harvard graduate—an author in his own right then indulging in his love of travel, fine books, and literature as a book buyer for the local antiquarian market. In the course of the evening's dancing, Howland and Marie marched about the room so entranced that they continued after the music stopped. Case afterward told her, "Marie, you have met your destiny," and bowed out of the marriage, remaining lifelong friends with both her and Howland.[10]

Clapp certainly had no concern for the sanctity of marriage. A series of booklets of short poems had gained some success at this point by celebrating, quite literally, the void of nothingness. William Allen Butler's *Nothing to Wear* lampooned the ascendancy of fashion successfully enough to inspire a number of spoofs, including Mortimer Thomson's *Nothing to Say*. Clapp's contribution was *Husband v. Wife; or, Nobody to Blame*.[11]

This broadly more cosmopolitan radicalism continued to inform bohemianism. Constituting a community of sorts, as surely as did Ira B. Davis's Protective Unions, the newspaper writers' "Fourth Estate" grew so rapidly that it absorbed many of these creative middle-class critics of capitalism. Veteran Fourierists like Parke Godwin, George Washington Curtis, and George Ripley helped Charles F. Briggs to establish *Putnam's Magazine*. Horace Greeley's *New York Tribune* employed a large number of writers on the edge of the radical movements, including William Henry Fry, the *Tribune*'s music critic and the author of some of the first indigenous American opera, who yet addressed the rallies of the unemployed.[12]

Clapp, Andrews, Brisbane, and other members of Andrews's "League" worked alongside "the Red Republican associations which have sprung up in the City." From 1855, they regularly paraded through lower Broadway honoring the revolutionary experience abroad as "Universal Democratic Republicans." Although the French predominated, accounts mention German, English, Italian, Hungarian, Polish, and Cuban émigrés, as well as "that

rarity, a Russian Democrat." At an August 1856 mass meeting of Germans, future socialist leader Adolph Douai discussed "opposition to slavery among workingmen of the South," and Charles A. Dana of the *Tribune* spoke, as did Friedrich Kapp and Friedrich Jacobi of the Kommunist Klub. Such events raised the Stars and Stripes alongside the red flag, which Bernard Paul Ernest "Honeste" Saint-Gaudens described as "the symbol of the solidarity and fraternity of nations," a "banner which had often been with the people against the power of feudality." Another Christian socialist, Joseph Dejacques, had suffered exile and spent time in New Orleans, where he had publicly advocated abolition among the recent French émigrés. When he moved on to New York, he launched his own paper, *Le Libertaire: Journal d'un Mouvement Social*. By June 9, when *Libertaire* appeared, he had become an admirer of Pierre Joseph Proudhon.[13] French speakers, such as Brisbane and Clapp, provided a natural liaison to such groups.

To be sure, odd oars dipped into these troubled waters. A few years before, George N. Sanders, the former editor of the *Democratic Review*, had made many friends among foreign radicals. A proponent of the expansion of Anglo-Saxon slaveholding civilization under the rubric of "Manifest Destiny," the "Southern Rights" Democrat tried to begin his service as a U.S. consul at London by hosting most of the prominent continental revolutionaries. When the Senate failed to confirm him, Sanders settled in New York, where he embraced "Red Republicanism." He reminded the émigrés that they had contended for "white men, and not for niggers in Europe." So, too, the Ostend Manifesto expressed a Democratic ambition to eject Spain from Cuba in the name of liberating the island. As some proslavery and imperialist Democrats jostled for a place among the "Red Republicans of America," Clapp saw nothing but trouble in an American attempt to assimilate Cuba as the "land of the flea and the home of the slave."[14]

The meaning of "Red Republicanism" remained uncertain even among those to whom the label was more regularly applied. The peculiar conservatism of the new Republican Party in New York left some socialists, land reformers, and abolitionists more inclined to a more independent radicalism. The brief rise of the Nativists in New York City had driven radical immigrants to the Democrats, taking along some homegrown radicals, such as Ira B. Davis. Tammany promises about hosting a joint reform meeting fizzled in 1856, but some Democrats spoke at the land-reform meeting held

in the park. The press quoted Davis as saying that Democratic presidential candidate, James Buchanan, "assured him that he had always been and always would be, in favor of the dominant principles of the Homestead Bill."[15]

Yet, American socialists, abolitionists, and land reformers generally found such a course even more unacceptable than did their German and émigré counterparts. Joshua K. Ingalls, Warren Chase, and other prominent radicals scheduled a Fourth of July meeting upstate in conjunction with the abolitionists around Gerrit Smith, in preparation for the upcoming conventions of both the committee to colonize Kansas and the one to form the new Republican Party. Smith, in particular, found John C. Fremont and the Republican campaign too mild, at least in New York, where he helped maintain the Radical Abolitionist Party. Against the background of violence in Kansas, Smith warned: "They are looking after ballots when their eyes should be fixed on bayonets—they are counting votes when they should be mustering armed men—they are looking after civil rulers when they should be searching after military ones."[16]

Most radicals, however, embraced the Republican campaign, for all its shortcomings. Their activities revolved around the new "Mechanics and Workmen's Central Republican Union," launched in September 1856 to welcome "all workingmen favorable to the cause of Free Labor, Free Soil and Fremont and Dayton" to lectures and reading rooms "open day and evening." The banner under which they marched included "an arm grasping a hammer large enough to knock down all possible opposition" with the inscription "We strike for Freedom." They also sponsored reading rooms "open day and evening."[17]

In fact, the radicals maintained this organization beyond the November election. By January 1857, Ingalls and other prominent land reformers dominated the Mechanics' and Workingmen's Central Republican Union, which sought to foster "the rights of the Workingmen and Mechanics to an equal division of the uncultivated soil of the country" and "the aims and objects of the Free-Soil Party." That summer, a Mechanics' and Workingmen's State Central Committee" reported forty-two functioning affiliates with a total membership of 11,310. By November, the local Workingmen's Association mobilized 5,000 who marched on Mayor Fernando Wood's office to the sound of martial music, under a banner displaying "the word 'Work,' both in German and English."[18]

Then, too, the conduct of those Republicans in office gained considerable credibility among radicals. By the fall of 1858, after the Democratic crush-

ing of the Homestead Bill, these land reformers simply endorsed the state Republican ticket, followed by a state convention of the forty-three workingmen's organizations. This convention declared for land reform and legislated ten-hour work days on public works. It also expressed its preference: "The Republican candidates were all declared nominated, they having received the largest number of votes." Radicals took their places among the officers and speakers at the large Republican campaign rallies in New York. As late as the summer of 1859, after Vice President John C. Breckenridge had blocked Senate passage of the Homestead Bill, John Commerford read the executive committee of the land reformers a letter from Benjamin F. Wade arguing that "the game of the monopolist is nearly played out, its enemies cannot prevent its triumph beyond the term of the present Administration."[19]

French radicals particularly embraced the Italian struggle for independence against the imperial government of France. Like them, Clapp scoffed at the English and American press descriptions of Napoleon III as "the Savior of Society, the Apostle of Liberty, the Great Military Hero of the Age, etc., etc." His solicitous feelings for the French extended to the Italians working against the emperor as well. When the press reported that Giuseppe Garibaldi was "threatening to shoot any of his men who venture to profess themselves Mazzinians, Republicans, or even *Garibaldists*," Clapp published the story under the heading "Garibalderdash."[20]

The Italian revolution drew blood. Convinced that Louis Napoleon had been the chief architect of the antiliberal reaction throughout Europe, Felice Orsini—an ex-seminarian and member of the Constituent Assembly of the crushed Roman Republic—went to Paris and orchestrated a conspiracy to take the life of the emperor. The attempt on January 4, 1858, left the emperor and empress unhurt but killed twenty-three bystanders and injured another forty. On March 13, Orsini went to the guillotine bravely and calmly, and the authorities arrested Simon Bernard as a conspirator. British radicals like John Stuart Mill, Harriet Martineau, and Charles Bradlaugh rallied to support the struggle of the émigrés in Britain to defend freedom of speech, including the right to call for tyrannicide. The mobilizations and debate became extremely important in shaping a new kind of opportunity for the internationalists in the future.[21]

Rallies and demonstrations also took place in the United States. On Thursday, April 22, 1858, "*Revolutionists of all the Nationalities*" paraded through lower

Broadway to the City Hall Park in what the *Times* "understood to partake of the worst qualities, and to exhibit the most exceptional features, of Red Republicanism". A rifle company of Turners led the various national societies with "a huge catafalque, erected on a large four-wheeled wagon" topped by "an Egyptian sarcophagus, covered with crepe." The *Times* estimated 15,000 to 20,000 stood along the line of marchers and reported that there "could not have been less than two thousand persons in line, with three hundred torches distributed among them. Each wore a band of crepe on the left arm and nearly all had a badge on the left breast." From their headquarters at 293 Broadway, the Germans displayed a banner depicting "the Goddess of Reason—embracing a white man and a negro, under the auspices of the Universal Republic." Midday brought "speeches, toasts and songs, of the most ultra character" and authorization of "a Permanent Revolutionary Committee" of one hundred "for the spread of true liberty throughout the world."[22]

The leading American speaker, John Allen, was not only an associate of Clapp, Brisbane, Chase, and others but a plain-talking abolitionist. A decade before, he had told a thousand celebrants of May Day in Cincinnati: "Working men, as Reformers, had not always been just to labor. The cause of labor was one. The time had come when the laborers of the North must make common cause with the laborers of the South; and the prejudices of color be done away with. Land reformers were especially called on at this juncture to give the weight of their influence on the side of freedom." At the 1858 rally, he "announced that 20,000 freemen had gathered together there for the purpose of doing homage to the memory of the sainted ORSINI and PIERRI, and to announce themselves as friends of the Republique Universelle."[23]

Subsequent weeks saw more such marches. Prominent abolitionists joined "the friends of universal freedom," who delivered speeches in French, Italian, German, and English. A Chicago artillery company led a local torchlight "Red Republican demonstration." Although unable to attend the Boston rally, William Lloyd Garrison sent a letter:

> Your meeting will receive no sanction from the American press, people, or Government. How can America sympathise with any struggle for freedom in the Old World? She holds every seventh person of her vast population in fetters of iron, as a brute beast, as an article of merchandise. With four millions of slaves in her ruthless grasp, she has not only lost all reverence for human rights, but she ridicules and rejects her own Declaration of Independence; and hence, her instincts

and feelings are with every tyrant in Europe, and against its downtrodden masses, and such will be her state and attitude until she breaks every fetter, and liberates every slave, on her own soil: then shall she lead the nations of the earth to universal freedom.[24]

The fact that violence sustained the existing social, economic, and political order left those serious about changing it no clear alternative.

On June 23, 1858, the "German Socialists" hosted "their wives and children, a considerable contingent of the French, a number of Poles, and a very small admixture of native Americans."[25] Italians also participated in this evening commemoration of "the June Days," the most radical phases of the revolution of ten years earlier. Presiding was Friedrich A. Sorge, the organizational founder of Marxism in the United States, who spoke in German, French, and English. A violinist, like Edouard Mollenhauer, Sorge made his living teaching the instrument and, in his early days, seemed to be an appropriate ally of the Americans present.

On this occasion, the American speaker was Lyman W. Case. The Pfaffian and free lover reportedly told them that he

> believed the only point at issue between the tyrants and the people, was the simple question between capital and labor, and in all his struggles for reform he never found himself at home among any people save those by whom he was now surrounded, because he saw that these were ready to fight, and the contest for the rights of humanity must be one of blood. The aristocracy of capital was the only aristocracy with which the people had to content, and that aristocracy erected its thrones on Fifth-avenue as in the capitals of Europe; both must be met by physical force. The destiny of man was communism—communism of soul, spiritual communism, communism of property, and could only be achieved through blood. (Loud cheers.)

Several months later, Case again met the émigrés' need for an American-born speaker, reminding them that the battle in the United States would not be for national autonomy but directly "against capital." He urged them to "fight this battle peaceably if they could but forcibly if necessary."[26]

In that same year the Permanent Revolutionary Committee of émigrés in London launched an "International Association." Coming out of the Orsini demonstrations, affiliates formed in "New York, Boston, Cincinnati, Chicago,

etc., etc.," their growth was seen as "extensive" and "truly wonderful." In New York, the International Association united English-, German-, Italian-, and French-speaking affiliates, although Cubans, Hungarians, and Poles also seem to have joined it. The French group also had branches in Boston, St. Louis, and New Orleans.[27]

Open expressions of sympathy with Orsini horrified Henry Raymond's *New York Times*. It conjured "the Moloch of Radicalism" and its "cosmopolitan sympathizers, who would be utter savages were they not absolute simpletons also." In an attempt to disassociate Republican politics from the "Red Republicanism" of the "foolish Teutons," the *Times* also noted their connection to Allen, Case, and the lot of characters at the Unitary Household, "Several Americans among the male portion of these congregations belong to the Red Republican associations which have sprung up in the City, and some of these figured conspicuously in the obsequies held in honor of ORSINI. The old Socialist champions are busy with the propagation of their disrupted theories."[28]

Within hours of the public praises of Orsini in New York, the "Free Convention" at Rutland, Vermont, on June 25–27 delivered the *Times* and other contenders for the leadership of Republicanism another shock. Clapp, Andrews and several thousand spiritualists, feminists, abolitionists, socialists, and other radicals cheered as Mrs. Julia Branch publicly challenged the institution of marriage. After a number of speakers, including Indian rights' advocate John Beeson, Clapp took the floor and called her speech

> the most dubious spectacle I have witnessed for twenty years,—a spectacle which would have led me instinctively to take my hat from my head, and, if necessary, my shoes from my feet, in the view that I was treading holy ground, is the spectacle I have just seen, a woman—a noble, virtuous, high-minded, delicate woman,—caring as much for her reputation as you care for yours; having something more than a man's regard for his reputation, because a man can do pretty much what he pleases, and his reputation remain unscathed, provided the fact is unknown; but a woman, carrying with her a woman's reputation, that cannot be breathed upon without being destroyed, that cannot be looked at without being broken, that cannot be suspected without her being driven into the haunts of vice,—for a woman, I say, with a woman's sensitive nature, with a woman's delicate reputation, to stand here upon this platform, before all these people, and, if need be, before

the world, and assert her right to discuss the marriage question,—to insist that marriage, as now understood, is slavery,—to assert that any institution is false in its nature that employs the element of coercion, is a noble, a magnificent spectacle; and yet, ladies and gentlemen, I know it will cover that woman with scorn; I know that on the wings of mighty winds it will go all abroad that she is a bad woman.

He reveled in the fact that "no subject is too sacred for discussion."[29]

The rest of the Free Convention generally agreed, and was certainly radical enough for Clapp. In addition to denouncing slavery, and related social ills, the convention resolved

that the earth, like the air and light, belongs in common to the children of men, and on it each human being is alike dependent. Each child, by virtue of its existence, has an equal and an inalienable right to so much of the earth's surface as is convenient, by proper culture, to support and perfect its development, and none has a right to any more; therefore, all laws authorizing and sustaining private property in land for the purpose of speculation, and which prevent men and women from possessing any land without paying for it, are as unjust as would be laws compelling them to pay for air and light, and ought to be at once and forever repealed.

Twenty-two years later, a variant of this statement would become the most radical statement the Socialistic Labor Party could introduce for adoption by a broad Greenback-Labor convention.[30]

The spiritualists dominated the convention and broke it down into a regional, if not national, movement of radical libertarians. The organizers tried again in September in Worcester and Utica, where Mrs. Branch urged the state to declare all children legitimate. After another attempt at St. James Hall at Buffalo, a "fifth session" took place in Utica on September 16–18. This was to be "a Free Convention" as "the mouthpiece of Human Liberty—the platform whence issue the mandates of unlimited Progress. Spiritualists, Materialists, Jews, Christians, Reformers—all, east, west, north, south—will hereby consider themselves cordially invited."[31]

Its simple lack of orthodoxy created a guarded predisposition to sympathize with spiritualism, if not the spiritualists. Agents of the *Saturday Press* included the spiritualist Samuel T. Munson, and the spiritualist publication

Banner of Light had the carpenter H. W. Ballard as an agent at Modern Times. The appeal of spiritualism for bohemians grew partly from its symmetry. As one spiritualist lecturer, Judge John W. Edmonds, argued, "Darling sins are taken with us to the other life, and long oppress us with their fearful weight. Old daily habit and modes of thought cling likewise with tenacity."[32] The extent to which spiritualism could overcome the conventional remained uncertain.

Ultimately, most bohemians could not overcome their own skepticism. Fitz-James O'Brien could write ghost stories that some critics have compared to Edgar Allan Poe's, but he and Mortimer Thomson mercilessly exposed the dishonesty of some of the mediums and the credulity of their clientele. Interestingly, the *Saturday Press* reported on the work of Jean Eugène Robert-Houdin, the French watchmaker tinkering with an automated chess game, who was also a stage illusionist and "the father of modern magic." Toward the close of the century, the young Jewish immigrant Ehrich Weiss, who gained worldwide fame as "Harry Houdini," resurrected both the name of and the older ambiguity about spiritualism. His hostility to mediums defrauding the public also recalled that of some American admirers of Robert-Houdin.[33]

Yet, even as the *Times* shrieked about Orsini, it rediscovered Greeley's Fourierism and the imminent threat of free love. It repeated its recitation of American Fourierist history and experiment, as a prelude to an exposé, this time of the Unitary Household: "A modest home in Waverley-place is the present shelter of the Free-Lovers." It also reported plans for moving into the St. Denis, "but this is probably a grander flight than the most sagacious of the Socialists would be willing to attempt. It is only certain that preparations are being made in silence, and not the less certainly because silent, for a new enterprise of similar character with that which has so recently ended in disaster." There, added the *Times*,

> Unblushing adultery was no uncommon circumstance. The serving-maids were debauched; children of tender years fell victims in the arts of accomplished seducers; lust raged and decency was banished.... Instances have been related to us of the universal license which prevailed among the managers of the establishment of their chosen companions. It was no uncommon occurrence for brother and sister, cousins, and other relatives, to associate together as man and wife. To ruin a child was regarded as a pleasant deed. To seduce a wife was considered no wrong to the husband. To produce abortion was no sin.

There followed the predictable and fruitless attempts to correct the *Times* by Count Gurowski and Thomas L. Nichols.[34]

After Rutland, Clapp and the bohemians veered off into their own concerns. Others may well have accompanied them to Rutland. That summer, at Saratoga, Clapp, Edward Howland, and others discussed starting a paper. In his work as a book dealer, Howland had accumulated a massive collection that he offered to the group. This was later described as Howland's selling "his choice library he had spent many years and a fortune to collect, so Clapp could have the money," but this represented a group effort, embracing Howland's own desire for a literary outlet as well. As Junius Henri Browne wrote, Pfaff's "brotherhood contributed for money when they could get it, and for love when money could not be had." Some later saw the publication as the means by which the circle at Pfaff's drew together and others that it developed as an organ of the group. The timing indicates that the grouping had already been coalescing for almost two years but that the paper certainly expanded it and its influence.[35]

They secured a dingy little office at No. 9 Spruce Street that doubled as headquarters for the Brook Farm Association, behind the massive *Tribune* building on Park Row. Later, Clapp described the location of Greeley's paper as found "next door to the *Saturday Press* Building." They arranged for an outlet through a bookstore at 827 Broadway and issued the first number of the *New York Saturday Press* on October 28, 1858.[36]

Readers of the *Saturday Press* got four pages of six columns each for a nickel a copy—or two dollars for the year. Advertising took only about a quarter of the content, and the rest consisted of literary essays, fiction, and poetry—both original and reprinted—as well as news from the stage, music, and opera, and extensive chess coverage on the fourth page. Its regular early columns included: "Love Matters," "Waifs from Washington," "Private Opinions Publicly Expressed," "Dramatic Feuilleton," "Minor Experiences in America," "The Mount Vernon Papers," and Ada Clare's "Thoughts and Things." Another prominent newspaperman wrote that the *Press* "often sparkled with wit, and always shocked the orthodox with its irreverence and 'dangerous' opinions."[37]

William Winter, like many writers who invested into the structure and formulation of their work, appreciated the *Press* as "piquant, satirical, pugnacious, often fraught with quips and jibes relative to unworthy reputations of the hour, and, likewise, it must be admitted, sometimes relative to writers who merited more considerate treatment, eventually failed, but during its

brief existence, it was, in one way, a considerable power for good." Throughout, Clapp battled "a tendency to inertia and dry rot" through 'the gradual establishment of mediocrities as the shining exemplars of poetry, and the potential leaders of thought."[38]

The *Saturday Press* actually owed as much of its success to the inside knowledge of its regulars as to the institutional peculiarities of the periodical press. In promoting what it saw as the best in its field, the *Press* became an advocate for good journalism and publishing. It initiated the practice of publishing comprehensive weekly lists of newly released books, a practice that spread to the *Atlantic Monthly* and other publications. The *Press* lampooned journalistic practices, including "jocose misrepresentation" passing as book reviews. Clapp wrote one for which he refused to mention the title because he had already "wasted two hours and fifty minutes in reading it." On manuscript submissions, he promised to be "firm but courteous in accepting drinks and declining articles." The playful abuse of everyone involved, from editors to subscribers, endeared the *Press* to the owners, staff and, writers for other publications who would have loved to have mocked "the game" even as they played it. The *Boston Congregationalist* found the *Press* "the spiciest, frankest, and truest in its criticisms upon literature of any journal out." The *Tribune* declared it "one of the best weekly papers we have seen." The *Spirit of the Times* thought it "always distinguished for its independence and originality."[39]

Seen as "New York's answer to *The Atlantic Monthly*," the *Press* challenged Boston's prominence in American letters. Clapp tweaked the noses of the Bostonians, transforming Oliver Wendell Holmes's "autocrat" at the breakfast table into "the Professor" at his morning meal, inconsistently and arbitrarily debunking phrenology, while propounding on the importance of blood and race. Told that Nathaniel Hawthorne and another author were reluctant to meet him, Clapp dismissed them as "shysters." Holmes, Hawthorne, Ralph Waldo Emerson, Henry David Thoreau, and their Transcendentalist colleagues certainly emerged no worse for the wear and remained the ideal for the Ohioan William Dean Howells, who visited and recorded his poor impression of the rowdiness of the crowd at Pfaff's.[40]

Howells notwithstanding, the relationship between the *Saturday Press* and the Boston gentlemen of letters was never entirely antagonistic. George G. Clapp—Henry's brother—spent years as a clerk in a Boston bookstore and knew the Transcendentalists, as well as Daniel Webster, Wendell Phillips, and William Lloyd Garrison. The Benton brothers, Joel and Myron, Pfaffian

writers, had close ties to New England. A former Yale student, Edmund Clarence Stedman had worked on the edges of the brilliant New England literary circles before coming to New York in 1856. The New Hampshire–born Thomas Bailey Aldrich brought to the *Saturday Press* journalistic credentials from the *Evening Transcript* and regularly visited Pfaff's, though he boarded with his uncle, a merchant. In late 1859, Harvard graduate William Winter turned up and "had not been many days in the city" before being drawn into Clapp's paper as "sub-editor."[41]

Other Yankees of older and more established reputation showed up periodically. One evening, Horace Greeley emerged from the smoke of the place to exchange pleasantries with Adah Menken. No less surprisingly, the respectable and conservative Fitz-Greene Halleck, who lived with his sister in Connecticut escaped his rural exile as often as he could for "a night with the bohemians at Pfaff's. After ordering a hot whisky punch, he would tell the waiter it was too strong and to put in more water. Then he'd say it was all water and was too weak and to put more whisky in. In this way, he kept one punch going all night."[42]

The short-sighted Whiggishness of the Republicans in New York proved to be no obstacle for many social critics. Indeed, 1859 saw Fernando Wood win another mayoral election by campaigning as the spokesman for "the common man." The following year, the mayor supported for the presidency Stephen A. Douglas, the Democratic author of the Kansas problem. Even Greeley—among the most radical of the prominent Republicans in the city—urged the national party to limit its antislavery stance to Kansas and adopt the popular sovereignty position of the Northern Democrats as the basis for making Douglas a unifying sectional candidate of the North. Little wonder, perhaps, that radicals in New York remained somewhat ambivalent about the Republican Party and chose instead to find a good stew at Pfaff's.

Events abroad, meanwhile, restructured émigré life in New York. Napoleon III extended amnesty to the French exiles, and the outbreak of new hostilities in Italy drew many of the French and Italians back overseas, leaving German the dominant nationality among the city's radicals. Particularly unimpressed by the Republican Party, "the ultras of the Socialist, Communist and Red Republican Parties, about eight hundred in number" convened on October 13. Denouncing the Democrats over slavery and the Nativists and Republicans on "the emigrant's rights," they insisted that a new "people's party

must advocate the rights of the workingmen, and the equality of employers and employed—must seek the abolition of all monopolies—must reform the laws and the system of their administration—purify the Judiciary—oppose the election of Judges by the people—oppose the Sabbatarian spirit, which is seeking to deprive the workingman of his recreation, and finally stand erect for Universal Freedom, Civil and Religious."[43]

The local Allegemeine Arbeiterbund—the "General Workingmen's Union"—gathered a national convention on January 17, 1859. The "delegates from various socialistic organizations throughout the country" converged on their headquarters at the Steuben House at No. 293 Bowery. In addition to the local group, the bodies represented came from Williamsburg, Philadelphia, Cleveland, Chicago, Boston, and Louisville. As skeptical of the Republicans as the New Yorkers were, they, too, declared the need for socialists "to elect a President of the United States pledged to carry out its principles."[44]

Clapp shared the skepticism of the most radical émigrés and abolitionists about the Republican Party. He predicted that even its success in 1860 would have to rely on those experienced in office and that "from that moment the Republican party would be as dead as a nit." He predicted that after Lincoln's victory, Washington would present "so degrading a spectacle. Every hotel, every house, every street almost, crammed with hungry applicants for office; with able bodied men,—men, moreover, of respectable appearance,—men with shirts and faces as clean as their souls are dirty,—begging, like the abject mendicants they are, for the smallest crumb, that falls from the political table, in pay for their Democratic, Republican, or whatsoever services." He foresaw "thousands on thousands of men, in every part of the country ... waiting with palpitating hearts to figure next year in just such a begging crowd! Men who would sooner, any one of them, live on the smallest allowance of State-pap, than earn their thousands by useful labor." They "call themselves Democrats and Republicans! And not only that, but Christians! For if they didn't smuggle Christianity into the camp they might as well give up the ghost at once."[45]

Admirers of Orsini drew appropriate conclusions from the low-intensity warfare in Kansas. Paradoxically, the *New York Times*, the *Tribune*, and other Republican papers relied on a rather self-selecting process by which only the more radical correspondents could report on the doings of armed antislavery men. These included not only Augustus Wattles, who wrote for the *Saturday Press*, and but the ex-Chartist Richard J. Hinton, who was in and out of town during these years. Whitman remembered him as "a news-

paper man," adding, "Dick is my friend and means me well." Later associated with the *Round Table*, Hinton was a likely visitor to Pfaff's during his visits to the city. George Arnold's uncle—another Fourierist in New Jersey—was Marcus Spring, a supporter of the armed antislavery bands in Kansas, as was another abolitionist communitarian, George L. Stearns.[46]

Such people increasingly looked to John Brown, an uncompromising fighter for slave liberation, who hoped to expand his techniques back into the states themselves. Brown, in turn, approached Hugh Forbes, the most persistent officer of the émigré federation and the author of a manual on revolutionary warfare. In March 1857, he agreed to spend six months at $100 a month advising Brown on military affairs. In July, he reached Tabor, Iowa, and the differences began almost immediately. In August, Forbes declared unworkable Brown's plans to ignite a slave insurrection by seizing the federal arsenal at Harpers Ferry. He thought there were too few men for a serious operation, and he criticized the lack of any way of warning the slaves in advance. He preferred placing teams of "carefully selected colored and white persons" along the border and periodically infiltrating slaveholding territory to "instigate a series of slave stampedes, running Negroes into Canada." This would strategically render "slave property untenable" along the border, force its abandonment there, and roll the entire operations further south. By November, the only insider who had seriously questioned Brown's plan left Tabor. With some urgency, Brown began moving his recruits, arms, and supplies from Iowa eastward through Ohio into upstate New York, where he redoubled his efforts to persuade his backers of the viability of his plans.[47]

Forbes complained to John P. Hale, Thomas Wentworth Higginson, and the prominent radicals supporting Brown to warn them of both the futility of his attack and their failure to pay him his full salary. The news of Forbes's course rattled Brown, who instructed John Brown Jr. to write Forbes insisting that there had not been an annual contract and to warn that "spiteful letters" might do "great injury" to whatever hope of success they had, should it weaken the Massachusetts connection. Forbes's presence clearly panicked Brown's backers, who postponed his scheduled "dash," while offering generous funding for his cooperation. They simultaneously took measures to discredit Forbes with Senators Charles Sumner and Henry Wilson, fearing that any such activities would directly hurt the new Republican Party, possibly planting in the press a "Letter from Paris" disparaging Forbes's role with Garibaldi's armed insurrection.[48]

Nevertheless, Forbes's criticisms were obvious enough that others began making them independently. In November 1858, Lysander Spooner sent Higginson two printed documents and a cover letter proposing "A Plan for the Abolition of Slavery" that would break the political impasse. He proposed recruiting small armed bands of committed abolitionists who would conduct a series of raids aimed at freeing large numbers of slaves. To the extent that they could be successful at all, it would destroy the security of slave property. Spooner's plan not only resurrected Forbes's proposal, but its circulation would alert the South on the eve of Brown's initiative. Higginson responded that "a simple insurrection with decent *temporary* success" would be preferable, and Spooner strenuously objected to anything without "previous preparations" in terms of communications with the slaves. However, Parker and others, including Wendell Phillips, were sufficiently critical to keep Spooner from issuing his broadsides.[49]

Forbes's politics grew from the concept of an autonomous, if mutually supportive, nationalism. He found suspect abolitionist plans not rooted in the idea of self-emancipation. No less a supporter of John Brown than Hinton denied that Forbes had ever been "deliberately or intentionally treacherous." Based on his own connections in the city, Hinton found "details of this imbroglio which tend to show that Colonel Forbes must have about this time got into relations with a small coterie of clever colored men in New York City, revolving around a well-known physician of that race," who replied to white-supremacist ideas with "a counter race contempt, antagonism, and rage." Forbes associates certainly included black Cubans and likely the proto-nationalist militant Dr. James McCune Smith.[50]

Black self-organization took the same form as the Europeans' secret societies, and for much the same reasons. One of the leaders of the French in New York, Saint-Gaudens, became notorious as "a white Freemason, who would insist on associating with the negro Freemasons and presiding at their initiations. The other white Freemasons accordingly blacklisted him. So he told them to go elsewhere, and, in the future, never attended any but negro lodge meetings, though he always explained to his children that Freemasonry was a sublime and impressive order." In 1856, Jacques Étienne Marconis de Nègre, the leader of the renegade Antient and Primitive Rite of Memphis, visited the United States, partly to establish his rite here, but he also attended the "United Grand Lodge of New York"—the so-called Prince Hall Masons, the African Americans barred from the "accepted" order among the whites.

A few years later, some of the Prince Hall Masons at the fringes of Brown's efforts struggled to establish an order around "African Mysteries" or "African-American Mysteries" dedicated to the overthrow of slavery. One of Brown's men dismissed it as "some such confounded humbug."⁵¹ Forbes and the radical émigré circles, however, would not have done so.

By 1857, leadership of the Order of Memphis fell to Harry J. Seymour. A regular on the local stage who had appeared alongside Frank S. Chanfrau, Seymour remained as much an actor offstage as on the boards. He claimed, at different times, to have been born in 1816, 1819, and 1821. While it is certain that his parents were English, it is unclear as to whether he had been born in England, at sea—or in the port of New Orleans—on a Spanish brig, the *Dos Amigos*. So, too, in 1843, he either came to live in the United States, took to the stage in Mobile, Alabama—either for his debut or his American debut—or did all of these in that year. His name began turning up in the casts of New York plays starting around 1849, though the record reveals a gap in his activities from 1852–53 into the summer of 1856. While he may have been traveling elsewhere, Seymour had also started a good business in costuming for the stage.⁵² Surprising it would be if he had never darkened Pfaff's door, and he certainly associated with many who did.

After a hiatus of several months, Brown quietly resurrected his plans and made a quick and clumsy, if heroic, seizure of the arsenal at Harpers Ferry on October 16–18, 1859. It ended with Brown and the few survivors in the custody of the state of Virginia, the courts of which opted to try them for treason to the state. Even as he solicited the help of the émigré circles in New York for a rescue attempt—Hinton volunteered to go to Virginia and cover the case for the *New York Tribune*—the paper already had one of its reporters among Brown's armed insurgents. Realizing that it would only be allowed to report on the event secretly, the *Tribune* sent staff less likely to be recognized, particularly Henry Streel Olcott, the agricultural editor (and later cofounder of the Theosophical Society), and its drama critic Edwards H. House, who later decided to remain in Washington, "within gun-shot of Harpers Ferry."⁵³

Through Clapp's *Press*, House debunked the "generally accepted belief that one of the greatest privileges of an American citizen—*the* greatest par excellence—is freedom of speech. This is a delusion so generally prevalent both in the North and South, that a caution cannot be too soon sounded that such nonsense don't go down here." Bohemians had never shared the

delusion. Rawson recalled how people began a lawyerly argument around the table at Pfaff's, "as to which should have the jurisdiction and the *honor* of hanging Ossawattomie, the United States or the State of Virginia." Disgusted, Clapp simply "suggested that the grand old man might be hanged between the two thieves."[54]

A few weeks after the killing of John Brown, Clapp wrote his wonderfully eccentric and bluntly honest holiday message to the readers of the *Saturday Press*. Mocking the ritual expression of good will by public figures and publications, he wrote: "With a few choice exceptions, we wish everybody a Merry Christmas. If we were more Christian, by which we mean if we were more noble, more manly, we should make no exceptions, but extend our good wishes, especially as they cost nothing, to the entire human race. But, then, it is such a raving and incomprehensible race, and includes such queer kind of people!"[55]

By 1858–60, the bohemians contributed to the emergence of Republicanism less directly and ever more warily. As a group, they continued their literary guerilla war on the Democratic administration, while as individuals, they almost instinctively resisted any efforts to restrict freedom of discussion and expression. In the aftermath of Kansas, Felice Orsini and John Brown provided a model for forcible self-defense. At least some bohemians had direct sympathies with both. That the established order had lost the allegiance of those charged with its literary defense bode poorly for the stability of the government or the nation. The bohemians rightly doubted the ability of electoral politics to solve the crisis, and they could not see the war as anything but destructive of human liberty. Clapp's solution to these looming hellish realities was to psychologically distance himself from the entire process.

After Lincoln's election came Southern secession, starting with South Carolina. In New York, however, the South Carolinian Ada Clare also marked the crisis by trying her best to ignore it. She hosted a Thanksgiving banquet at her home on Forty-second street. Although "suffering from a cold and hoarseness," she presented "the Grand Seignor of Turkey." Aided by Wilkins Anna Mari, "Sir Archibald Hooper, Lord Pierceall Clapp," the group "toasted every one but first of all proposed the health on the Youngest and Loveliest—the Queen of Bohemia." She replied with a toast to "the Oldest Man." Clapp retorted with "the infant Prince of Bohemia."[56] So for them flickered the last brief warmth of twilight before the darkest of nights.

CHAPTER 5

Representing Alienation

THE REPUBLICAN CIVILIZATION AND ITS DISCONTENTS

―――⚯―――

> The records of man's life and struggles in all ages, in peace and in war, through the fictitious "honesties" of business enterprises, or in the eccentric ways called crimes, declare most emphatically that the "great good" *is* "goods" or their equivalent in the "representatives of value" which we call money, in almost everybody's heart; and the sickening details of the struggles for it, with which the detective becomes familiar, are so multiplied, that one might almost write the history of current times, as well as that of the past, in one phrase—"Money-getting!" "money-getting!"
> —George S. McWatters

Notwithstanding such a succinct presentation of historical materialism, one could scarcely find a greater paragon of Republican respectability than "Officer Mac." The founder of the lost children's bureau of the police department, he organized a campaign to protect war veterans and their families from being defrauded, providing an example of an effective citizenship initiative praised by observers from Ralph Waldo Emerson to George Jacob Holyoake. Still, McWatters knew not only Vice President Henry Wilson and other officials but the counterfeiters and streetwalkers he encountered in his work in New York. Perhaps at no other point in our history could anyone have so seamlessly combined the roles of policeman and private detective, theater critic and social critic, ardent Republican and lifelong labor radical.[1] In other ways, though, McWatters represented a prototype of the modern rebel, an insider choosing to function as an outsider because of his essential commitment to

the professed values of institutions that ultimately betray those values—the cop or detective so preoccupied with justice as to play outside the rules and is, therefore, defined as such by the very existence of such rules.

Bohemianism emerged alongside the Republican Party. The social alienation of the self-consciously creative—though they often embrace their "outsider" status—bore a natural resemblance to that of the self-aware producer, which fueled the radical versions of the classical Republican ethos of "free soil, free land, free labor." In a civilization increasingly bent on understanding itself through scientific, rational, and technological means, the bohemians explored social truth from the perspective of its alienated margins. Without questioning the social context of human achievements, they insisted that creativity remained an innately individual process, the integrity of which represented the most human features of civilization, creating a genuine social radicalism without specific political implications. In short, respectable midcentury Republicanism owed much to the bohemians, who performed respectable toil during the day, while at its close, some of them left the composing rooms, school yards, and even police stations and shed their respectability as they tumbled into the cellars of Pfaff's. In fact, bohemianism itself existed only in relation to republican respectability.

The bohemians of antebellum New York, like their contemporaries in Paris and London, surfaced in the wake of a massive upheaval to extend, defend, or revive the republicanism that had failed to transform the world after its emergence in the previous century. This involved a broad spectrum of political and social ideas. On both sides of the Atlantic, rival elites clashed for power, appealing to "the people" to support their efforts. Cultural workers, particularly those associated with the press, became the essential shock troops in this effort.

Socially, the bohemians in America, as abroad, came disproportionately from those sectors of the middle class facing decline and from the more ambitious of "the lower orders," eager to find a niche in the expanding worlds of arts and letters. Ada Clare and Edward Howland were memorable exceptions to the general prevalence of the latter around the table at Pfaff's. Large numbers of the writers, such as Franklin J. Ottarson, came from the newspaper and printing trades, and Frank S. Chanfrau worked as a ship carpenter before turning to the stage. Richard Stoddard, Ned Underhill, and Marie Stevens came directly from the factories, foundries, and mills of the "Industrial Revolution."[2]

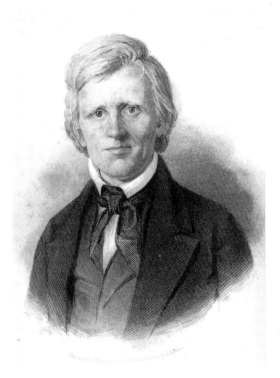

Nathaniel Peabody Rogers (1794–1846). The New Hampshire abolitionist and mentor of Henry Clapp. From *A Collection from the Newspaper Writings of Nathaniel Peabody Rogers* (Concord: John R. French, 1847).

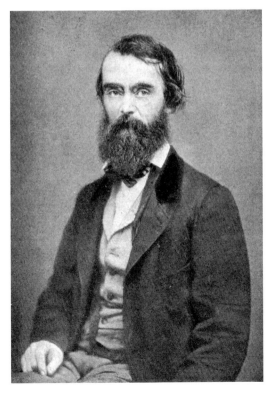

Henry Clapp (1814–1875). Called "the oldest man." From Winter, *Old Friends*.

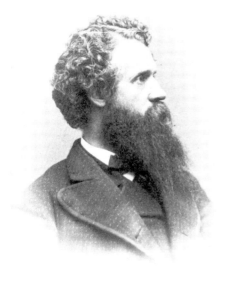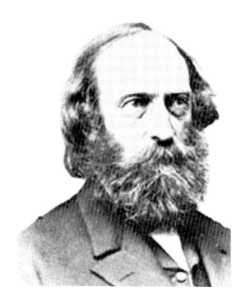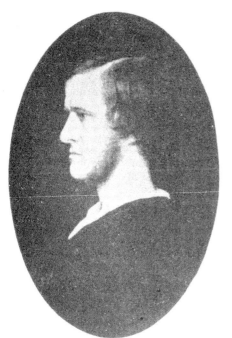

Top left: Edward Fitch Underhill (1830–1898). Pioneer bohemian, feminist, innovative socialist, and journalist. Image from Picture History at www.picturehistory.com.

Top right: Stephen Pearl Andrews (1812–1886). The self-elected Pantarch.

Left: Albert Brisbane (1809–1890). Leader of the American followers of socialist thinker Charles Fourier. From Albert and Redelia Brisbane, *A Mental Biography*.

Taylor's Hotel, the site of the notorious "Free Love League." From "New-York Daguerreotyped," *Putnam's Monthly Magazine of American Literatures, Science and Art*, vol. 1 (April 1853), p. 363.

George Arnold (1834–1865). The poet son of New Jersey Fourierist leader. From Winter, *Old Friends*.

William Winter (1836–1917). The author of a series of important recollections of the circle at Pfaff's. From Winter, *Old Friends*.

Frank S. Chanfrau (1824–1884). Perhaps the most famous actor in the city for his portrayal of "Mose" the Bowery b'hoy. University of Washington Libraries, Digital Collections.

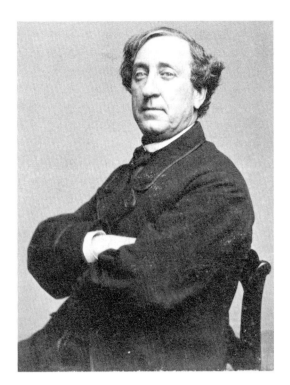

William Pleater Davidge (1814–1888). Founder and first president of Actors' Protective Union. University of Washington Libraries, Digital Collections.

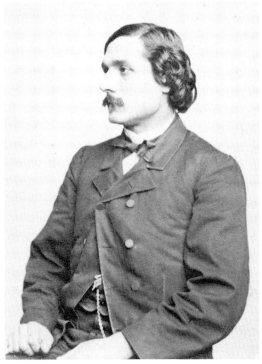

Edouard Mollenhauer (1827–1914). Founder and leader of the Musical Mutual Protective Union. University of Washington Libraries, Digital Collections.

George S. McWatters (1823?–1886). Socialist, founding Republican, and detective. From his *Knots Untied*.

Below: Portraits of Marie Stevens Case Howland, Ada Clare, and, below, Gettie Gay and Jenny Danforth. The original includes the signature of Christopher Oscanyan, the sometimes counsel of the Ottoman Empire in New York and owner of a Turkish coffee shop near Pfaff's, and is in the collections of the New York Public Library.

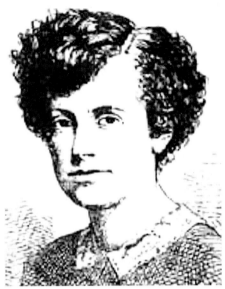

Jane McElhenney, aka Ada Clare (1836–1874). The "Queen of Bohemia" regularly hosted the bohemians at her house when Pfaff's was not open. From Albert Parry, *Garrets and Pretenders*.

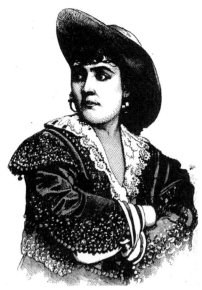

Adah Isaacs Menken (1835–1868). Daring woman of the stage who toured the country with a role that placed her on stage in flesh-colored tights.

Masthead of *The Saturday Press*.

A page of *The Saturday Press*.

Most customers at Pfaff's gambled everything in hopes they could make a living by the pen or the piano or the canvass. As Walt Whitman recalled, "Poor Henry! He, too, was always hard up. Poor Walt! Poor most everybody! Always hard up!" Whitman said of himself: "My own pleasure at Pfaff's was to look on—to see, talk little, absorb. I was never a great discusser, anyway—never." Clapp, however, arranged to have a woman upstate review Whitman's work. Whitman always believed "the girls have been my sturdiest defenders, upholders."[3]

Certainly, a central mythology in American civilization has always been the denial that classes exist, coupled with the paradoxical faith that the class structure encouraged individual mobility. This last idea grew from anecdotal evidence about such odd exceptions as that of Eliza Hensler. After auditioning for Max Maretzek, Hensler, the daughter of a poor Boston tailor, sang opera for a season in New York before being sent to study in Paris in 1856. Eventually, she landed work at the Opera in Lisbon, where Dom Fernando, the consort of Queen Maria della Gloria, took her under his protection. After the death of the queen, he ennobled the Yankee craftsman's daughter by making her the Countess of Edla and marrying her. This made her the sister-in-law of Queen Victoria and aunt to the Prince of Wales, along with establishing relations to most of the royal houses of Europe.[4] Nobody knew better than the hard-nosed bohemians that, for almost every other child of impoverished tradesmen, marrying into royalty remained the stuff of fairy tales.

Most bohemians knew that they were waging an uphill battle against statistical probabilities heavily predisposed to the exclusion of those without the proper family and class ties. Edward H. House, a lower-class student in an elite institution, left school when his teachers accused him of cheating because he wrote so well for one of his background. William Winter recalled that the actor Lawrence Barrett "rose from an obscure and humble position,—without fortune, without friends, without favouring circumstances, without education, without help save that of his talents and his will,—was for a long time met with indifference, or frigid obstruction, or impatient disparagement." Having "gained nothing without battle," he eventually attained stature in his field, but "the habit of warfare had got into his acting, and more or less it remained there to the last."[5] This likely described the experience of many at Pfaff's and lent a certain edge to their work and their humor.

Moreover, they understood those similar "hidden injuries of class." Mc-Watters thought it "one of the misfortunes of a detective's life, that he learns

to be suspicious of the innocent as well as of the guilty; and, like other men, detectives sometimes err in their judgment, and the innocent suffer, not only under unjust suspicions, but sometimes the penalty of offences of which they are not guilty, through the force of 'circumstantial evidence' which is brought to bear upon them." He recalled himself a case where suspicion fixed on an innocent roofer rather than on the guilty lawyer, adding, "I have known several instances of this kind in my experience."[6]

The class struggle such people waged proved to be a remarkably personal one. Antebellum social standards required a dehumanization, which Mortimer Thomson caricatured as "lazy, shiftless Northern white men," as well as nonwhites and women of the laboring classes. While even the more positive images of the worker in the nineteenth century tended to be like that portrayed in George Cooper's poem in the *Saturday Press:* the grimly faceless "Toiler" who "neither sighs nor sings; / His labor falls / In gloomy halls.—/ His only friend the hammer that he swings."[7] Still, bohemia allowed that when Walt Whitman heard America singing, it was the voice of these very people, the diverse sounds of the working people of the city.

While the emergence of new kinds of white-collar labor and creative crafts provided the bohemians avenues of escape from the demands of physical labor, they also opened more avenues for the exploitation of this new kind of work. One of the more unassuming and irregular participants at Pfaff's, Fitz-Greene Halleck made his living as an accommodating clerk to John Jacob Astor. He had the misfortune of agreeing, "in an unguarded moment," when his miserly employer said that any man ought to be able to live on $500 a year, and found later that the old millionaire "pensioned him off on that sum."[8]

Several bohemians led pioneering efforts to organize these new kinds of workers and the traditional crafts transformed by them. Ottarson's fellow printers sent him as their delegate to the 1850 national convention, at which he served as secretary. He also attended the September 1851 convention, another of the preliminary gatherings that led to the formation of the National Typographical Union.[9]

The desire for "a minimum salary" in the summer of 1864 led to the organization of the Actors Protective Union under the presidency of William Davidge Jr. After some thirty or forty "signed the articles of the association," they discussed addressing others in the craft across the country and voted to cooperate with other unions in the city. However, the citywide labor federation then required constituent unions to send representatives to evening

meetings and "the engagements of actors would necessarily prevent them complying with that rule, and the formal cooperation was on that account not effected."[10]

Musicians had serious grievances as well. Maretzek recalled that, in the depths of the depression, Maurice Strakosch proposed gradually to reduce what he was paying his performers. B. Ullmann suggested that this was "the same experiment as the peasant did with his donkey—by giving every day a little less oats to see whether, with time and patience, he may get accustomed not to eat at all." When one tenor rebelled at receiving half pay, Ullmann quipped, "your donkey, Mr. Strakosch, declines to be accustomed; this donkey wants all the oats he sees before him." A few years later, Edouard Mollenhauer became a prime mover in organizing the Musical Mutual Protective Union, which sought to combine cooperative performances with the "relief of such members as shall be unfortunate."[11]

These kinds of crafts had their own way of expressing and dramatizing class grievances. Particularly in the 1850s and 1860s, striking printers not only left their workplaces but organized cooperative newspapers. So, too, as the agent for Dion Boucicault's plays in the United States, House helped bring such dramas to the stage as *The Long Strike*, depicting labor grievances and workers' struggles

As had the earlier labor and radical papers, the *Saturday Press* protested the city's periodic "onslaught upon the street beggars," contrasting the persecution of the powerless to its institutional deference to "the political beggars and thieves" running their government. In the winter of 1854–55, a mass meeting of the unemployed selected Underhill to help evaluate proposals to reform currency, along with Ira B. Davis, a prominent leader of the largest local affiliate of the Brotherhood of the Union, which renamed itself the Ouvrier Circle in solidarity with the growing community of French revolutionary émigrés.[12]

The bohemian involvement in such activities reflected something of a class self-awareness and a shared faith in the "free labor" ethos also central to the emergent Republican Party. However, the concept incorporated contradictions and vagaries that events had yet to resolve. These, too, coexisted with radical, quasi-socialist, and even revolutionary impulses.

Class awareness among the bohemians did not require a conscious class hostility to the rulers of society. Indeed, when others spoofed in verse the vanity of the upper-class women who had *Nothing to Wear*, Thomson accused them of a "mobocratic snobbery" and asked whether it might be

That Charity, really, not merely in fables,
May apparel herself in satins and sables,
And costliest ribbons, and fragilest laces,
 Like the daintiest beauties of Madison Square,
And may take up a home in the loftiest places,
 With those who've, satirically, Nothing to Wear?
And in that blissful realm above,
Where the poor and the rich meet in meekness and love:
Where the works of each heart are unveiled to the light,
And Humbug and Cant yield to Truth and to Right—
Where the trickster lays off his mask of deceit,
And the cloak of the hypocrite drops to his feet,
And Honor is given, where Honor is due—
We *may* see that some from the Fifth Avenue,
Most nobly will speak in that great reckoning day,
While their earthy detractors have Nothing to Say.[13]

Still, while bohemians neither ascribed to it a particular set of political ideas nor believed that class identity mandated a class hostility, the experience of social hierarchy framed their essential sense of themselves as alienated outsiders.

Bohemians observed contemporary minds' groping toward a scientific understanding of the world, human society, and progress. At one point, the *Saturday Press* compared the reception of James Hinton's *Man and His Dwelling Place* to that of Robert Chambers's *Vestiges of the Natural History of Creation* and Henry Thomas Buckle's *History of Civilization in England*. It also offered an intelligent review of Charles Darwin's *The Origin of Species* as a byproduct of "the universal and necessary struggle for existence."[14] Throughout, they saw questions like slavery in light of Buckle's description of humanity's rise from ignorance and superstition, even if many did not entirely share the Victorian gradualism implicit (erroneously) in Darwin's evolution.

 Bohemians neither pursued nor endorsed any specific scientific proposition on these subjects, for several reasons. Clapp became, as described by one scholar, "Bohemia's primary theoretician, if such a term may be applied validly to the leader of a group so amorphous and disparate in its goals." Despite this—actually because of this—he would surely be the first to suggest that such an understanding required entirely unnecessary overgeneralizations of

his sometimes offhanded comments. The bohemian, wrote Clapp, "needs no adventitious aids from pomp, etiquette, enforced obedience, to have his claims to respect." They scoffed at the arrogance of "pedagogues," and he goaded New York University for its pompous welcome of the Prince of Wales to its "marble halls." When Union College later conferred an honorary Doctor of Laws degree on Ulysses S. Grant, Clapp explained that it was "not that the General needed a degree, but the college needed a Grant."[15] In short, bohemians suspected that institutions and personages supposedly committed to higher learning simply were not.

More fundamentally, though, Clapp and his circle found reason inadequate to an understanding of social and political realities of gender. On this the material world of capital seemed to them less informative, in terms of the human condition, than the cultural weight of tradition. When Catholic archbishop John Hughes urged women to embrace their natural role as wives, mothers, and cooks, Ada Clare commented "that there is no occasion for one woman in ten to be a cook, and the chief reason why men take any other view of the case is that they may keep woman in what is called her 'peculiar sphere.'" However, since "no one has yet been able to determine" what "that peculiar sphere" might be, she suggested "that woman's peculiar sphere is whatever field of action she finds herself best adopted to, and in which she can maintain herself, if need be, in entire independence of man."[16]

So, too, in the "Home-Made Shirt," the "Queen of Bohemia" wrote of how the father of a family, disturbed by the "continual talk in journals of the day about women's rights, etc." feared "that his own wife was in danger of becoming strongminded" and ordered her and his daughter to make homespun clothes, which he promised to wear. Since neither particularly shared this allegedly feminine skill, he was forced by his pledge to wear humorously misshapen clothes. When consulted, medical men advised him as to what alterations his body would need to make his shirts fit.[17] Without belaboring the artificial nature of the gender division of labor, she presented the reader with the obvious practical conclusion that it would ultimately be cheaper and more reasonable just to buy shirts.

While Ada Clare studiously avoided electoral politics and overtly radical social criticism, she wrote stridently and fearlessly on the cultural contradictions facing women. In arguing for practical dress reform, she pointed out how "male logic" imposed upon women a preoccupation with fashion and money. "If the Bloomer dress ever comes into sway, carried out in an elegant, tasteful,

coquettish manner," she wrote, "I fancy that it will bring with it a freedom for women from conventional lies, from deceit and much uncharitableness, and from their intense desire for money."[18] Her radicalism, then, remained essentially cultural.

So, also, could bohemians look beyond the economic shortcomings of slavery to offer an occasionally crisp focus on the absurdity of race. When someone at a political meeting pointed out "an octoroon," "Artemus Ward" replied: "'No, Yu don't say so! How long has she been in that way?' 'From her airliest infancy,' sed he. 'Wall, what on erth duz she du it fur?' sez I."[19] The bohemians chose to battle over questions of culture rather than electoral politics, but politics remained no less central to their understanding.

As with the critics of capital in the form of slavery, the bohemians argued about not only an exploitation of the workers but what such obsession with material wealth does to the individual owner. For Clapp: "The golden Rule is the golden test; / The Golden Mean means gold alone; / And the goldenest thing is e'er the best." John Burroughs thought it "a strange idea some people have of use; as if a man must go jingling his money in his pocket to establish his claim to wealth; or reciting passages from books to gain the honor of wisdom. Good painting and good sculpture need no explanation; and a really wise man need not hang out a sign-board or employ a trumpeter. Wisdom, like the sun, is its own herald."[20]

The preoccupation with wealth created a din that overwhelmed the community. Clapp heard "no twaddle so insufferable as that which has begun to be so rife in large cities like New York, where money is the chief end of man, and where, therefore, only so-called business (or those peculiar and distinct Wall Street operations by which money is, more or less honestly, made) is considered the legitimate sphere of occupation." The new city seemed peopled by "scamps ... who always stand ready to profit by other people's labors." He declined to offer "a classification of these scamps, for fear that the various species of the genus 'who profit by other people's labors' might include some reader's most respectable friends." Despite this claimed desire for forbearance, Clapp referred to Wall Street as "Caterwaul Street."[21]

McWatters—who embraced the "Greenback" monetary views of E. N. Kellogg, his neighbor at Modern Times—bluntly described banking as another kind of speculation that made money without actually making anything of real value. With an astonishing frankness, Officer Mac described this violation of the monopoly demanded by the bankers as the great offense

of the counterfeiters, "who, by their great talent as engravers, have added so much to the mechanical skill of the country." He thought it "as much one man's *natural* right to 'make money' as another's, but that the few manage to make a monopoly of the business." If criminal counterfeiters "do no good, they certainly do no harm, save to the regular counterfeiters, by forestalling their field, and getting away from the poor dupes money which might otherwise fall into the 'regular' gentlemen's hands."[22]

The socialist detective not only quoted counterfeiters on banking but madams on morality. One told him: "Wall Street gamblers—Wall Street commits its forgeries, and practices false pretences all the while, and men call these things there respectable. Why may not others gamble on a smaller scale, and practice their smaller cunning?" Mac noted that another maintained five orphaned children at schools, awarded dowries to those of her girls who were marrying, and assisted others when they wished to leave the business. Based on his experience, he found it "a not unfrequent thing in New York."[23]

Immersed in the hard realities of the new cities, McWatters gained a reputation for kindness and refinement that reflected choices that became less common as time went by. He gave Ada Clare "a big brown mug, which had a green frog inside" for her son and dubbed her boy "the Prince," which name the group adopted for him. Becoming known as "a genial and kind-hearted policeman," he helped establish the procedures for aiding missing children in finding their parents. In October 1860, his daughter married Signor Achille Errani of the Academy of Music, brought into the country by another of the circle, Max Maretzek. Officer Mac worked out of the Twenty-sixth precinct on Mulberry Street a few blocks north of City Hall, where he organized the railroad and steamboat services for finding missing persons. A later guidebook to the city described McWatters as "famous in New York. He is the theatrical critic of the Police Department. His opinions on music and the drama are of weighty authority among members of the force, and, like most critics, he is dogmatic and forcible."[24] The changing nature of his own work would make him as much of an anomaly as the madams paying for the education of orphans.

Moreover, bohemians, as culture workers, knew that establishing these articles of social and economic faith as orthodoxies of "nature" required, in part, the construction of an acceptable history, preferably a profitable one. Clapp thought "Glorious and Immortal Memory" among the new "hobbies" of Americans, particularly when Washington's home and tomb were "being

retailed" in what Clapp called "Mount Vernonism." The Indians in Thomson's *Plu-Ri-Bus-Tah* not only faced slaughter at the hands of the title figure, but Goddess America complained bitterly that the real Indians "have cleared out and left the country, / When the poet, Henry Wadsworth, / Wrote the song of Hiawatha, / He took all my Indian subjects."[25]

Thomson, one of the more conservative of the bohemians, mocked these self-deceptions about the American past. Applying the rough wisdom of the New York streets to the high-minded parlors of New England, he penned a spoof on Henry Wadsworth Longfellow's *Hiawatha* that told the tale of Plu-Ri-Bus-Tah, leader of the "Pil-grim-fath-us." Thomson frankly declared his intention "to slaughter the American Eagle, cut the throat of the Goddess of Liberty, annihilate the Yankee nation, and break things generally; and I flatter myself that—I have done it." That goddess, with "her blood-red nightcap" shared the stage with her sisters Justice and America, who held her dominion over the continent from a distant and brooding Jupiter, who sat "With one leg across the other / In the style of Mrs. Bloomer, / At the Woman's Rights Convention." When Plu-Ri-Bus-Tah battled Britain, the goddess of Liberty held his jacket, and they developed "a 'passional attraction,' / As the 'Free-love' people have it."[26] The result was Yunga-Merrakah—the "Young America" of questionable legitimacy.

Plu-Ri-Bus-Tah went about making one of many in the most unimaginably ruthless ways. Encountering native peoples, he decided to

burn your towns and wigwams,
He shall plow your grounds of hunting,
He shall fell your woods and forest,
Slay your weakened, warring nations,
Drive them westward to the river,
Drive them westward to the ocean;
Feast his dogs upon your corpses.

Encountering an African, Plu-Ri-Bus-Tah resolved to "Make him work and do his drudging, / But he didn't mean to pay him, / Pay him for his toiling labor." As he explained directly to his victim, "I am white, and I am stronger, / You are black, and you are weaker, / And, beside, you have no business, / And no right to be a nigger." Entrepreneurship also fleeced newcomers to the country. The *Saturday Press* noted that the United States chose as its national symbol a bird of prey that "doesn't care a feather for anybody."[27]

Reducing everything saleable to a commodity, and had pervasive impact on the civilization. Plu-Ri-Bus-Tah may have still prayed to God on Sundays, "But the week-day prayer he uttered, / Daily, hourly prayer he uttered, / From his heart came hot and earnest, / And the language run this wise: 'Potent, and ALMIGHTY DOLLAR!"

All the rail-roads, all the steamers,
All the scows, or tugs, or clippers,
All were bringing money, money,
 Money home to Plu-Ri-Bus-Tah
Bringing it from Northern corn-fields,
Bringing it from Southern rice-fields,
Bringing it from every country,
Every land, and state, and province.
All were bringing money, money,
 Money home to Plu-Ri-Bus-Tah.

Despite Plu-Ri-Bus-Tah's claim to love Liberty, he actually loved only the image of the goddess on his money.[28]

Clapp's "The Song of the Worldling" fringed on the religious. He drew on the imagery of both the Old Testament ("We bow before a golden shrine, / And worship, all, the Golden Calf") and the New ("Give us this day our daily gold"), and prayed "wisdom, bring me worth; / But bring me gold, and I'll rule the earth."

God's but a sterner name for gold;
 Or gold a softer name for God;
Who tempts us with a golden crown;
 And rules us with a golden rod.[29]

Thus, the former veteran Sunday school teacher recast capitalism as the new idolatry.

From this perspective, bohemian values rested on very familiar sources. After reciting the news coverage of the Indian mutiny and the religious riots in Belfast, Ada Clare asked, "When will our poor world be sufficiently enlightened to throw off the Christian religion, and assume in its place the *Religion of Christ?*" However, the moral impulse that remained central to Clapp's view of the world was evident in the title of his most comprehensive

statement on antebellum social reform: "Modern Christianity," published in the abolitionist *Liberty Bell*. When others discussed the value of experience in correcting injustices, Clapp scoffed, "Then what is the use of Christianity?" Thomson's collaborator, Ned Underhill agreed, "Upon man himself rests his salvation here, and which he must work but himself unassisted except as the genial rays of Christianity soften the asperities of human nature."[30]

Bohemianism saw that the prevailing, institutionalized standards could be both rationalizing and moralizing while being neither rational nor moral. In doing so, it doubtlessly owed much to the abolitionist distinction between institutions and some of the values they professed to defend. Clapp insisted that "the great demand of the age is for more *Humanity*," and quoted Nathaniel Peabody Rogers, his old mentor in the abolitionist movement, as saying, "I may be wrong in supposing the welfare of mankind an object of paramount concern with me to the glory of God.... Mankind needs love and help. God needs neither." Tellingly, he elsewhere declared that "a real Republican or Democrat" would be "driven from the political arena as summarily as a real Christian would be driven from the Church."[31] The bohemians understood the legitimacy of capitalism and its institutions as requiring the continuous marketing of compatible values, assumptions, and versions of the past, a process that made a law and politics secular parodies of justice and religion.

Awash in the Republican insurgency, bohemianism offered a social vision beyond any political doctrine and rooted in an insistence that should follow one's bliss, to use a modern phrase. Without questioning the social context and foundations of human achievements, the bohemians believed that creativity remained an innately individual process, the integrity of which provided the best measure of a civilization. McWatters thought the world would tend to misunderstand any person who "did not lead the life which his talents apparently indicated," sensing that "in such men's characters, there is obviously always 'a screw loose;' and for want of fixedness or tightness of the same 'screw,' is it perhaps, that the general machine will not work."[32]

Clapp reprinted Rogers's views as to what justice for working people entailed. Rather like other antebellum reformers, Rogers believed "everybody ought to earn his own living by manual labor, and if practicable, had better earn this much, by cultivating the face of the ground." He also thought physical work to be "not so healthful or pleasant as when mingled with the cultivation and adornment of the earth, nor so sure of requital." He questioned

its merits if "prosecuted constantly and uninterruptedly."³³ Here were seeds that would grow into what socialist Paul Lafargue would later advocate as "the right to be lazy."

Then, too, finding yourself required trial-and-error experimentation. Free love meant many things, among them the idea of liberated sexuality. The use of psychoactive substances to explore personal consciousness seemed important to some: Ned Underhill hinted in adopting the pen name "Knight Russ Ockside, M.D.," and Fitz-Hugh Ludlow, the son of a local clergyman, published his own praises of hashish.³⁴ All such activities fell under a cultural sanction in respectable society, and reflected the priority bohemians placed on individual experience rather than on middle-class respectability.

Bohemian objections ran deeper than the immediate social and institutional injustices of the day. The group Clapp called the New York *Saturday Press*-byterians distrusted all sorts of self-righteousness, for which they saw contemporary American Protestantism as the prototype. The "hideous" dogma of some Protestant sects disgusted Ada Clare, and Clapp, at one point, described a particularly "vain and popular clergyman" as "continually looking for a vacancy in the Trinity." Liberty for Clapp represented "Freedom *NOT* to Worship God." Bohemians generally challenged "the divine right of the Church to rule, and the divine right of the King to rule," also "the divine right of the Majority to rule." Ultimately, they scorned any coercive power by "the class, which call themselves Kings by the Grace of God, or Presidents by vote of the majority." And the lack of any engagement in politics per se meant that a bohemian "never tries to enforce an unjust claim, he never needs to compromise, to pursue a temporizing policy."³⁵

The bohemians developed their ideas alongside the transatlantic evolution of libertarian and anarchist tendencies within socialism. Clapp made no secret of his faith that the world would be better off with the extinction of all governing authorities, and "not only the race of Governors, but the whole race of Legislators. And what a calamity that would be to us all! Think of a world without Governors or Legislators. The United States, for example, without a Congress or a President. Washington washed out of existence." The death of government would leave thirty-two states "like so many orphans, to look out for themselves. Or, worse still, if possible, the people left to look out for themselves without any States to provide for or to tax them; without any State-House even; nay, absolutely without any capitol!" Clapp hastened to add:

If we should seriously propose such a thing, the office of the SATURDAY PRESS would be pulled down about our ears before morning. So, we beg most distinctly to say that we do *not* propose it, but only with fear and trembling suggest it was a calamity to be provided against in every possible way, and, especially, by keeping up the race of Governors and Legislators, without whom the Custom House, as well as many of our other institutions, could not be kept up for a day.[36]

In the same way that a familiar Christian morality fueled their disgust at crass commercialism, something of a traditionalist suspicion of institutional authority informed what was common among their political predispositions. Clapp's tongue-in-cheek commentary "on the Beauty and Necessity of Having Governors" described human beings as "born under the fatal necessity of being governed." "Cain has such an irrepressible desire to kill Abel,—and the world is made up of Cains and Abels,—that some power must be maintained to keep peace between them. And this power is what is called GOVERNMENT." Clapp added that government hadn't actually "thus far, that we know of, prevented many people from being killed, but so long as men think it has we ought not perhaps to complain."[37]

Nothing demonstrated this human arrogation of authority so completely as capital punishment. After "a thorough study of the subject," Clapp concluded "that people were not deterred from crime by fear." He entertained the Rutland Free Convention with a story illustrating the contradictions: "Some time since, a man was to be hung: At the scaffold, the Lord's prayer was repeated, and the people said, *Amen!* If that portion of the prayer which says, 'Forgive us our trespasses as we forgive those who trespass against us,' had been answered, they would have all been hung in the twinkling of an eye. And what a spectacle they would have presented!" He thought it "a serious reflection that we have persons in authority among us who could plan and carry out such shockingly brutal arrangements." "If our civilization and the morals of society require that we should maintain such a class," he added, "we had better relapse into a decent and human barbarism."[38]

This was no less true of slavery, however stubbornly Clapp feigned a skeptical disinterest in antislavery politics, stating that he had "no special interest to discuss the subject." Certainly, he scoffed at the dishonesty of Mrs. G. M. Flanders's *The Ebony Idol*, for depicting slavery as "the apple of discord" in the Eden of a New England village in order "to ridicule the Abolition movement in the North." The American Anti-Slavery Society reprinted Thomson's ac-

count of an 1859 slave auction at Savannah, and the *Saturday Press* reprinted articles from such papers as the *National Anti-Slavery Standard*.[39] For Clapp, though, slavery was a morally settled question that now attracted growing numbers of political critics obliviously unconcerned on the issue of race.

For bohemians, social movements had values insofar as they tended to promote the well-being of the individual or inspired skepticism to the extent they did not. The age seemed to have "been to all its privilege of reform, and haughtily aware of all its rights." There was much doubt as to whether "the nineteenth century is holier than its dead brothers were." Clapp wrote, "The worst of Movements is that, when they move at all, they move in such funny little circles that it makes one dizzy to look at them. The Movers themselves don't think so, for they imagine that they are traversing and moving the universe. This, however, we like, for it makes them amusing, at least. This, with the tragic aspect when they get excited (presenting one of the most moving spectacles we can think of), is one of their redeeming features." Worse was when movements reordered themselves to fit into electoral politics. The temperance movement, recalled Clapp, "went into politics, where, of course, it made a fool of itself, besides making fools of a great many people who ought to have known better, and knaves of a great many more who did know better." Increasingly, Clapp concluded that movements usually failed to move anything. In part, he implied that progress came with time rather collective human activism: "Somehow, the age seems pretty much resolved to do its own moving. It is more and more inclined to look upon all organized and official attempts to move it, with suspicion."[40]

In large part, his skepticism grew from the reliance of movements on leaders concerned about attaining or keeping respectability, which predisposed them to ape the status quo rather than to change it. For Clapp, Horace Greeley seemed to typify the problem. After Greeley went west and interviewed Brigham Young about polygamy and the *Book of Mormon*, Clapp responded with a spoof in which Young came to New York and employed the same paternalistic condescension to grill Greeley on a *Book of Fourier*. The appearance of one of Greeley's letters indicating he had political ambitions caused "a state of comic perplexity" among Republicans, particularly those in the rural districts who idealized him. Clapp scoffed at their shock at seeing Greeley as part of "that hitherto suspicious class of people commonly known by the too opprobrious term office-seekers" and suggested that Greeley's earlier denunciation of politicians had been written from "a Pickwickian point of view, and that he didn't mean any more by it than politicians unusually

mean when they talk about such things." What Clapp saw as the heart of Greeley's faith was the trinity of "the Dollar, the Dime, and the Cent."[41] In short, radicals, too, could share the faith of Plu-Ri-Bus-Tah.

As the State seemed unlikely to wither in the near future, Clapp suggested making a virtue of the necessity. He advised thinking people to establish first "a perfect dominion over one's self," which "leaves no desire to influence, or command others." Such a "self-possession . . . makes the Bohemian reverenced by the strong, and saves him the mortification of finding himself a small man, in a position which is too great for him." Since the bohemian is neither a politician nor an office seeker, he is "never made angry or disturbed by failure. He is most successful when the world generally thinks him least so; for the world counts by numbers, and does not see that a fixed point may be the centre of a circle whose circumference is infinity." Lead yourself, first, advised Clapp, leaving others to follow or not; the realization that compulsion cannot persuade frees everyone. "The Bohemian is naturally a Ruler—naturally a Leader. Or perhaps it would be better to say that mankind naturally subject themselves to him and instinctively follow his lead." However, "his kingdom is the world of thought. He rules the best men of his time, by their manly sympathy with his freedom of truth and his greatness of soul," being "as careless of strength, and as certain of his power, as nature is. He never needs to enforce his rule. He will have a spontaneous subjection or none. For his laws are justice, and his rule is truth: therefore his subjects have the only freedom possible, and can blame no one but themselves if they prefer the miseries of Grundyism."[42] In contrast, institutional justice meant mere law, and institutional faith only an organizational affinity.

For all his suspicions of these established mores and institutions, Clapp understood them. From another point of view, he asked "what life, liberty, or happiness is possible to a Politician without a chance at the succulent loaves and delicate fishes of office." The idea of "a Country without a Custom House is no more to be thought of than a solar system without a sun." Elections offered voters the choice of retaining "the same set of Politicians" or replacing them with "another perhaps more rapacious set." Unwilling to address issues and ideas seriously, an electoral contest quickly became "foul with personalities." It required a civic culture in which "the simple-minded people in Peoria and elsewhere who think that because a man wears a white coat, or because he is called 'Honest Abe,' or because he talks through his nose, or because he prates

night and day against office-seeking, or because he lives in a log cabin, or splits rails, or writes his name 'Sam,' that therefore he must be what is called a 'high-souled patriot,' will learn, now, that in so thinking they are very stupid." In the present campaign, he added, one party had just strung "four or five banners suspended across Broadway" in an effort to sway the "diligent reader of the banner inscriptions."[43] Nothing in the world of advertising, public relations, and sound bytes would have surprised Clapp.

Politics, as a celebration of the conventional, would never rest entirely easily on a circle that ruthlessly criticized it everywhere in letters. At one point, the *Tribune* noted the presence in the British cabinet of Edward George Earl Bulwer-Lytton and Benjamin Disraeli—"both poets"—to demonstrate that literary work should be no obstacle to the Democratic Congressional campaign of "General" George P. Morris. This inspired Clapp to "doubt if General Morris's poetic nature would serve as an obstacle in the way of his doing anything except, it may be, writing good poetry." When the press reported the withdrawal of the florid Victorian writer Bulwer-Lytton, Clapp noted that he was "said to have retired from society in consequence of being utterly deaf: a more likely cause would be his *not* being utterly deaf." Of another, Clapp said "he aimed at nothing and always hit the mark precisely." Of course, in hindsight, as Winter noted, a satirist, "especially one who writes 'satire with no kindness in it,' must expect to be disliked."[44]

Clapp pressed the point as the 1860 election approached, asking people to develop greater familiarity with the concerns of New York voters: "Find out—it won't take you long—all they know about Government. All they know about anything. And after that, tell us if you would trust them with the management of the most trifling affair in the world in which you took any interest. No. You wouldn't trust your dog with them. If you did, you would have to advertise it the next day as 'Lost.' And yet you propose that they shall elect your rulers and make your laws!" Without the intervention of chance, "the best the nation can hope for is some wily pettifogger, who has a flash name, talks big words about popular rights, and cares about as much for the rabble who vote for him as for so many Hottentots."[45]

Such a skepticism about the masses combined an elitist rationalization of whatever privileges bohemians might enjoy or hope to enjoy with the increasingly obvious shortcomings of the old radical faith in the capacity of the people as they are for reason and self-government. That is, it also represented

a sense of affairs at a particular time and place. More broadly, Ada Clare condemned the American approach to education, writing that "good-meaning men, whose lives have been spent in the dull unmeaning routine of some vocation of which the only aim is wealth, naturally, but foolishly, demand for their children a *practical* education." The results were institutions that sought to convey facts rather than "the method of arriving at truth."[46] The capacities of the people seemed inexorably linked to the institutions and authorities that would shape those capacities as suited their specific interests.

In short, the most seemingly elitist of bohemian commentary most directly aimed at a critique of the existing state of civilization itself. At the height of the Civil War, veteran land reformer Thomas A. Devyr brought a long document to Secretary of the Treasury Salmon Chase protesting government debt. He found himself in the office of the bohemian-turned-functionary Edmund C. Stedman, "a clever writer and somewhat of a Reformer, [who] occupied a large office in the Treasury Department." Stedman told the petitioner frankly the demands of the war meant that the government "will borrow and will have National Banks," to which Devyr asked rhetorically, "What will the people say?" At this, Stedman lost patience. "The people? If we bid them put their heads in that corner," he said, pointing to it, "til we put our foot on their necks they will do it."[47] While the unrepentant radical Devyr heard this as contempt for democratic values, Stedman likely intended it as no more than a simple statement of fact.

Bohemians believed that the merits of a civilization turned on the freedom of the individual to create, comprehend, and contribute to the wider society. Adam Gurowski's *America and Europe* praised not only "man's individuality" but Fourier's associationism, which revealed "a higher, more scientific, and therefore fuller scope and guarantee for the development of individuality, for the play of its moral, mental, and physical powers and activities." However, he wrote, as he frequently told Whitman, that, in embodying individualism, "America fills the present, throws effulgent rays into the future."[48] Such a sense of Fourierism as a kind of libertarian anticapitalism, broadly compatible with an American mainstream, suited the bohemian vision.

What Gurowski described as the enlightening influence of the American would not be perpetual. Only a few years after he wrote, the eruption of the sectional crisis cast a dark shadow across their horizons that eclipsed all such

"effulgent rays." The shrill rhetoric of the sectional conflict, the thunder of war, and the drumbeat of martial conformity left little room for "the development of individuality" in poetry, pictures, and music. Events were about to tear America's first bohemia to pieces.

CONCLUSION

Iconoclasts in Iconic Times

―⚬⚬⚬―

"All quiet along the Potomac to-night,"
 No sound save the rush of the river;
While soft falls the dew on the face of the dead,
 The picket's off duty for ever.
 —*Ethel Lynn Beers, "All Quiet Along the Potomac"
 inspired by a newspaper headline of the same title.*

If truth be the first casualty of war, those who seek their livelihood in the pursuit of truth would be advised to consider rethinking their careers. Henry Clapp resisted the dynamics of the escalating sectional tensions so persistently that Edward House complained of the "unusual carelessness and recklessness" of his "ancient" friend. "Nobody knows more surely than yourself the difference between right and wrong, truth and lies, beauty and deformity, reason and madness, white and black."[1] However, the veteran abolitionist simply could not reduce the fact of war as to something like slavery, particularly given what seemed to him to be the rank hypocrisy of the Republican and Unionist coalitions on race.

The predicament of bohemianism was part of the broader national crisis, culminating in the breakdown of electoral politics in the United States. Bohemianism made it possible to have a radical critique of society without

any compelling need for radical political action. More subtly, bohemians' flouting of convention opened the possibility for the later commercializing of sensationalism for its own sake. In the end, the first bohemian circles in American history became a direct casualty of the Civil War.

The year 1860 provided a succession of distractions. In February, the rising star of midwestern Republicanism, Abraham Lincoln arrived in Gotham, hoping to remedy the ignorance of him that prevailed in much of the Northeast. Before his scheduled speech at the Cooper Institute on February 27, the local committee took him up to Mathew Brady's studio, near Bleecker Street, at 643 Broadway, next door to Pfaff's.[2]

Clapp and his friends had more immediate problems. Their *Saturday Press* won critical acclaim but could make no money. As Walt Whitman recalled, Clapp waged through 1860 "the most heroic fight right along to keep the *Press* alive." Stories abounded of Clapp's lack of management and even of his physically hiding from creditors. He wrote Whitman at least three times in May 1860, the first through Clapp's brother George, then on his way to Boston. He was "fighting like a thousand Hussars" to establish the *Press* and at the end of the month needed a hundred dollars "before Saturday night or be in a scrap the horror of which keeps me awake o' nights." Although absent for the final scenes, Whitman thought the "generous, careful editor" had simply "tried to carry an impossible load."[3]

After his coverage of John Brown's trial and execution, House began getting assignments previously unavailable to a drama critic. Having earlier written on Asian affairs, he covered the May arrival of the first Japanese embassy in Washington for the *Tribune*. Because their hosts knew no Japanese and the ambassadors spoke no English, one of their number, the seventeen-year-old Onojirou Noriyuki (or "Tommy") served as translator by using a pidgin Dutch. As if the newcomers were not confused enough by the receptions in Washington, they were shuttled to other cities. Despite the language barrier, House spent weeks with the visitors and became quite enamored of their culture. When the "Errand-Bearers" spent five days at New York toward the end of June, it moved Whitman to write of them: "First-comers, guests, two-sworded princes, / Lesson-giving princes, leaning back in their open barouches, bare-headed, impassive, / This day they ride through Manhattan."[4] Their impact on House's future would prove to be a little less than profound.

The shadow of France fell across parts of the city in July. Elmer Ellsworth took his Chicago Zouaves on tour. "The same drill and discipline are not suited to the armies of all countries," adding that the Americans drew mostly from the English who acquired it from the Germans. "No longer of so much importance that infantry should be solid, as that the men should be active, agile and acute—that they should act intelligently and bravely, singly, in pairs, in fours, and in tens." He added that the United States had "the best raw material in the world. The average man of America makes an excellent light infantryman. He has individuality, self-reliance, quickness, familiarity with the use of weapons, and great nervous energy." Not only would House's destiny be entwined with that of the Zouaves, but the exhibition moved Fitz-James O'Brien to verse.[5]

Nor did we Yankees credit quite
Their evolutions in the fight,
But now we're very sure what they
Have done can here be done to-day,
When those before our sight deploys
The gallant corps from Illinois
 American Zouaves!

Autumn brought the young Prince of Wales, "Bertie," as his friends called him. He provided the bohemians with yet another opportunity to demonstrate that they still had some tricks up their sleeves. On October 12, the city gave him several parades and a military review, and a university official stood amid the paneled walls of an academic building and welcomed him to its "marble halls," inspiring Clapp's comment: "If he had not been told he would never have known it. In fact he did not know it after he was told." After an illuminated night procession, the prince attended an exclusive Grand Ball at the Academy of Music opposite the Unitary Household, not far from Pfaff's. In the course of this, House or one of the other reporters asked the prince if he preferred a more relaxed atmosphere. A group of them slipped over to Pfaff's, where the amused bohemians entertained their royal guest. When the *London Times* later noted criticisms of the prince's habits, one of those who "made no ceremony of conveying a piece of our mind to you"—likely Clapp—confessed to "a suspicion abroad that Your R.H. drinks." On behalf of his bohemian friends, he acknowledged both their respect for the British mind and wrote that "we should like you to acquire influence over it."[6]

Nevertheless, the November election overshadowed all these other events of the year. Clapp proposed running an Everyman, a "John Smith," for the office and mimicked publications that took the subject more seriously by listing a succession of persons allegedly mentioned as possible candidates. Along with the usual politicians, Clapp discussed various levels of support for Ned Buntline, J. August Page, various "Personnae of the *Saturday Press*," and even Lord Dundreary, a comic figure from Tom Taylor's *Our American Cousin*, the new hit over at Laura Keene's theater. He thought "the humors of the body politic are gathering to a head," and "the politicians are trying to raise an excitement, and make people believe that what they call a crisis, or something of that sort, is near at hand." Certainly, he added, political workers "have been doing a very active business in the drinking way, and have talked and swaggered more than usual." Moreover, all parties claimed that the future of the country hung on their victory, the Democrats making "illuminated exhortations to save the Union."[7]

Clapp scorned it all. One reader asked "whether the real name of the Republican candidate for the Presidency is 'Abe,' 'Abram,' 'Abraham,' 'Isaac,' or 'Jacob.'" Clapp replied:

> We have consulted the best authorities within our reach and are unable to procure any light upon the subject. All that we can find out about Mr. Lincoln is that he is sixteen feet high, and fifty-one years long; that he is as thin and angular as a split rail; that he was born a Hoosier, but finally became a Sucker; that he has been in turn a farm-laborer, a top-sawyer, a flat boatman, a counter jumper, a militia captain, a lawyer, a Presbyterian, and a politician; that he beat Douglas ... in Illinois, and drove him into the U.S. Senate; that his favorite motto is, "two shillings are better than one"; and, that he is spotless in everything but his linen.

True, the *Press* distributed the *Tribune* Republican tracts and Clapp acknowledged that "there may be a choice between the two candidates," but he thought it ultimately "not likely to be essential."[8]

Certainly, Clapp lacked the enthusiasm of youth in his evaluation of the escalating sectional conflict. Not only had Clapp lived in New Orleans, but his sister Harriet lived with her husband, James W. Hazard, in Mobile. Many of his circle in New York were southerners, albeit those who had left behind the South and its ways: Ada Clare, Edward Howland, Adah Menken, and

William Henry Hurlbert, who had attended the 1849 Peace Congress with Clapp, and returned from Paris to remain in New York.[9] While there can be no doubt as to where the loyalties of Clapp, a veteran abolitionist, lay, he could not overlook what war would mean.

Indeed, it would be mistaken to see Clapp's position as simply an abandonment of his abolitionism. To the contrary, the best explanation is that it mirrored that of the Radical Abolition Party, which sharply criticized the Republican acceptance of Democratic assumptions about the constitutional sanctioning of slavery. When House cited the hostility of the Southern political machines to the Republicans, Clapp argued: "That the South is alarmed by the action of the Republican party proves no more in its favor, as an anti-Slavery party, than would be proved in favor of a set of quacks, by the fact that their presence had produced a panic in the hospitals." He added, with genuine disgust, that "the self-styled anti-Slavery party feels so little interest in bettering the condition of the negro that it has just refused to him the poor right of suffrage."[10]

More generally, from Clapp's perspective, aspirants to office ultimately had no concerns "about the black man, or the white man, or the brown man. Their contest is nothing but a vulgar struggle for the loaves and fishes of offices." Certainly, his prediction of Washington after the Republican victory was virtually prescient as he anticipated "thousands on thousands of men, in every part of the country ... waiting with palpitating hearts to figure next year in just such a begging crowd! Men who would sooner, any one of them, live on the smallest allowance of State-pap, than earn their thousands by useful labor." Victors would have to rely on those experienced in office, and "from that moment the Republican party would be as dead as a nit." With the Radical Abolitionists, Clapp complained of office seekers who "call themselves Democrats and Republicans! And not only that, but Christians! For if they didn't smuggle Christianity into the camp they might as well give up the ghost at once."[11]

Clapp discerned a real motto of politicians beneath the pious sloganmongering: "In Gold we trust." Underestimating the significance of the Republican Party, he saw "very little difference between the two great parties." Although they called themselves Democratic and Republican, "there is no Republicanism nor Democracy about either of them, but that doesn't matter." In the end, "each of them is kept together, as some one once said of the old Whig party, 'by the cohesive power of public plunder.' ... It requires the spoils to keep any party alive." In that sense, 1860 represented simply "another

fight, to determine which shall have the privilege of plundering the country for the next four years." He continued, "If any one is inclined to join in a political struggle, the chief object of which is to feed these cormorants, we, of course, have no objection. Every one to his taste. For our part, we heartily despise the whole concern."[12]

This disaffection with politics did not end with the election of Lincoln. When Adam Gurowski sought to introduce slavery into the *Saturday Press*, Clapp reaffirmed his disinclination "to mix up in any way in the anti-Slavery discussion." House challenged him: "After declaring that for thirty years not a sensible word has been written on the subject, you go on with choice written words of your own." He wrote: "You, Ancient, have an old fame as a prominent anti-Slavery man," citing Clapp's voluminous record as an abolitionist, noting that all who knew Clapp recognized him as one "high and honored among those who 'crusaded' in the strongest anti-Slavery style." House asked whether the Republican denial of black equality should be cited "to authorize his bondage, to justify hunting him with dogs, and branding him with hot irons, and violating his wife,—or what stands for his wife in the beautiful system of the South,—and selling his children?" Clapp complained that his "best friends tried to wheedle you into voting for Abe Lincoln."[13] However, it is not clear that Clapp did not join almost all the other abolitionists among Lincoln's supporters.

The wave of election interests contributed to swamping the *Saturday Press*. The *Sunday Atlas* suggested as its epitaph: "Died of too much Bohemian twaddle." Certainly, intense political turmoil has never proved compatible with bohemianism of any sort. Years before, Clapp had told other critics of war in England that, "with all his hatred to slavery, he could not conceive anything more destructive of human freedom than the system which they that night condemned." Wrote Clapp, "The Bohemian needs no armies to force men to submit to his guidance. In fact armies are generally employed by Mrs. Grundy's favorites in trying to prevent people from loving, reverencing, and following the lead of some great Bohemian."[14]

Most immediately, war indirectly provided all the work that the physically healthy men who frequented Pfaff's might have wanted as reporters, though other opportunities could follow. In May 1861, House was at the side of Colonel Elmer Ellsworth when the latter became the first Union officer killed in the war. House and Thomas Bailey Aldrich observed the Battle of Bull Run

so closely that both were nearly captured. Based on his journalistic success, House went to Europe, where his coverage of John Heenan's fight with Tom King won a growing reputation in England. He lived with Charles Reade and associated with other bohemians, including the Irish playwright Dion Boucicault. After briefly managing the St. James Theatre in London, House got the rights to bring Boucicault's plays to the United States, assuring him of a good base income when he went to New York. After the war, House moved to Japan and became an early U.S. commentator on Asian civilization.[15]

Many war correspondents who had spent time in New York had passed through Pfaff's and Clapp's circle. A writer for *Putnam's*, William Swinton went to the seat of war for the *Times* and became so conversant in military matters that his discussions of them incurred the displeasure of General Grant. Others included Charles Henry Webb, William Conant Church, Joseph Howard Jr., Mortimer Thomson, Edmund Clarence Stedman, and Junius Henri Browne, who knew enough about the bohemians to have likely been one himself. Albert Leighton Rawson's engravings indicate that he may have done some war coverage as well. The work of humorist Ossian Euclid Dodge—among the "occasional callers" at Pfaff's—entertained the nation, as did that of Charles Farrar Browne, as "Artemus Ward."[16]

Fitz-James O'Brien and Aldrich applied to work on General Frederick Landers's staff. The army selected Aldrich, but he was out of town, so O'Brien went to the front. Confederates ambushed him with a small reconnaissance force of cavalry and demanded their surrender on February 15, 1862. O'Brien rode forward with his revolver and shot "the foremost rebel" from his saddle, even as he himself was wounded. When the news reached Pfaff's, Clapp commented that O'Brien had been wounded in Aldrich's shoulder, but the wound took O'Brien's life on April 6. Lawrence P. Barrett, who had studied under Edmund Kean, also took a commission. "After distinguishing himself on the battlefield, he resumed his profession with Edwin Booth. A. F. Banks, another bohemian, was elsewhere described as "late of the army."[17]

Those who remained at Pfaff's clung to their peacetime mugs, but surely felt the familiar world slipping away around them. George McWatters had raised money to assist the beleaguered Free Staters in Kansas and organized the Patriotic Association of Metropolitan Police to assist the families of soldiers. When the war broke out, he found himself again at odds with Mayor Fernando Wood, whose response to the secession crisis had been to suggest that New York City might secede and declare itself a "free city" did nothing

to constrain commerce with the new Confederacy. On May 12, 1861, Officer Mac acted on his own responsibility to seize artillery bound for Georgia from a North River pier. In July 1863, he faced combat, as one of a small band of policemen who defended the newspaper offices down town during the draft riots." When some of the rioters entered the *Tribune* and started a fire, a number of the police assaulted the building. Officer McWatters, on entering the door, was assaulted by a burly ruffian, armed with a hay-rung, who, by a powerful blow on the shoulder, knocked him down; instantly on his feet again, he more than repaid on the heads of the riots the blow." They cleared the *Tribune* "speedily."[18]

Clapp and Ada Clare found work writing on cultural questions for the *New York Leader*, a Democratic weekly edited by John Clancy and Charles G. Halpine, "Miles O'Reilly." Clapp also wrote for *Vanity Fair*, edited by his friend Browne as "Artemus Ward." Among the newcomers to Pfaff's in the war years was Georges Clemenceau, later the premier of France during the First World War.[19] However, the story of the war eclipsed appreciation for clever and humorous writings.

The war—with its interest in simplistic patriotic verse—assaulted the bohemians' sensibilities. Robert H. Newell collected "The Rejected 'National Anthems,'" and *Vanity Fair* had its own offering, "A Hint to Poets: Showing How to Make a War Song." It began

The air is glad with bannered life
 And gay with pomp of stripes and stars!
(Here, for the rhyme, you'll mention "strife,"
 And happily allude to "Mars.")
A nation musters to the field,
 Truth to maintain and wrong to right!
(Here promise that the foe shall yield,
 And promise it with all your might.)

This Tin Pan Alley process showed that poetry, like truth, could become a casualty of the war.[20]

Indeed, some bohemians responded to this new radical interest in such things military with satire. As troubles reemerged in Italy during 1860, Hugh Forbes returned to that country, as did many hopeful émigrés, perhaps contributing something to George Arnold's series of spoofs as "McArone," a fictional

comrade of Garibaldi. The self-lionizing letters of this would-be hero and salesman of martial honor regularly recounted fights from which he "emerged from the fray, covered with mud, blood, and glory." In his case, severed limbs regenerated themselves, and in these battles, Zouaves "progressed with a series of back hand-springs firing and loading as they went." By spring of 1861, "McArone" returned to the United States and began covering the war here. So, too, Newell's fictional Mackerel Brigade mocked the phony romanticism and self-serving patriotism of wartime public life. He wrote under the pen name "Orpheus C. Kerr," which echoed Clapp's forebodings about the legions of office seekers inspired by "the flesh-pots" of Washington.[21]

Yet, bohemians themselves became logical choices to produce the literary weapons of war and to staff the offices of a rapidly expanding federal government. After his stint as a war correspondent, Edmund Clarence Stedman joined the wartime civil service in Washington, a prelude to his abandonment of journalism for a seat on the stock exchange. John Swinton wrote Whitman that being in Washington working on the war effort was "even more refreshing than to sit by Pfaff's privy and eat sweet-breads and drink coffee, and listen to the intolerable wit of the crack-brains." William D. O'Connor reported that he was drilling every day for an hour after work in the capital. There, he encountered Count Gurowski, applying his skills in more than a dozen languages in the State Department. Most famously, Whitman came to Washington after his brother George was wounded, soon found himself caring for the hospitalized soldiers in and around the capital, and got a government office that permitted him to continue such work.[22]

Wartime culture expanded the demand for entertainment, which hastened the assent of celebrity. As Adah Isaacs Menken's third marriage, to the boxer Heenan, began disintegrating, both appeared in public with black eyes, and some of her friends at Pfaff's began fearing for her safety. Heenan moved out and refused to pay her rent, resulting in her July eviction and an October lawsuit, in which his lawyer countered with an assertion that the marriage had not been legal. Driven to take a small furnished room in Jersey City, she plunged deeper into despair and actually wrote her suicide note on December 29, though she thought better of it and set it aside to reinvent herself.[23]

The bohemian rejection of the conventional eased the way for her new course to fame and success. As the war erupted in April 1861, "the Menken" got the strange offer to play the male role of Mazeppa, a Polish noble whose story Voltaire had popularized in his *History of Charles XII, King of Sweden*.

Mazeppa, a minor court figure had an affair with a wife of another nobleman, who arranged to have him tied, naked, to the back of a wild horse and sent into the wilderness—where peasants found him half-starved and nursed him back to health. After Lord Byron turned the tale into a poem, various playwrights took up the challenge of transferring it to the stage. After a trial run of her performance in Albany, the New York producers braced for its reception in Manhattan on June 13, 1861. Whitman and others joined her at Pfaff's, where Edwin Booth, Ada Clare, and Fitz-James O'Brien stopped by the table.[24]

Menken's remarkable performance is inseparable from the dislocations and disruptions of war, the appearance of sex shows along Mercer Street, and the bringing of such commercialized sensuality to the respectable stage. It involved her stripping on stage to an approximated nudity that was no less shocking for the fact that she was playing a male role. She used a black velvet cloak to accentuate the flesh-colored tights that hid little of her form and came close enough to skin to entice the willing and offend the rest. She was tied to an actual horse for a precarious ride, elevating her figure ever higher above the stage over ramps and scaffolds before she disappeared into the wing near the top of the stage. A brilliant horsewoman from youth, she trained the stunning black mare that behaved beautifully. The crowd invariably roared its approval. The first New York City performance ended with a curtain call that found Menken so nervous that Booth clambered onto the stage to calm her briefly before leaving her to her adoring audience.[25]

In the wake of this stunning performance, Adah Isaacs Menken came into her own. Newell, Whitman, O'Brien, and others whisked her off to Pfaff's, where no less a personage than Horace Greeley came by to acknowledge her triumph. An instant hit, the role took her on the road, back to Cincinnati and beyond, to St. Louis. To her credit, she performed other roles, did dramatic readings, and even impersonations. In September 1862, Newell coaxed her into a fourth marriage, which lasted less than a week and ended with her escape from a locked room. Rawson recalled her continued wartime attendance at Pfaff's when she was in town, and her later "rare-ripe, volume of poems," *Infelicia*.[26] Adah Isaacs Menken's showy bravado won her a fame denied the quiet literary talents of Ada Clare, for whom theatrical achievement proved so difficult.

The stage also permitted Charles Farrar Browne to grow beyond writing. At the time *Vanity Fair* was going under, in the summer of 1863, the local

press had become "very much exercised over a foolish humbug," a "Twenty-seventh-Street Ghost," and Charles Farrar Browne decided to give a "lecture" on the subject as Artemus Ward. He rehearsed about half of it at Pfaff's, "and for three-quarters of an hour the party was, literally, in a roar." The performance, at Niblo's, netted $4,200. Later that summer, Browne got a telegraph asking, "What will you take for forty nights in California?" "Brandy and soda," quipped Clapp. Browne used the answer and became a legend in the west before he arrived.[27]

California also seduced Jane McElhenney, "Ada Clare." Cut off from her family and her inheritance in South Carolina, she was left in dire straits by the war. Although she picked up some newspaper work, she left for San Francisco early in 1864. There, she began writing for the *Golden Era* and later the *San Francisco Bulletin*. She wrote a notable series of letters to the latter describing her visit to Hawaii. After an unsuccessful appearance in a production of *Camille* in December 1864, she returned to New York but remained eager to find an opportunity on the stage.[28]

Others also went afield. The gentlemen's agreements between Max Maretzek, Maurice Strakosch, and Bernard Ullmann broke down. Strakosch and Ullmann headed for Europe, leaving Maretzek the master of New York–based American opera. The Howlands went overseas, as did painters like George Henry Boughton, and Bayard Taylor accepted a diplomatic appointment to St. Petersburg. Back home, Maretzek spread his tiny organization thin over a broad field of operations, finding himself eventually with a touring company stranded far from the bright lights of Manhattan, in a Mexican town caught between the French and Juaristas.[29]

Back in New York City, some bohemians made an ill-fated attempt to revive the milieu in 1864 and 1865. Richard Henry Stoddard, Dick Hinton, Frank Ottarson—now a federal officeholder—got together with some other old Pfaffians to launch the *Round Table*. Mirroring the trend within the radical tradition, they sought to define their effort in terms of the shortcomings of their predecessors, while Clapp dismissed them as "bogus Bohemians" in search of respectability.[30] Regardless of which view was nearer correct, the *Round Table* failed as surely as had the *Saturday Press*.

The complexities of Orsini's legacy reemerged to haunt republicanism of all stripes. On April 14, President and Mrs. Lincoln escaped from the onerous duties of the White House to see *Our American Cousin*, then showing at the Ford Theatre. Act III was under way when, behind the party, the

actor John Wilkes Booth, who was loosely associated with the informal network of Confederate spies and saboteurs operating out of Montreal, run by George N. Sanders. After the character of Mrs. Mountchessington told Asa Trenchard—the upstart American cousin "you are not used to the manners of good society, and that, alone, will excuse the impertinence of which you have been guilty," Trenchard replied, "Don't know the manners of good society, eh? Well, I guess I know enough to turn you inside out, old gal, you sockdologizing old mantrap!" Waiting for the predictably loud laugh, Booth moved quietly forward and fired into the back of the president's head at nearly point-blank range, leaped from the box to the stage, and made his getaway even as Mrs. Lincoln's scream alerted the theater.

Laura Keene, by all accounts, possessed the coolest head in the theater. She moved to the front of the stage, asked for a doctor, and urged everyone to stay where they were until the president would be moved out. With Mrs. Lincoln in hysterics, Keene cradled the president's head as the physicians diagnosed the wound. Her daughter, the wife of Albert L. Rawson, kept the bloodied dress for years. Further bohemian contributions, among them Whitman's "O Captain! My Captain!" and "When Lilacs Last in the Dooryard Bloomed" articulated a national grief.

The war's end brought serious efforts to revive what had been lost. Some continued to follow the example of Browne or Howells, moving to the great metropolis and seeking out Pfaff's. Charles G. Halpine, "Miles O'Reilly," a friend of O'Brien, had been in the army with him but resigned and turned to writing. After the war, new faces turned up occasionally at Pfaff's, including Henry W. Shaw ("Josh Billings"), and Samuel L. Clemens ("Mark Twain").[31]

Clapp decided to make another attempt at running a newspaper. In August 1865, he, Arnold, Charles Farrar Browne, Charles Pfaff, and others restarted the *Saturday Press*. Clapp noted: "This paper was stopped in 1860, for want of means; it is now started again for the same reason." The new *Saturday Press* functioned out of 64 Nassau Street and cost six cents a copy or three dollars a year for twelve pages of three columns. Though the *Press* was "neither old enough nor weak enough to require a staff," S. D. Shanly joined the group, which could do little more than to keep the paper limping along. It was in this strange aftermath that the collective memory of the antebellum experience was cast, in part consciously. Plugging his famous hangout, Clapp wrote, of Pfaff's: "This famous Bohemian resort has recently been improved by the

addition of a large garden and a 'beautiful landscape,' designed by the artists of a neighboring theatre. A wag wrote upon the walls of the establishment, the other day, 'C. Pfaff and die!'"³²

Nevertheless, Arnold seems never to have recovered from the disappointments of the war years. After a last poetic homage to "Beer," he "slipped out of the World which had been much and little to him, and left behind him many sincere mourners who speak of him still with words of love and moistened eyes." His death on November 9, 1865, kicked the *Saturday Press* into a limp less than three months after its revival. Arnold's early death, at the age of thirty-three, added to those of Henry W. Herbert; William North; O'Brien, killed in the war; the actor William H. Reynolds, drowned at Keyport in 1863; and others.³³

Moreover, after Arnold's death, the mortality list grew quickly. Thomas Hanlon, the eldest of the gymnastic brothers had survived some bad falls, but his accident in Cincinnati in August 1865 resulted in severe head damage and a gradual descent to death three years later. Count Gurowski died in the spring of 1866, of typhoid fever in Washington. Mostly because of his entertaining lectures, Charles Farrar Browne as Artemus Ward had gained, by his death in 1867, a net worth of almost $100,000, enough to support his aged mother and, after her death, found an asylum for old and disabled printers. Perhaps most notoriously, Adah Isaacs Menken toured Europe, having much publicized dalliances with various prominent figures, including the aged Alexandre Dumas, before her health failed and she died in 1868 in Paris. Charles B. Seymour attended the Paris Exposition in 1868 and died the following spring.³⁴ The cultural triumph of hard-nosed money-making over romanticism ascribed each such death to the innate moral failings of bohemianism.

After *Vanity Fair* and the *Leader*—and the second failure of the *Saturday Press*—Clapp became "a casual writer for City journals," but "merely a contributor, and had no regular journalistic standing." Writing as "Figaro" on the theater, he "afforded amusement to the town; but gradually he drifted into penury." By 1870, the old socialist retired to a New Jersey farm, and Whitman's notebook gave Clapp's address as "Phalanx, Red Bank, N.J.," the old Fourierist community of the Arnold clan. However, he had already begun to take some solace in drink, as he continued to sink into his pessimism about the American people, politics, and letters. Rawson reported that Clapp's "great enemy was King Alcohol, and he was too strong for the king of the bohemians." "Poor fellow," said Whitman of Clapp, "he died in the gutter—

drink—drink—took him down, down." Pfaff fed him for years in gratitude for his services to him and his saloon."[35]

Yet, Clapp's demise was not so simple. A former municipal officer got him admitted into the newly established State Inebriate Asylum at Binghamton. At the time, the massive new structure had ten wards of twenty-two rooms each, a spacious dining hall, a reading room, lecture hall, three parlors, bowling alleys, a billiard room. It cost $20 a week, payable at least three months in advance for up to a year's treatment. Almost immediately, the institution was swamped with applicants, and its attempted cures enjoyed some much touted successes.[36]

At times, Clapp seemed to have become one of these successes. By mid-1867, he had a good-paying job as clerk of a New York court, and the following year he became the assistant assessor of Internal Revenue in the city. At the 1868 New York Press Club reception for Charles Dickens, Clapp was in particularly good form; one participant commented on the "great keenness of mind" of the old bohemian, "who said some things worthy of Rivarol or any other wittiest Frenchmen we might choose to select." O'Connor wrote Whitman at one point that he had met a well-dressed and sober Clapp and added jokingly that Clapp seemed to have become "a respectable citizen," headed for "the guilty result of Bohemianism, a place on the Common Council or Board of Alderman!"[37]

The New York Press Club meeting for Dickens also contributed an important legacy of early bohemianism. The club barred women from the gathering, an insult that moved Franklin J. Ottarson's wife, "a very bright little woman," to propose that the female reporters form their own club. Joining her were Jane Croly—the wife of David G. Croly—and Ella M. Clymer, who had come to New York from the former socialist community at New Harmony.[38] Through their new sisterly order, "Sorosis," the shadow of bohemianism grew longer.

Surely remembered by these women, despite her absence, was the pioneering Ada Clare. After her brief appearance on the wartime California stage, Clare seems to have disappeared, though she turned up working in a Galveston theater and married its manager, Frank Noyes, who readily adopted her son, Aubrey, as his own. Noyes, however, seems to have not lived long, because she soon toured the South as "Agnes Stanfield" and even took the stage in *East Lynne* at Rochester, New York. While there, she visited an old friend who had a small lap dog. When she pet the dog, it bit her on the nose. Whitman later told Horace Traubel that "from this, or from the

worry of it, resulted hydrophobia—or what passes for it. (The doctors still debate it, as they debated it then: was it not altogether a fiction? And in the meantime people die of it right along!)" Beautiful, charming and tragic, she died March 4, 1874. Her old friend Marie Stephens Case Howland took in the teenaged Aubrey, who later married Howland's niece.[39]

Clapp died on April 10, 1875, a bit more than a year after Ada Clare. The *New York Times* said that he had died, "neither old nor young—about the beginning of a natural decline." That fall, McWatters gathered a committee to move Clapp's remains back to Nantucket. William Winter and George H. Butler participated, and Charles Delmonico, who boasted the most famous and profitable restaurant in the city, contributed to the effort. "At the request of a few friends," Winter wrote a touching epitaph.

Wit stops to grieve and laughter stops to sigh
That so much wit and laughter e'er could die;
But Pity, conscious of its anguish past,
Is glad this tortur'd spirit rests at last.
His purpose, thought, and goodness ran to waste,
He made a happiness he could not taste:
Mirth could not help him, talent could not save:
Through cloud and storm he drifted to the grave.
Ah, give his memory,—who made the cheer,
And gave so many smiles,—a single tear!

Because the lines were "not approved by his only relative then living, and therefore not inscribed over his ashes," the gravestone held only a simple memorial to Henry Clapp as a "journalist, satirist, orator—'Figaro.'"[40]

Already, some of that old circle that had so tormented Mayor Fernando Wood had helped to topple "Boss" Tweed, winning an appreciation that had always eluded Clapp and many of his friends. Thomas Nast's cartoons severely weakened Tweed's hold on the city's power structure by teaching the public to laugh at power. Franklin Ottarson provided a congressional committee with ample evidence of voting fraud under New York's Tweed Ring, and died in 1884 at seventy-five "in a very feeble condition brought on by hard work and irregular habits."[41]

Officer McWatters assisted in this work against Tweed, as he had against Wood. In mid-July 1866, he came to public attention when he saved a tugboat engineer who had tried to protect a woman from "insult" by an ex–school

trustee accompanied by "a number of Fourth Ward ruffians." The following year, he established the Lost Children's Bureau and became the unofficial theater critic. In a world with no social services, he organized advice and relief for the families of hundreds of veterans, and Ralph Waldo Emerson boasted of the work of this "private policeman" in exposing the abuse of veterans by private claims agents. On racial issues, he wrote, "We old Abolitionists ought to feel that our work is not yet finished." His activities for the Republican Party resulted in the appointment of the "old rosy-cheeked, white-headed police officer" to the New York Custom House in October 1870, where the English cooperationist George Jacob Holyoake met him a few years later. He also began publishing true detective stories. After a remarkable career of good works, McWatters succumbed to pneumonia in 1886.[42]

At that point in American history, respectability did not yet require a rejection of radicalism. Edward and Marie Howland returned to the city after the war, helped organize a new Society of the Solidarity, loosely allied with the International Workingmen's Association. After moving to a cozy home in an atmosphere of several thousand choice books at Hammonton, New Jersey, the couple kept its ties to Victoria Woodhull and the American Internationalists and became active in the new agriculture Grange movement. Years later, they planned a new socialist community at Topolobampo, Sinaloa, in Mexico. Edward died there in 1890, and Marie eventually settled at the Fairhope Single Tax Colony in Alabama.[43]

Clapp's old friend Whitman remained the most famous of the old bohemians. In 1877 he met a Canadian psychiatrist and author, Richard Maurice Bucke, who would become his personal physician, close friend, and sanctioned literary executor. By the 1881 seventh edition of *Leaves of Grass*, the collection of poetry was quite large, and did well enough to allow Whitman to purchase a home in Camden, New Jersey. After a long and very well-documented old age, he died on March 26, 1892.

John Swinton provides an example of such continuity within the city itself. After serving as the managing editor of the *New York Times* at the close of the war, he moved to the *New York Sun*, leaving that position in 1883 to run *John Swinton's Paper*, which lasted into 1887. In 1894, Swinton wrote a book-length defense of Eugene V. Debs and the Pullman workers: *Striking for Life: Labor's Side of the Labor Question*, republished the following year as *A Momentous Question: The Respective Attitudes of Labor and Capital*. None of this would have surprised any of his old friends seated around the long table in Pfaff's cellar.

By the later years of the century, a new generation had taken up bohemianism. New issues generated different conflicts, but the new bohemians faced similar frustrations that inspired analogous reactions. Since then, the disaffected creative mind has been a continual presence in American life under many labels, among them "avant garde," "beat," "hippie," "goth," or "hip-hop." Indeed, the continual, repeated claims of novelty are themselves a consistent part of the experience.

A goodly number of those who then flitted about the artistic and literary circles of Greenwich Village, its environs, and similar locations elsewhere in the country were overtly radical. For example, Charles Sotheran, Sergei Shevitch, and his wife, Helena Von Racowitza, remained unapologetic labor radicals, as did Boston's John Boyle O'Reilly, who poetically praised life "In Bohemia."[44] Nevertheless, in some quarters, the tint of radicalism had become little more than part of the youthful pose, and in others it was dispensed with entirely.

Sitting at the table in Pfaff's, Henry Clapp used to reminisce about his political work. The ideas of Charles Fourier had already inspired dozens of American socialist communities, which had functioned with varying degrees of viability and success before being overwhelmed by the laws of supply and demand. Socialists, in turn, experimented with new kinds of communities, such as Modern Times, and with cooperatives of all sorts that sought to reach beyond the ethos of the dominant capitalist order without having to physically leave their cities and homes. To inform this experimentation, Clapp labored on a translation of Fourier's key writings. At one point during a late-night session, Albert Brisbane, the editor, fell asleep, but with one eye fluttering open and disconcertingly fixing on Clapp. Brisbane, it turned out, had a glass eye, the result of a childhood accident.[45] Having quite literally had a blind eye turned toward him, Clapp not only accepted the idea of translating socialism into land reform and abolitionist politics but also took it on himself to translate the impulse into a cultural expression.

As elsewhere in the western world, specific circumstances made such a development possible. Wealth had supplanted inherited nobility as a source of power, only to prove itself largely inherited and unequal. The convergence of leisure, prosperity, and mass culture opened not only a space but a time for utopian values. The players and makers of music—from the vaudevillian to the operatic—discovered Pfaff's, followed by the theater critics and

playwrights, actors and actresses, as well as theater managers and owners. Those who made their living by the pen followed by the legion, joined a range of visual artists from the engravers, who illustrated writings, to serious landscape painters. That particular period in the history of western societies allowed for a creativity that challenged wealth and power, which had not yet learned just how thoroughly purchasable creativity could be.

The social order responded to bohemianism with no less hostility. Its critics—often Gotham's practically minded businessmen, clergymen, lawyers, and editors—said that the bohemian adulation of creativity sufficed to excuse the failure to produce anything or to not seek and take regular employment. As a group, though, bohemians did not embrace an impoverished vagrancy but tolerated it as a means to a possible end. That they did so in a society defined by what they saw as a slavish devotion to upward mobility and material success showed both a measure of their commitment to the integrity of creative pursuits and the depths of their alienation from the structures and standards of the new capitalist civilization.

Defenders of middle-class respectability easily conflated the temporary and self-absorbed nature of the bohemian life with the idea of adolescent rebelliousness. This comforting trivialization blanketed the reality that many promising and memorable writers, poets, artists, and musicians died without ever having grown out of their bohemian lives. Indeed, many did so when quite young.

This caricature of bohemianism required dismissing the older bohemians as people whose work did not merit success. It implicitly embraced the fiction of an ultimately meritocratic marketplace. Academic students of bohemianism, successful enough to be able to choose their own work, even to an area of research, also tend to be unsympathetic to the less successful. One scholar thought what contemporaries said on the subject "more bordered on slander rather than rational criticism," but he seemed to accept the pretenses of "the unseen, ravenous beast in Bohemia." That is, failures or suicides were not seen as being "destroyed by Bohemia" rather than being casualties of the marketplace.[46]

The instinctive responses of the status quo certainly included gross misrepresentation, almost from the inception. Bohemians objected to the subjugation of sex to market relations, which a commercial information industry transposed into a "free love." While circumstantial evidence indicates that the bohemians themselves had a hand in the process, it coaxed Mayor Fernando Wood's administration into an action that gave the new Republican

Party a decisive window of opportunity in the largest city in the Union.⁴⁷ The tendency to intimidate, dismiss or domesticate bohemianism further identified it as part and parcel of a range of reform currents that inspired the "other Republicans."

Bohemians made it very easy for themselves to be misrepresented. Some of this was surely their exuberant unconcern at their outcast status, but bohemian delight at tweaking public prejudices contributed as well. The Secret Society, or League, sponsored by Andrews, Brisbane, and the radicals had hardly even implied anything more serious and menacing than the Ornithorhynhus circle or "the Elephant Club," but Clapp's hint of a dark conspiratorial secret society with no officers, agenda, or program lurking behind all the fun was intended to cause the minders of Mrs. Grundy no end of concern.

Still, the evolving structure of power—political as well as economic—tended to favor the larger and wealthier concerns, resulting in an increasingly uniform currency of value and values. At the same time, the ever more complex and expanding nature of capitalism increasingly required appealing simultaneously to a polymorphous consumer public. The former minimizes political expressions of dissent, while the latter requires discontent and diversity. The paradox fosters novelty, while it ceaselessly strives to domesticate that novelty into something marketable.

Initially, while the relationship between bohemianism and Republicanism varied somewhat with the individual, the same economic, social, and political changes that created bohemianism also shaped a crisis so fundamental that it threatened the survival of the nation. The synchronicity of their development was no coincidence. Conversely, the resolution of that crisis—the rise of Republicanism, the election of 1860, and the outbreak of hostilities—destroyed bohemianism, even as it dissolved Fourierism, socialism, and almost all of the remaining social experiments. The Unitary Household crumbled in the frenzy of activities leading to the election, and the less centralized Modern Times community limped into the war but did not survive it.⁴⁸

So, too, by the end, many proponents of Republicanism and wartime unionism found that these fell short of their expectations. Alvan Earl Bovay in Ripon, Wisconsin, launched the first local meetings for a third-party movement in response to the Kansas-Nebraska Act of February 1854, Donald Campbell Henderson promoted its first state organization in Michigan, and Horace Greeley publicized the name: Republican Party. Abolitionists, land reformers, socialists, women's suffragists, and émigré revolutionaries had

been marginal enough to initiate something new, but too marginal to resist its expropriation in the interests of the same profit-centered system that had established and rationalized the preservation of slavery as an obligation of government to money-making enterprises. Republicanism proved useful to eliminate slavery but also to extend that rationalization to where, as several U.S. presidents subsequently explained, the business of America is business. Bovay, Henderson, and Greeley no more had that in mind than had Wright, Andrews, and Underhill.

Underlying this dismissive stance are the assumptions about human nature. Failing to ask why capitalism is not compatible with personal creativity, it breathes the idea of a divinely ordained "human nature"—like a soul—into a social order, the institutions of which were often described in a more reflective age as "soulless" creations of human interactions.

From the perspective of a reactionary such as James Gordon Bennett of the *New York Herald*, their similarity would just as surely doom the Republican effort to remake the nation. Bennett saw the social critiques of European radicals such as Pierre-Joseph Proudhon as an attempt "to assail the rights of capitalists and property owners in the North, as the anti-slavery fanatics have assailed the rights of the slaveowners in the South." If consistent, the Republican assault on "the right of property in the Southern States" in the interest of blacks would lead to radicals agitating workers in the North "to sack our cities. Fanaticism and folly, having satiated themselves upon the abolition question, must seek fresh fields and pastures new. But there is no greater or more dangerous absurdity than this attempt to alter the laws of commerce to suit the whims of a few dissatisfied abstractionists, who are always wandering about to search of something to 'reform.'"[49] An explanation of this requires no recourse to Mrs. Grundy's original sin or the old bugaboo of "human nature."

Faced with unprecedented opportunities, a booming market economy balks at nothing that might provide it with an immediate advantage in its drive to maximize its profitability. In the rapidity of its growth and expansion, capitalism assimilated everything that might assist it, expropriating to its own purposes every innovation that could be incorporated into the profit mill. This reality bent the course of Republicanism or Fourierism or bohemianism, shaping results unintended by its proponents.

For this reason, early socialism—and its bohemian variants—made unintentional contribuitions to the emergence of American capitalism. There was the utopian drive to escape the competitive madhouse of the market

economy. Bohemia—the very name borrowed from a specific location—represented the ultimate transcendence of what scholars have discussed as a "spatial utopianism." Even as Modern Times transformed from a socialist community into a pragmatic collection of individualists up the Long Island Railroad, the old ideas inspired cooperative Protective Unions or Unitary Households within the metropolitan complex itself.

There certainly seemed to be no reason why the marketplace could not offer a time and place to escape the competitive madhouse of the market economy. Underhill's utopianism ended in beach cottages on Nantucket Island, the Howlands' at Hammonton near the New Jersey shore. At Pfaff's, utopia became no larger than one's place on the bench and those with whom you were holding temporary communion. However, bohemians carried the ethos where they went: the librarian at the new Astor Library at Lafayette and Eighth streets recalled Clapp, Arnold, Wood, O' Brien, Mullen, "and many others of the guild" as "a much-abused and unjustly-stigmatized class of young writers," who were "all of them genial and kindhearted companions, and brilliant intellects."[50]

It is a commonplace observation apparent in the current evolution of the modern American metropolis. College students and various bohemian types may prefer concentrating in particular neighborhoods, but any success they achieve in carving out a livable niche in a capitalist city eventually paves the way for real-estate speculators, development, gentrification, and their own displacement. The process may be predicated on an expanding economy, but this has been the case periodically enough for it to have happened repeatedly for generations. The market consumes and draws nourishment from its critics very effectively.

The kind of dynamic market capitalism America experienced in the mid-nineteenth century systematically digested practices intended as alternatives. The successful cooperative, by definition, must become competitive and become the joint stock company. Abolitionist, atheist, and land reformer Elizur Wright produced actuarial tables for the purposes of mutual aid to extend cooperative measures to establish security for workers, but with his workable actuarial tables, he inadvertently made himself "the father of life insurance" in the United States.[51]

The struggle for language and spelling reform by such figures as Stephen Pearl Andrews or Elias Longley and his sons in Cincinnati also produced a saleable product. The development of phonography, the use of writing to

express sounds, among these utopians perfected stenography and shorthand. These became essential recordkeeping tools of American business and the civilization it built.

While friends fondly recalled the radicalism of Ned Underhill with his "red-haired and rather young wife named Evelyn," he was surely most widely known and remembered for his contribution to stenographic reporting and his 1880 *Handbook of Instruction for the Type-Writer*.[52] Underhill's exploration of the optimal technique in using the new typewriter went beyond the hunt-and-peck approach to establishing the rudiments of ten-fingered typing, permitting speed with accuracy.

The ability of the market economy also extended to efforts to seeking a temporal refuge from the tensions of capitalist civilization. On one level, Pfaff's itself came to represent a practical refuge of fellowship from the cutthroat competition of the workaday world in a few regularly stolen hours at the close of the day. So, too, the emergence of Christmas with its utopian language owed much to Thomas Nast, whose cartoons Americanized Father Christmas or Saint Nicholas, as well as subverted the Tweed Ring.[53] Under the patronage of this secularized saint, Christmas was to be a holiday that temporarily set aside the ongoing celebration of selfishness, in which everyone could share ... for a price.

Overt gloating over the domestication of cultural dissent began very quickly. Not long after Clapp's death, Junius Henri Browne wrote that bohemianism survived "without the distinguishing name or any organization, but better, and higher, and freer, and purer, it exists, and does good, though it may be invisible, work." He declared respectable, pleasant, and sweet professionals "Bohemians in the best sense," as opposed to those "of the pseudo-Bohemian class." The former, wrote Browne, "are found in the pulpit, on the bench, on the tripod; and every day they are increasing the area of Thought, the breadth of Charity, the depth of Love."[54] When all else failed, the old order subjugated bohemianism by declaring it respectable, just as the smiling nineteenth-century monarch declares himself a republican or the twentieth-century monopolist a democrat.

Respectable or not, later "bohemianism" was never really the same, because the context had changed so completely. Ignoring this defining consideration, even sympathetic looks at bohemianism rely on reading the present into the past. In the wake of the First World War, the early historian of bohemianism Alfred Parry asserted that Fitz-James O'Brien had no real unionist sentiments

when he immersed himself in the war effort, fought, and died in Virginia. However, O'Brien and the circle at Pfaff's generally left an ample record of a deep dedication to the cause for which he gave his life.

Most fundamentally, bohemianism demonstrated how those unintended contributions extended to attitudes and ideas as well. The socialists rejected capitalist economics and politics and suggested alternatives, and the bohemians shared the rejection of the status quo but also remained skeptical of all of it. "In all the other emergencies of life," Clapp wrote, "you do put your trust in the wisest man; whereas in government you put your faith, as a rule, in the foolishest man,—such an one, for instance, as Franklin Pierce, or James Buchanan, neither of whom is fit to govern a henroost." In contrast, the father of the Democratic Party, Andrew Jackson, had been primarily a soldier, and "the soldier, like the sailor, knows that Democracy is a humbug. In truth we all know it." He added that "a political party based on the principles that the majority have a right to govern, must necessarily pander to the vices of the multitude, and in the end becomes despicable as an organized band of vagrants, pickpockets, and pimps."[55]

Capitalist values conscripted such skepticism, placed it into the uniform of cynicism, and trained it as a reserve force capable of repulsing any and all serious efforts to change the world. The original bohemians no more intended this than Wright, Andrews, Longley, or Underhill sought to find ways to make possible a more scientific management of work and its remuneration or than Bovay, Henderson, or Greeley hoped to create an unchecked and unquestionable control of business over the political system. When a thoughtful skepticism veers into sweeping cynicism, it actually turns bohemianism inside out in the interest of Mrs. Grundy's faith in the permanent and divinely ordained nature of transient human conditions.

One suspects that Henry Clapp would look with some pity on those who did not understand this, just as he repudiated those who hoped to build coherence and order from his rebellion. "The world is too serious by half," he wrote, believing "this 'rush of brains to the head' will be the death of it." He asked, "What is there as stupid and solemn as man in all God's creation? What is there here on the earth, or up yonder in the skies, to be so mighty solemn about? Nature herself is half the time on the broad grin. She laughs at us even through her tears."[56] Clapp would also take heart in the hope that others, long after his death, would share the laughter and the tears.

Notes

Introduction

1. Clapp's "New Portrait of Paris: Painted from Life," *Saturday Press*, Nov. 13, 1858, 1. Clapp's fascinating but sadly disjointed reminiscence appeared under this title serially in his *Saturday Press*, Nov. 13, 1858, to Jan. 8, 1859, specifically: Nov. 13, 1 (chaps. 1–3), Nov. 20, 1 (chap. 4), Nov. 20, 1 (chap. 4–5), Nov. 27, 1 (chap. 6), Nov. 27, 1 and Dec. 4, 1 (chap. 7), Dec. 11, 1 and Dec. 18, 1 (chap. 8), Dec. 25, 1–2 (chap. 9), Jan. 1, 1 (chap. 10), and Jan. 8, 1 (chaps. 11–12). One gets the impression that Clapp did not have the time to write such a portrait and may have grown bored with the project himself after undertaking it. In these accounts, he takes until chapter 5 to reach Paris and spends chapters 5 through 8 on his first hours in the city. His final installment begins: "I have thus far described only a few incidents of my first day in Paris." It ends with a notice that it would be continued, but it is not. Clapp, "New Portrait of Paris," Jan. 8, 1859, 1.

2. "The Queen of Bohemia" [from New York correspondence of the *Philadelphia Dispatch*], *Saturday Press*, Nov. 10, 1860, 1.

3. Eugene T. Lalor, "The Literary Bohemians of New York City in the Mid-Nineteenth Century" (Ph.D. diss., St. John's Univ., New York, 1976), 357.

1. The King of Bohemia

Epigraph from Allen Churchill, *The Improper Bohemians* (New York: E. P. Dutton, 1959), 25.

1. Lalor, "Literary Bohemians," 70, with a chapter on Clapp, 70–128. For general biographical notices, see *The National Cyclopaedia of American Biography*, 50 vols. (New York: James T. White & Co., 1899), 9:121; James D. Hart, *The Oxford Companion to American Literature* 6th ed. (New York: Oxford Univ. Press, 1995); Stanley J. Kunitz and Howard Haycraft, eds. *American Authors, 1600–1900: A Biographical Dictionary of American Literature,* (New York: H. W. Wilson, 1938); W. J. Burke and Will D. Howe, *American Authors and Books: 1640 to the Present Day,* ed. by Irving Weiss and Anne Weiss, 3d rev. ed. (New York: Crown, 1972); "American Literature," in *The Penguin Companion to World Literature,* ed. by Malcolm Bradbury, Eric Mottram, and Jean Franco (New York: McGraw-Hill, 1971).

2. G. J. M. [probably a transcription error for "G. S. M." or George S. McWatters], "Bohemianism," *Brooklyn Daily Eagle*, May 25, 1884, 9. This was likely from the fall of 1873, as Clapp mentioned his father's death, which was August 21, 1873. General biographical facts are also from Lalor, "Literary Bohemians," 71; William Winter, *Old Friends: Being Literary Recollections of Other Days* (New York: Moffat, Yard, 1909), 59; "Queries and Answers in All Branches of Literature," *New York Daily Times*, Mar. 9, 1913, 134; and Ebenezer Clapp, comp., *The Clapp Memorial: Record of the Clapp Family in America* (Boston: David Clapp & Son, 1876), 39, 40, with a reprinting of the obituary from the *Boston Globe*, Apr. 13, 1875.

3. W. H. F., "Nantucket" [from *Nantucket Mirror*], *Saturday Press*, Dec. 18, 1858, 4.

4. Clapp, "New Portrait of Paris" Nov. 13, 1858, 1; [McWatters], "Bohemianism," 9, is the biographical source for the next three paragraphs. Robert Uhl described the goal of the second sailing trip as Rio. Clapp's transcription says "Rio Grande," and I suspect the latter was the result of misreading the shorthand. See Uhl's "Masters of the Merchant Marine," *American Heritage Magazine* 34 (Apr.–May 1983): 68–77.

5. Albert Parry, *Garrets and Pretenders: A History of Bohemianism in America* (New York: Covici, Friede, 1933), 43. The bookseller Andrew J. Allen objected to young Clapp's exchange with a customer, who had asked the price of a gift set. Clapp had told the man that it would cost $10. "I will give you $8," the man replied. "You may be a liar, but I am not," quipped the young man. Allen not only fired Clapp, but he "wrote a letter to my father complaining about my conduct." The wholesale oil and candle house was that of Henry and William Lincoln in Boston.

6. Sources that describe Clapp as having been driven to writing because he had failed at these other pursuits offer no evidence for this assertion.

7. Parry, *Garrets and Pretenders*, 45; Thomas Low Nichols, *Forty Years of American Life, 1821–1861* (1864; repr., New York: Stackpole Sons, 1937), 128.

8. See Duffy's biographical introduction to *Parson Clapp of the Strangers' Church of New Orleans*, ed. by John Duffy (Baton Rouge: Louisiana State Univ. Press, 1957) 3–4, 8–9, 33, 37, 47; which included (and repaginated) Theodore Clapp's *Autobiographical Sketches and Recollections: During a Thirty-Five Years' Residence at New Orleans* (Boston: Phillips, Sampson & Company, 1858), 39–41, and an acknowledgement of Jewish assistance in a Unitarian project (68–71). A trustee of the College of Orleans, Reverend Clapp was also fined for allowing "free people of color" to use the institution for dances, but see also his moderate views on slavery (37, 166–67).

9. Parry, *Garrets and Pretenders*, 44; Winter, *Old Friends*, 59; Charles T. Congdon, *Reminiscences of a Journalist* (Boston: J. R. Osgood, 1880), 339; Lalor, "The Literary Bohemians," 72; and [McWatters,] "Bohemianism," 9. In 1858, Clapp recalled, "I have had experience in different reform movements for these twenty years." *Proceedings of the Free Convention Held at Rutland, Vt., June 25th, 26th, 27th, 1858* (Boston: J. R. Yerrinton & Son, 1858), 56.

10. "Henry Clapp, Jr."; "Proceedings of an Anti-Slavery Convention Holden in

Nantucket," *Liberator*, June 5, 1846, 91 and July 14, 1843, 110. Along with prominent abolitionists like Frederick Douglass, Charles L. Redmond, Stephen S. Foster, and George Bradburn, Fourierists like John Allen and John O. Wattles and the Reverend Elias Smith were also present.

11. Charles H. Bell, *The Bench and Bar of New Hampshire* (Boston: Houghton, Mifflin, 1894); Ezra S. Stearns, *History of Plymouth, New Hampshire* (1906; repr., Somersworth, N.H.: New England History Press, in collaboration with the Plymouth Historical Society, 1987).

12. "Social Reform Convention at Boston," [from the *New York Tribune*], *Phalanx*, Jan. 5, 1844, 46.

13. Thomas Wentworth Higginson, *Cheerful Yesterdays* (Boston: Houghton, Mifflin, 1898), 85; Winter, *Old Friends*, 59–60.

14. Untitled, *Phalanx*, Feb. 8, 1844, 315.

15. Congdon, *Reminiscences*, 173; Lalor, "Literary Bohemians," 73.

16. Henry Clapp Jr., "Prison Sonnets," *Harbinger*, June 13, 1846, 7; Winter, *Old Friends*, 59; and [McWatters,] "Bohemianism," 9.

17. Congdon, *Reminiscences*, 339; Kunitz and Haycraft, *American Authors*, 151; Lalor, "Literary Bohemians," 73; *The Letters of William Lloyd Garrison*: vol. 3, *No Union with Slaveholders*, ed., Walter M. Merrill (Cambridge, Mass.: Belknap Press of Harvard Univ. Press, 1973), 417n6; Henry Clapp Jr., "Modern Christianity," *The Liberty Bell. By Friends of Freedom* 6 (1845): 177–84, and collected in Clapp's *The Pioneer; or, Leaves from an Editor's Portfolio* (Lynn, Mass.: J. B. Tolman, 1846), 40–43.

18. William Lloyd Garrison to Christopher Robinson, Nov. 27, 1844, and to Richard D. Webb, Mar. 1, 1845, both in Merrill, *The Letters of William Lloyd Garrison*, 3:270, 288. In 1845, the Adelphic Union Library Association brought Clapp to Boston, as it did Stephen Pearl Andrews, James McCune Smith, E. H. Chapin, and others from out of town. See *William Cooper Nell: Selected Writings 1832–1874*, ed. by Dorothy Porter Wesley and Constance Porter Uzelac (Baltimore: Black Classic, 2003), 148.

19. "Northern White Slavery" and "Recantation" [both from the *Pioneer*], *Liberator*, Mar. 26, 1846, 45.

20. "Henry Clapp, Jr.," "Henry Clapp, Jr. and Wm. Lloyd Garrison," *Liberator*, June 19, 1846, 91, 98.

21. "Henry Clapp, Jr.," "Henry Clapp, Jr. and Wm. Lloyd Garrison," "Henry Clapp, Jr.," *Liberator*, June 5, 19, 26, 1846, 91, 98, 102.

22. "Henry Clapp, Jr. and the Boston Triumvirate," *Liberator*, July 3, 1846, 105.

23. William Lloyd Garrison to Helen E. Garrison, Aug. 3, 4, Sept. 17, 1846, in Merrill, *The Letters of William Lloyd Garrison*, 3:357, 363, 414; Francis Bishop letter, Dec. 1846, in "Dr. Campbell—the Alliance—Henry Clapp, Jr.," *Liberator*, Feb. 26, 1847, 35; and [McWatters,] "Bohemianism," 9, in which Clapp recalls that he sailed on the "Henry Clay" and that Rev. Dr. DeWitt was among the passengers.

24. "Henry Clapp, Jr. and the Boston Triumvirate," *Liberator*, July 3, 1846, 105; William Lloyd Garrison to Henry C. Wright, Mar. 1, 1847, Merrill, *The Letters of William Lloyd Garrison*, 3:473.

25. "Peace Movements Abroad" and "London Peace Society," *Advocate of Peace and Universal Brotherhood* (Dec. 1846): 280, (Sept.–Oct. 1847): 119.

26. Clapp's "New Portrait of Paris," Nov. 13, 1858, 1; "Correspondence of the National Era" and "British and Foreign Anti-Slavery Society," *National Era*, June 10, 24, 1847, 2; William Lloyd Garrison to Henry C. Wright, Mar. 1, 1847, 473, 474n1; and untitled item [from *Chronotype*], *Harbinger*, Aug. 12, 1848, 115. Burritt remained an abolitionist and an immediatist but increasingly groped toward some form of compensated emancipation for the South by the North "as both are equally responsible for its existence." "The Lecture Season," *Brooklyn Daily Eagle*, Dec. 3, 1856, 2.

27. "Anniversary Week in New York [from the *Pioneer*]," *Liberator*, May 21, 1848, 81; "Meeting of Associationists in Boston," *Harbinger*, June 10, 1848, 44; untitled item, *Scientific American* 3 (July 8, 1848): 330; "The Peace Congress at Brussels," *National Era* 2 (Nov. 16, 1848): 181; "'The Lynn Pioneer'"; *Trumpet and Universalist Magazine*, May 6, 1848, 186; Lalor, "Literary Bohemians," 72. See also Agricola, "Foreign Correspondence," *Independent*, June 21, 1849, 1. For Garrison's further commentary, see "The Lynn Pioneer," *Liberator*, Mar. 2, 1849, 34.

28. William E. Farrison, *William Wells Brown: Author and Reformer* (Chicago: Univ. of Chicago Press, 1969), 147–51. *Standard of Freedom* (London), Sept. 8, 1849, cited in Peter C. Ripley, *The Black Abolitionist Papers* (Chapel Hill: Univ. of North Carolina Press, 1985), 1:155, 164n2; "European Correspondence" and "Foreign Correspondence," *National Era*, Aug. 21, Sept. 20, 1849, 133, 149, letter from "Tavistock"; "History of the Peace Congresses," *Advocate of Peace* 62 (Oct. 1900): 188–89, which mistakenly described Clapp as being from Cincinnati; and [McWatters,] "Bohemianism," 9; Clapp's "New Portrait of Paris," Dec. 11, 1858, 1. Also see "After-scenes in Paris," *Advocate of Peace* (Jan.–Feb. 1850): 174–76. For Pennington's own account of his escape from slavery, see *The Fugitive Blacksmith; or, Events in the History of James W.C. Pennington* (London: Charles Gilpen, 1849).

29. Dame Ashfield spoke the line in Thomas Morton's *Speed the Plough* [1798]. Act 1, scene 1. "Anniversary Week in New York [from the *Pioneer*]," *Liberator*, May 21, 1848, 81; Clapp on Garrison from "Northern White Slavery" and "Recantation" [both from the *Pioneer*], *Liberator*, Mar. 26, 1846, 45.

30. For the city, see Peter Ackroyd, *London: The Biography* (New York: Anchor, 2000); Stephen Inwood's more defined discussion of this period in *A History of London* (London: Macmillan, 1998), 411–693; or Liza Picard, *Victorian London: The Talk of a City, 1840–1870* (New York: St. Martin's Griffin, 2005).

31. See Christopher A. Kent, "The Idea of Bohemia in Mid-Victorian England," in *On Bohemia: The Code of the Self-Exiled*, ed. by César Graña and Marigay Graña (New Brunswick, N.J.: Transaction, 1990), 158–67; Timothy Hilton, *The Pre-Raphaelites* (London: Thames and Hudson, 1970); Susan P. Casteras and Alicia Craig Faxon,

eds., *Pre-Raphaelite Art in Its European Context*, (Madison, N.J.: Fairleigh Dickinson Univ. Press, 1995); and E. P. Thompson, *William Morris: Romantic and Revolutionary*, 2d ed. (Stanford, Calif.: Stanford Univ. Press, 1976), 40–60.

32. Senex, "A Slender Sheaf of Memories," *Lippincott's Monthly Magazine* (Nov. 1902): 605, 610, 611.

33. Ibid., 610.

34. Pauvette letter, New York, July 15, 1852, in Clapp, "New Portrait of Paris," Nov. 27, 1858, 1, Dec. 25, 1858, 2. For estimations of the population of Paris, see Paul Bairoch, *Cities and Economic Development: From the Dawn of History to the Present*, trans. by Christopher Braider (Chicago: Univ. of Chicago Press, 1991), who calculated 1,053,000, while Tertius Chandler, *Four Thousand Years of Urban Growth: An Historical Census* (Lewiston, N.Y.: Edwin Mellen, 1987) suggested as many as 1,314,000. See William Makepeace Thackeray, *The Paris Sketch Book* (London: Smith, Elder, 1870), 19.

35. Thomas Armstrong, *A Memoir*, ed. by L. M. Lamont (London: Martin Secier, 1912), 116, cited in Gordon Fleming, *The Young Whistler, 1834–44* (London: Allen & Unwin, 1978), 120; Honoré de Balzac, *Z. Marcas*, in *The Brotherhood of Consolation and Z. Marcas*, trans. by Katharine P. Worneley, (Boston: Little, Brown, 1899), 335–36

36. [McWatters,] "Bohemianism," 9; Clapp, "New Portrait of Paris," Dec. 25, 1858, 1–2, Jan. 1, 1859, 1, Jan. 8, 1859, 1. Clapp may have written such items as the "Letters from Paris" signed "Progress" in the *Home Journal*, Mar. 23, 1850, 4. See also Henry Mayhew, *London Labour and the London Poor: The Condition and Earnings of Those That Will Work, Cannot Work, and Will Not Work*, 4 vols. (London: C. Griffin, [1861–62]).

37. Robert Darnton, *The Literary Underground of the Old Regime* (Cambridge Mass.: Harvard Univ. Press, 1982), 17. James H. Billington, *Fire in the Minds of Men: Origins of the Revolutionary Faith* (New York: Basic, 1980), 30.

38. Clapp's friend Albert Brisbane had witnessed "the June Days," partly from the refuge of a café. Redelia Brisbane, *Albert Brisbane: A Mental Biography* (Boston: Arena, 1893), 268–71; and "Letter from the Editor," *Saturday Press*, Aug. 6, 1859, 2. For a discussion of the political dimensions of Bohemianism, see Malcolm Easton, *Artists and Writers in Paris: The Bohemian Idea, 1805–1867* (London: Edward Arnold, 1964); César Graña, *Bohemian versus Bourgeois: French Society and the French Man of Letters in the Nineteenth Century* (New York: Basic, 1964), 64–65; and Jerrold Seigel, *Bohemian Paris: Culture, Politics, and the Boundaries of Bourgeois Life, 1830–1930* (New York: Viking, 1986). For the geography of the political turmoil in Paris, see Jill Harsin, *Barricades: The War of the Streets in Revolutionary Paris, 1830–1848* (New York: Palgrave, 2002).

39. Clapp, "New Portrait of Paris," Dec. 25, 1858, 1, Jan. 1, 1859, 1. See also W. Scott Haine, *The World of the Paris Café: Sociability among the French Working Class, 1789–1914* (Baltimore: Johns Hopkins Univ. Press, 1996), 183–86.

40. Giacomo Puccini rewrote the play as his opera *La Bohème* (1896), and after many cinematic versions, it was most recently seriously revised as *Moulin Rouge* (2001).

41. Puccini, in act 1, scene 8 of *La Bohème* described a territory "bounded on the

north by hope, labor, and gaiety; on the south by need and courage; on the east and west, by slander and the hospice." Quoted in William Henry Hudson, "A Glimpse of Bohemia," *Idle Hours in a Library* (San Francisco: William Doxey, 1897), 181–82.

42. Clapp, "New Portrait of Paris," Dec. 25, 1858, 1; Nichols, *Forty Years of American Life*, 130.

43. On his age, see Clapp, "New Portrait of Paris," Dec. 25, 1858, 1; and on the pipe and the symbol of peace, see "New Portrait of Paris," Dec. 4, 1858, 1.

44. Clapp, "New Portrait of Paris," Dec. 25, 1858, 1. For the style of taking coffee, see "New Portrait of Paris," Jan. 8, 1859, 1.

45. Clapp, "New Portrait of Paris," Nov. 13, 1858, 1; and "On the Death of the Temperance Movement," *Saturday Press*, Dec. 11, 1858, 2. After a Temperance Convention in Saratoga, Clapp refurbished this essay and printed it as "The Temperance Movement," *Saturday Press*, Aug. 12, 1865, 29.

46. Haine describes these distinctions in *World of the Paris Café*, 180–92. See also Elizabeth Wilson, "Bohemians, Grisettes, and Demi-Mondaines," in *Violetta and Her Sisters: The Lady of the Camellias: Responses to the Myth*, ed. by Nicholas John (Boston: Faber, 1994).

47. Clapp, "New Portrait of Paris," Dec. 4, 1858, 2 (on marriage), Dec. 25, 1858, 1, Jan. 1, 1859, 1. For a humorous look at traditional New England courtship and marriage, see Henry Clapp Jr., "Love Experiences of an Impressible Man" [from *Harper's Monthly*], *Saturday Press*, Nov. 6, 1858, 4. Although written as the experience of a "Mr. Green," this essay surely contains some autobiographical content. Clapp's account of life in Paris mentions particularly "studentesses" named Octavie, Rosallie, and Pauvette; the last named writing him from New York. "New Portrait of Paris," Dec. 25, 1858, 2.

48. Horace Greeley, *Recollections of a Busy Life, Including Reminiscences of American Politics and Politicians, from the Opening of the Missouri Contest to the Downfall of Slavery* (New York: J. B. Ford & Co., 1868), 275; "Queries and Answers in All Branches of Literature," 134; and for the self-made man quip, see M. A. DeWolfe Howe, *Memories of a Hostess: A Chronicle of Eminent Friendships Drawn Chiefly from the Diaries of Mrs. James T. Fields* (Boston: Atlantic Monthly Press, 1922), 185. Parry, *Garrets and Pretenders*, 44.

49. Clapp to the editor, Oct. 22, 1855, under "The Free Lovers," "A Rich Development. Free Love Nowhere," *New York Times*, Oct. 23, 1855, 3, Oct. 19, 1855, 4. A black abolitionist, who had shared a platform with Clapp in England, noted his recent return in a letter of February 19, 1854. Wesley, *William Cooper Nell*, 375.

50. Junius Henry Browne, *The Great Metropolis: A Mirror of New York* (Hartford, Conn.: American Publishing Company, 1869), 152–53; and, on Clapp speaking French, see Winter, *Old Friends*, 58.

51. Horace Traubel, *With Walt Whitman in Camden*, vol. 2: *July 16, 1888–October 31, 1888* (New York: D. Appleton and Company, 1908), 317; Clapp contributed a story to the *Knickerbocker* for November 1858, but the rumors of this story lack attribution. Untitled announcements, *National Era*, Nov. 4, 1858, 175; Albert L. Rawson,

"A Bygone Bohemia," *Frank Leslie's Popular Monthly* 41 (Jan. 1896): [3–4]; Arthur Bartlett Maurice, "Literary Clubland," *Bookman* 21 (June 1905): 396, reprinted in 43 (Aug. 1916): 649, and his "Literary Snapshots," *Bookman* 54 (Jan. 1922): 485; Charles Hemstreet, "The Literary Landmarks of New York," *Critic* 421 (Aug. 1903): 154; Launt Thompson segment in Alvan S. Southworth, "The Sculptors of New York," *Frank Leslie's Popular Monthly* 25 (Feb. 1888): 5; Thomas Dunn English, May 31, 1886, letter, "That Club at Pfaff's," *Literary World* 17 (June 12, 1886): 202; and "Obituary," *New York Daily Times*, Apr. 11, 1875, 7.

52. Emily Hahn, *Romantic Rebels: An Informal History of Bohemia* (Boston: Houghton Mifflin, 1967), 28. "A Roman Punch," *Vanity Fair* 1 (Mar. 10, 1860): 172; Letter of Dink Freer, "In the Bookman's Mail," *Bookman* 64 (Sept. 1926): 117; and Browne, *Great Metropolis*, 152–53; Winter, *Old Friends*, 57–58; and Horace Traubel, *With Walt Whitman in Camden*, 2:317.

53. Hahn, *Romantic Rebels*, 28; Freer, "In the Bookman's Mail," 117; Browne, *Great Metropolis*, 152–53; and Rawson, "Bygone Bohemia," [3].

54. Winter, *Old Friends*, 57, 58–59, 60.

55. Howe, *Memories of a Hostess*, 185; and Traubel, *With Walt Whitman in Camden*, vol. 1: *March 28–July 14, 1888* (Boston: Small, Maynard & Company, 1906), 237.

56. Clapp, "New Portrait of Paris;," Nov. 20, 1858, 1.

57. Bruce A. McConachie, "'Theatre of the Mob': Apocalyptic Melodrama and Preindustrial Riots in Antebellum New York," in *Theatre for Working-Class Audiences in the United States, 1830–1880*, ed. by Bruce A. McConachie and Daniel Friedman (Westport, Conn.: Greenwood, 1985), 17–46; and Max Maretzek, *Sharps and Flats: A Sequel to "Crotchets and Quavers,"* (New York: American Musician Publishing, 1890), 1:38–39, 40.

2. A Scandal in Bohemia

1. "The Free Lovers: Practical Operation of the Free-Love League in the City of New York" and Clapp to the editor, Oct. 22, 1855, under "The Free Lovers," *New York Times*, Oct. 10, 23, 1855, 1, 3.

2. "Free Democratic National Convention," and "Proceedings of the Free Democratic National Convention," *National Era*, Aug. 19, 26, 1852, 134, 137–38. On their 1852 presidential candidate, see Richard H. Sewell, *John P. Hale and the Politics of Abolition* (Cambridge, Mass.: Harvard Univ. Press, 1965).

3. "The Ingraham Committee and the Universal Democratic Republicanism," "The Society of Universal Democrat Republicanism," "The Great Anti-Bedini Meeting," *New York Times*, Oct. 28, 1853, 1, Nov. 11, 1853, 1, Jan. 26, 1854, 3, Feb. 8, 1854, 2; and "Society of Universal Democratic Republicanism," *New York Tribune*, Oct. 28, 1853, 5.

4. Patrick H. Hutton, *The Cult of the Revolutionary Tradition: The Blanquists in French Politics, 1864–1893* (Berkeley: Univ. of California Press, 1981), 18. See also J. H. Roberts's *The Mythology of the Secret Societies* (London: Secker and Warburg, 1972) and James H. Billington's sweeping polemic, *Fire in the Minds of Men*.

5. Nichols, *Forty Years of American Life*, 258; Bruce Levine, *The Spirit of 1848: German Immigrants, Labor Conflict, and the Coming of the Civil War* (Urbana: Univ. of Illinois Press, 1992).

6. Boris I. Nicolaevsky, "Secret Societies and the First International," in *The Revolutionary Internationals, 1864–1943*, ed. by Milorad M. Drachkovitch (Stanford, Calif.: Stanford Univ. Press for the Hoover Institution on War, Revolution, and Peace, 1966), 36–56; Jacques Etienne Marconis, *Lectures of a Chapter, Senate, and Council: According to the Forms of the Antient and Primitive Rite, but Embracing All Systems of High Grade Masonry* (London: John Hogg, 1882). See also Andrew Prescott, "'The Cause of Humanity': Charles Bradlaugh and Freemasonry," *Ars Quatuor Coronatorum* 116 (2003): 15–64.

7. "New-York City. Republican Festival. Grand Celebration of the Universal Democratic republicans. Processions, Banquets at the Shakespeare Hotel, Speeches, &c., &c.," *New York Times*, Feb. 25, 1854, 8.

8. A modern, well-indexed or digitized file of the *New York Times* would include several dozen articles on these associations from September 1853 into November 1855.

9. Theodore Dwight, *The Roman Republic of 1849; with Accounts of the Inquisition, and the Siege of Rome, and Biographical Sketches, with Original Portraits* (New York: R. Van Dien, 1851), 198–99; George M. Trevelyan, *Garibaldi's Defence of the Roman Republic*, 3d ed. (London: Longmans, Green. 1914), vii, 349. Christopher Hibbert, *Garibaldi and His Enemies: The Clash of Arms and Personalities in the Making of Italy* (Boston: Little, Brown, 1965), 104, 106, 108, 110; Hugh Forbes, *Forbes's Answer to Archbishop Hughes*, 2d. ed. (Boston: privately printed, 1850); Forbes, *Manual for the Patriotic Volunteer on Active Service in Regular and Irregular War: Being the Arts and Science of Obtaining and Maintaining Liberty and Independence*, 2 vols., 2d ed. (New York: W. H. Tinson, Printer, 1855), 1:viii, 9, 10, vii. For the endorsement of its principles, see "The Union of the Liberal Societies," *New York Times*, July 20, 1854, 5.

10. "The Society of Universal Democratic Republicanism" and "Union of the Liberal Societies," *New York Times*, Apr. 12, July 6, 1854, 8, 4.

11. J. Wayne Laurens, *The Crisis: Or, the Enemies of America Unmasked* (Philadelphia: G. D. Miller, 1855), 181, 208. Oddly, the majority of individuals cited as exponents of dangerous foreign radicalism were actually Americans, but facts have rarely tempered such charges.

12. After the Civil War, Davis became a leader of the International Workingmen's Association in the city.

13. Roger Wunderlich, *Low Living and High Thinking at Modern Times, New York* (Syracuse, N.Y.: Syracuse Univ. Press, 1992). See also Nichols, *Forty Years of American Life*, 241.

14. During the Paris Commune, the Order of Memphis placed its flag on the barricade. William B. Green, *The Blazing Star; with an Appendix Treating of the Jewish Kabbala* (Boston: A. Williams, 1872), 20–21, identified that as the lodge of which he had been a member in Paris.

15. George S. McWatters, *Knots Untied; or, Ways and By-Ways in the Hidden Life of American Detectives* (Hartford, Conn.: J. B. Burr and Hyde, 1871), 22, 29–30, and also for "A Forced Marriage Scheme Defeated," 387–413; and "The Gambler's Wax Finger," 113–30; George Jacob Holyoake, "A Stranger in America," *Littell's Living Age* 31 (Aug. 7, 1880): 365; and *Circular*, City of Modern Times, Long Island, N.Y., Sept. 1852, in Andrews, preface to Josiah Warren, *Practical Details in Equitable Commerce: Showing the Workings, in Actual Experiment, During a Series of Years, of the Social Principles Expounded in the Work Called "Equitable Commerce," by the Author of This, and "The Science of Society,"* by Stephen Pearl Andrews (New York: Fowler and Wells, 1852), viii, cited in Wunderlich, *Low Living and High Thinking*, 34. See also Marcus Klein, *Easterns, Westerns, and Private Eyes: American Matters, 1870–1900* (Madison: Univ. of Wisconsin Press, 1994), 157–58.

16. Carl J. Guarneri, *The Utopian Alternative: Fourierism in Nineteenth-Century America* (Ithaca, N.Y.: Cornell Univ. Press, 1991), 356–57, 365–66, 396; *Love vs. Marriage*, part 1 (New York: Fowler and Wells, 1852), and in *Involuntary Seminal Losses; Their Causes, Effects, and Cure.* (New York: Fowler and Wells, 1852).

17. Timothy J. Gilfoyle, *City of Eros: New York City, Prostitution, and the Commercialization of Sex, 1790–1920* (New York: Norton, 1992), 135–38; Jean L. Silver-Isenstadt, *Shameless: The Visionary Life of Mary Gove Nichols* (Baltimore: Johns Hopkins Univ. Press, 2002), 11, 13, 24–35, 48–49, 79–80, 85–86, 100–102. See also *Mary Lyndon; or, Revelations of a Life, An Autobiography* (New York: Stinger and Townsend, 1855); and "Mrs. Mary S. Gove," *Water Cure Journal* 1 (Jan. 1, 1846): 38; "Mary Gove," *Godey's Magazine and Lady's Book* 33 (July 1846): 16; untitled item on the conversion of the Nicholses to Catholicism, *National Era* 11 (May 7, 1857): 74.

18. Timothy Gilfoyle, Patricia Cline Cohen, and Helen Lefkowitz Horowitz argue that this subculture of literate unmarried heterosexual males embraced a kind of "libertine republicanism" around a natural right of male gratification in the commercialized sex of the metropolis. *The Flash Press: Sporting Male Weeklies in 1840s New York* (Chicago: Univ. of Chicago Press, 2008), 49, 52, 173, 241n1, 267n64.

19. Nichols, *Forty Years of American Life*, 167–68, 239; Silver-Isenstadt, *Shameless*, 8, 109–25, 126. Thomas Low Nichols, *Woman, in All Ages and Nations* (New York: Fowler and Wells, [1849]); and Thomas Low Nichols, *Esoteric Anthropology* (London: Nichols & Co., 1853); and Dr. Thomas Low Nichols and Mrs. Mary S. Gove Nichols, *Marriage: Its History, Character, and Results* (Cincinnati: V. Nicholson & Co. [1854]); and "The World's Convention," *Nichols Journal of Health, Water-Cure and Human Progress* 1 (Oct. 1853): 55.

20. George E. MacDonald, *Fifty Years of Freethought: Being the Story of the Truth Seeker, with the Natural History of Its Third Editor*, 2 vols. (New York: Truth Seeker, 1929, 1931), 1:207–8; Walt Whitman, *Notebooks and Unpublished Prose Manuscripts*, ed. by Edward F. Grier (New York: New York Univ. Press, 1984), 1:250; and Underhill letters as "The Unitary Household. Letter from the Proprietor in Reply to the Times" and "The Unitary Household. Letter from Mr. Underhill in Reply to the Article in

the Times," as well as "Edward F. Underhill Dead," *New York Times*, June 25, 1858, 2, Sept. 26, 1860, 2, and June 19, 1898, 7.

21. "The Free Love System: Origin, Progress and Position of the Anti-Marriage Movement," "The Free Lovers. Practical Operation of the Free-Love League in the City of New York," and "Practical Socialism in New-York," *New York Times*, Sept. 8, 1855, 2, Oct. 10, 1855, 1, June 22, 1858, 5.

22. Jerome Mushkat, *Fernando Wood: A Political Biography* (Kent, Ohio: Kent State Univ. Press, 1990), 41–47. "New-York City Kansas League," "The 'Practical Democrats,' Meeting in the Park. The Platform of the Party," "Meeting of Practical Democrats," "Convention of Liberal Societies," "The 'Practical Democrats,'" "The Liberal Societies on Politics," "City Politics," "New-York City. Meeting of the Liberal Societies.—The Soule Affair.—Maine Law," *New York Times*, Aug. 10, 1854, 9, Sept. 28, 1854, 4, Oct. 12, 1854, 6, Oct. 13, 1854, 8, Oct. 18, 1854, 8, Oct. 20, 1854, 3, Nov. 1, 1854, 1, Nov. 16, 1854, 8.

23. Amy Bridges, *City in the Republic: Antebellum New York and the Origins of Machine Politics* (Cambridge: Cambridge Univ. Press, 1984), 116n63, 117nn63–64; John R. Commons et al., eds. *A Documentary History of American Industrial Society*, 10 vols. (1910; repr., New York, Russell & Russell, 1958), 8:27, 287, 288, 301; and Thomas Ainge Devyr, "American Section," in *The Odd Book of the Nineteenth Century; or, "Chivalry" in Modern Days: A Personal Record of Reform—Chiefly LAND REFORM, for the Last Fifty Years* (Greenpoint, N.Y.: privately printed, 1882), 66–69, 101–2; "Eight Hours a Day's Work," "Meeting of the Unemployed Workingmen in the Park," "Second Mass Meeting of the American Democracy," *New York Tribune*, Dec. 1, 1854, 4 Dec. 23, 1854, 5, Sept. 18, 1855, 5; "New-York City. Meeting of the Liberal Societies.—The Soule Affair.—Maine Law," "The Liberal Societies in Conclave," "The City Poor. Meeting of the Unemployed," "The Labor Movement. Second Meeting of the Unemployed," "The Unemployed. Large Meeting in Hope Chapel," "Meeting of the Liberal Societies," "Workingmen's Conference," "Workingmen's Mass Meeting. Gathering at the Broadway Tabernacle," "The Tabernacle Meeting," Letter from William West, "A Workingman's Reply to Mr. Olmsted" with "Work and Wages—Mr. Olmsted in Reply to Mr. West," and a series of notices under "City Politics" for the fall, *New York Times*, Nov. 16, 1854, 8, Dec. 15, 1854, 4, Dec. 22, 1854, 2, Dec. 23, 1854, 3, Jan. 9, 1855, 4, Jan. 17, 1855, 4, Jan. 30, 1855, 4, Jan. 31, 1855, 3, Feb. 2, 1855, 2, Feb. 9, 1855, 2, Sept. 18, 1855, 8, Oct. 15, 1855, 1, Nov. 1, 1855, 1.

24. "The Free Lovers. Practical Operation of the Free-Love League in the City of New York," and Clapp to the editor, Oct. 22, 1855, under "The Free Lovers," *New York Times*, Oct. 10, 1855, 1, Oct. 23, 1855, 3. For histories, see Joshua K. Ingalls, *Reminiscences of an Octogenarian in the Field of Industrial and Social Reform* (New York, M. L. Holbrook, 1897), 153, 156, 157–58, 159; Taylor Stoehr, ed. *Free Love in America: A Documentary History* (New York: AMS Press, 1979), 6, 23, 319–21.

25. Brisbane was later the inventor of the proposed tubular railway, or hollow ball way, mentioned in Rawson, "Bygone Bohemia," [6, 8]. See also Whitman, *Notebooks*

and Unpublished Prose Manuscripts, 2:825; Charles Nordhoff, "A Struggle for Life" [from *Harper's Monthly* for December], and an account of the Shakers. "Minor Experiences in America. 17," *Saturday Press,* Dec. 8, 1860, 1, 4, and Dec. 15, 1860, 1; "Letter from Mr. Brisbane," and Clapp to the editor, Oct. 22, 1855, under "The Free Lovers," *New York Times,* Oct. 20, 1855, 1, Oct. 23, 1855, 3.

26. "The Free Love System: Origin, Progress and Position of the Anti-Marriage Movement," "The Free Lovers. Practical Operation of the Free-Love League in the City of New York," Clapp to the editor, Oct. 22, 1855, under "The Free Lovers," and "Practical Socialism in New-York," *New York Times,* Sept. 8, 1855, 2, Oct. 10, 1855, 1, Oct. 23, 1855, 3, and June 22, 1858, 5; Mortimer Thomson [as Q.K. Philander Doesticks, P.B.], *Plu-Ri-Bus-Tah: A Song That's by No Author* (New York: Livermore & Rudd, 1856), 97; and "A Notable Hotel," miscellaneous back pages, *Scribner's Magazine* 11 (June 1892): A024. The organizers wished to keep the gatherings small, which became the source of the *Times* assertion that "an oath of secrecy is required of every visitor."

27. "The New Organization," *Spiritual Telegraph Papers,* vol. 5: May, June, July 1854, 9 vols. (New York: Partridge & Brittan, 1853–57), 291–93; and "Meeting of the Associations of the North American Phalanx" in the issue of March 31, 1855, 2, indicates that local backers of that Fourierist community with which George Arnold had been associated were already meeting at 555 Broadway. "A Fourierite Celebration," *New York Herald,* Apr. 10, 1856, 8.

28. "The Free Lovers. Practical Operation of the Free-Love League in the City of New York," *New York Times,* Oct. 10, 1855, 1.

29. Paul M. Gaston, *Women of Fair Hope* (Athens: Univ. of Georgia Press, 1984), 23–26, quotation on 27, 28–29, 30–31; letter to *Young America,* in *Voice of Industry,* July 16, 1846; and Dwight C. Kilbourn, *The Bench and Bar of Litchfield County, Connecticut 1709–1909: Biographical Sketches of Members History and Catalogue of the Litchfield Law School Historical Notes* (Litchfield, Conn.: privately printed, 1909).

30. Gilfoyle, *City of Eros,* 58, 113–14. Gilfoyle, Cohen, and Horowitz argue that this subculture of literate unmarried heterosexual males embraced a kind of "libertine republicanism," around a natural right of male gratification in the commercialized sex of the metropolis. *The Flash Press,* 55–56. See generally Charles Winick and Paul M. Kinsie, *The Lively Commerce: Prostitution in the United States* (Chicago: Quadrangle, 1971). On the position of women in the labor movement, see "The Congress of Trades," *New York Herald,* Sept. 4, 1850, 1.

31. Gilfoyle, *City of Eros,* 109–12, 127–29, 138, and 232–36, for the debauchery of the festivals held by the "French Association" or "Friends of Gayety." The Commissioners of Public Charities and Corrections communication from Superintendent of Blackwell's Island reported the southeast staircase tower of the building occupied by women leaning west and south. "The Leaning Tower of New York," *Saturday Press,* May 26, 1860, 3.

33. Warren B. Chase, *Forty Years on the Spiritual Rostrum* (Boston: Colby & Rich, 1888), 50–51, 84; Untitled notice and "Miss Harding's Enterprise in behalf of Homeless and Outcast Females," *Banner of Light,* May 5, 1860, 2–3, Apr. 13, 1861, 1.

34. "The Free Lovers. Practical Operation of the Free-Love League in the City of New York," and "Practical Socialism in New-York," *New York Times*, Oct. 10, 1855, 1, June 22, 1858, 5; and Ingalls, *Reminiscences of an Octogenarian*, 153, 156; Nessung, "Spiritualism," *Saturday Press*, Sept. 17, 1859, 2.

35. "Red Republicanism in the United States," and "Affairs in Boston. Progress of the Gardner Movement—Red Republican Convention and Candidate—Gov. Gardner at Newburyport—The Chief Justiceship of the Supreme Court—Miscellanies, &c., &c.," *New York Times*, Dec. 31, 1856, 4, Sept. 5, 1857, 2.

36. "The Political Prize-Fight," *Saturday Press*, June 9, 1860, 2.

37. "Veritas," letter to the editor, "The Morals of Fourierism," "The Free Love System: Origin, Progress and Position of the Anti-Marriage Movement," Charles Partridge, "Spiritualists and the Free Love System," J. A. letter to the editor, "Women's Rights and the Free-Love System," and Adin Ballou, "Rebuke of the Spiritualists," *New York Times*, Aug. 28, 1855, 2, Sept. 8, 1855, 2, Sept. 22, 1855, 4, Sept. 26, 1855, 2, Sept. 29, 1854, 6; Warren Chase's argument in "The Free Love Theory," "The 'Free-Love' Movement," *New York Daily Tribune*, Sept. 27, 1855, Oct. 16, 1855, 4; Stephen Pearl Andrews, ed., *Love, Marriage, and Divorce and the Sovereignty of the Individual: A Discussion Between Henry James, Horace Greeley, and Stephen Pearl Andrews: Including the Final Replies of Mr. Andrews, Rejected by the Tribune* (1853; repr., Boston: B. R. Tucker, 1889).

38. Ingalls, *Reminiscences of an Octogenarian*, 156–57. See also "The Free Love System: Origin, Progress, and Position of the Anti-Marriage Movement," *Littell's Living Age* 10 (Sept. 29, 1855): 815–21.

39. "Letter from Mr. Brisbane." *New York Times*, Oct. 20, 1855, 1.

40. "A Rich Development. Free Love Nowhere," *New York Times*, Oct. 19, 1855, 4.

41. Ibid.; "Letter from Mr. Brisbane." *New York Times*, Oct. 20, 1855, 1.

42. "Letter from Mr. Brisbane" *New York Times*, Oct. 20, 1855, 1; and "A Rich Development. Free Love Nowhere," *New York Times*, Oct. 19, 1855, 4.

43. "Letter from Mr. Brisbane." *New York Times*, Oct. 20, 1855, 1.

44. "A Rich Development. Free Love Nowhere," "Letter from Mr. Brisbane." *New York Times*, Oct. 19, 1855, 4, Oct. 20, 1855, 1.

45. "A Rich Development. Free Love Nowhere," "The Free-Lovers' Troubles. Hearing at the Mayor's Office," *New York Times*, Oct. 19, 1855, 4, Oct. 20, 1855, 2. Underhill "had been through the fire a dozen years earlier when the police raided a club of social radicals in session in a hall on Broadway and he got taken along with Albert Brisbane, the father of Arthur, and other persons in attendance." MacDonald, *Fifty Years of Freethought*, 1:208.

46. For this and the following two paragraphs, see "The Free-Lovers' Troubles. Hearing at the Mayor's Office," *New York Times*, Oct. 20, 1855, 2.

47. "Free Love Before the Court," *New York Times*, Oct. 22, 1855, 3. The witnesses included Whig councilman Ridder, Michael G. Hart, and Captain Kissner

48. R. W. G. letter to the editor, "From One Who was at the Free-Love Meeting,"

"The Free Lovers," "The Free-Lovers in Court. Investigation Terminated," *New York Times*, Oct. 22, 1855, 6, Oct. 23, 1855, 3, Oct. 24, 1855, 3.

49. "The Free-Lovers in Court. Investigation Terminated," "Club Law for New York," and "Letter from Mr. Brisbane," *New York Times*, Oct. 20, 1855, 1, Oct. 22, 1855, 4, Oct. 24, 1855, 3.

50. "The Free Lovers," "The Free Lovers. No Disturbance Last Night," and "U[nderhill]" letter on "Capt. Turnbull," *New York Times*, Oct. 23, 1855, 3, 4, Oct. 26, 1855, 8.

51. Mushkat, *Fernando Wood*, 49–50, 258n30. Ira B. Davis and some others continued to cling to the Democratic machine. "Mayoralty Meeting at Tammany," *New York Herald*, Nov. 29, 1857, 1.

52. Untitled Oddfellows item in "New-York City," "State Temperance Convention at Utica," "City Politics," "Union for the Sake of the Union," "Our New Laws," "Funeral of Charles C. B. Seymour," "Obituary," and "An Aged Journalist Declining," *New York Times*, Feb. 17, 1852, 2, Oct. 5, 1855, 7, Oct. 9, 1855, 1, and Nov. 1, 1855, 1, Apr. 29, 1856, 2, May 30, 1857, 1, May 6, 1869, 5, Apr. 11, 1875, 7, Aug. 9, 1884, 8; Browne, *Great Metropolis*, 156; Andrews, *North Reports the Civil War*, 755; Rawson, "Bygone Bohemia," [7]; and Young, quoted, James L. Huffman, *A Yankee in Meiji Japan: The Crusading Journalist Edward H. House* (Lanham, Md.: Rowman & Littlefield, 2003), 21.

53. McWatters had a serious argument with the police department's tailor when he joined the force. See his letter, "The Police and Their Tailor," *New York Herald*, Aug. 17, 1859, 2.

54. "About Webb and Bennett," *Saturday Press*, Oct. 1, 1859, 2; and Parry, *Garrets and Pretenders*, 45.

3. Utopia on Broadway

Epigraph from Advertisement, *Saturday Press*, Oct. 20, 1860, 2.

1. William Winter, *Vagrant Memories, Being Further Recollections of Other Days* (New York: George H. Doran, 1915), 158, 160, 161; Richard B. Stott, *Workers in the Metropolis: Class, Ethnicity, and Youth in Antebellum New York City* (Ithaca, N.Y.: Cornell Univ. Press, 1990), 223–24, 257–59; Thomas Allston Brown, *History of the American Stage* (New York: Benjamin Blom, 1870), 66; Browne, *Great Metropolis*, 156; the many productions indexed in and George C. Odell, *Annals of the New York Stage*, 15 vols. (New York: Columbia Univ. Press, 1929–49). See also Charles Gayler's *The Love of a Prince; or, The Court of Prussia* (New York: S. French, [1857]), *Out of the Streets: A Story of New York Life* (New York: Robert M. DeWitt, Publishers, 1869), *Fritz, the Emigrant* (New York: F. Leslie's Publishing House, 1876), and *Sleepy Hollow; or The Headless Horseman: A Comic Pastoral Opera in Three Acts, Music by Max Maretzek, words by Charles Gayler* (New York: [F. Rullman], 1879); and *The Son of the Night: A Drama, in Three Days: And a Prologue* (New York: S. French [186–]).

2. "The Saratoga Convention," "Anti-Nebraska Meeting at Saratoga," and "Temperance Meeting in Saratoga," *New York Tribune*, Aug. 17, 1854, 4, Aug. 18, 1854, 4, as well as

the "Anti-Nebraska Convention at Auburn," Sept. 27, 1854, 4–5, Sept. 27, 28, 1855, and an editorial, "Republicanism Inaugurated," Sept. 28, 1855. Also from the same paper, see "Free-Soil Republican Club," "Republican Demonstration," Sept. 14, 1855, 5.

3. *Wilson's Business Directory of New York City* (New York: John F. Trow, 1859), 286, 287, 318, 319, 321, 339.

4. Ibid., 95; and Mark A. Lause, "American Radicals and Organized Marxism: The Initial Experience, 1868–1874," *Labor History* 33 (Winter 1992): 57.

5. The offices of a few major periodicals were nearby, including the *Journal of Specific Homeopathy* and *New York Our Cousin*, near the Metropolitan Hotel, S. Leland & Co. *Wilson's Business Directory of New York City*, 240, 319, 321; "Pfaff's," *Saturday Press*, Dec. 3, 1859, 2; and Nichols, *Forty Years of American Life*, 166.

6. "Pfaff's," *Saturday Press*, Dec. 3, 1859, 2. Rufus Rockwell Wilson, *New York: Old and New; Its Story, Streets, and Landmarks*, 2d ed., 2 vols. (Philadelphia: J. B. Lippincott, 1903), 2:140–41; Lalor, "Literary Bohemians," 127n61; "Queries and Answers in All Branches of Literature," 134; Parry, *Garrets and Pretenders*, 22, 22–23; Hahn, *Romantic Rebels*, 20; and Horace Traubel, *With Walt Whitman in Camden*, vol. 9: *October 1, 1891–April 3, 1892*, ed. by Jeanne Chapman, Robert MacIsaac (Oregon House, Calif.: W. L. Bentley, 1996), 225. Thomas Nichols noted, "Cellars or underground basements for business purposes, are very rare in London and very common in New York." *Forty Years of American Life*, 130,

7. Hahn, *Romantic Rebels*, 20, 27; Winter, *Old Friends*, 308–9, 313, 317.

8. Fitz-James O'Brien, "Sir Brasil's Falcon," *United States Democratic Review* 33 (Sept. 1853): 248–57. See Francis Wolle, *Fitz-James O'Brien: A Literary Bohemian of the Eighteen-Fifties* (Boulder: Univ. of Colorado Press, 1944).

9. On William North, see Senex, "A Slender Sheaf of Memories," 610–11; "The Slave of the Lamp by William North," *United States Democratic Review* 35 (May 1855): 417–18; William North, *The Slave of the Lamp: A Posthumous Novel* (New York: H. Long & Brother, 1855); William North, "The Magnetic Portraits," *Saturday Press*, Oct. 30, 1858, 1; Charles F. Briggs, "The Old and the New," *Putnam's Magazine* 1 (Jan. 1868): 2; Charles B. Seymour to Frank Bellew, Nov. 17, 1854, in Winter, *Old Friends*, 313–17, with Seymour's letter on 313–14, and a copy of North's note on 317. On Charles B. Seymour, see Browne, *Great Metropolis*, 156; Winter, *Old Friends*, 310–13; Charles B. Seymour, *Self-Made Men* (New York: Harper & Brothers, 1858). "Obituary," *New York Daily Times*, Apr. 11, 1875, 7.

10. Hemstreet, "Literary Landmarks of New York," 155–56; Briggs, "Old and the New," 3; Lalor, "Literary Bohemians," 4. See also Thomas Picton, "Memoir," in *Life and Writings of Frank Forester*, ed. by David Judd, 2 vols. (New York: Orange Judd, 1882); William S. Hunt, *Frank Forester: A Tragedy in Exile* (Newark, N.J.: Careret Book Club, 1933).

11. Browne, *Great Metropolis*, 156; Maurice, "Literary Clubland," 396; Hemstreet, "Literary Landmarks of New York," 155. "Obituary," *New York Daily Times*, Apr. 11, 1875, 7.

Thomson became a wartime correspondent of the *New York Tribune*. J. Cutler Andrews, *The North Reports the Civil War* (Pittsburgh: Univ. of Pittsburgh Press, 1955), 758.

12. The 1880 U.S. Census gives Charles's birth as the same as one Karl Pfaff, born to Michael Pfaff and Maria Anna Kohler on Jan. 13, 1820, and christened the same day at Katholisch Elzach, Freiburg. "Death of Charles I. Pfaff," under "In and About the City," *New York Times*, Apr. 26, 1890, 2. For a comparison to less upscale saloons, see Madelon Powers, *Faces along the Bar: Lore and Order in the Workingman's Saloon, 1870–1920* (Chicago: Univ. of Chicago Press, 1998).

13. Ed James quoted in Paul Lewis, *Queen of the Plaza: A Biography of Adah Isaacs Menken* (New York: Funk & Wagnalls, 1964), 10; and Traubel, *With Walt Whitman in Camden*, 9:225, 363, 370–71, 413.

14. Swinton to Whitman, June 1861, in Traubel, *With Walt Whitman in Camden*, 1:416.

15. George Arnold, "Why Thomas Was Discharged," *Atlantic Tales: A Collection of Stories*, 2d ed. (Boston: Ticknor and Fields, 1866), 162–79; Browne, *Great Metropolis*, 155; Guarneri, *Utopian Alternative*, 322, 323–24. Maurice, "Literary Clubland," 396; Hemstreet, "Literary Landmarks of New York," 155; English, "That Club at Pfaff's," 202; "Obituary," *New York Daily Times*, Apr. 11, 1875, 7; and Rawson, "Bygone Bohemia," [5, 7, 9, 10].

16. Briggs, "Old and the New," 3; Louis M. Starr, *Bohemian Brigade: Civil War Newsmen in Action* (New York: Alfred A. Knopf, 1954), 9. See also William Swinton, *Rambles among Words: Their Poetry and Wisdom* (New York: C. Scribner, 1859).

17. Traubel, *With Walt Whitman in Camden*, 1:417.

18. Bayard Taylor, "Friend Eli's Daughter," *Atlantic Tales: A Collection of Stories*, (Boston: Ticknor and Fields, 1866), 367–98. Taylor was a wartime reporter for the *New York Tribune*. Andrews, *North Reports the Civil War*, 758; Hemstreet, "Literary Landmarks of New York," 156; R. H. Stoddard, "Reminiscences of Bayard Taylor," *Atlantic Monthly* 43 (Feb. 1879): 245–46, 251.

19. Stoddard, "Reminiscences of Bayard Taylor," 242–43, 246, 247–48, and his "James Russell Lowell, Editor of 'The North American Review' from 1864 to 1873," *North American Review* 153 (Oct. 1891): 460–68. Parry, *Garrets and Pretenders*, 41, 46, 59, 77; Edmund Clarence Stedman, *Recollections, Personal and Literary* (New York: A. S. Barnes, 1903); Maurice, "Literary Clubland," 396.

20. Rawson, "Bygone Bohemia," [7, 9, 10]; letter to "Gurowski," *Saturday Press*, Jan. 1, 1859, 1; "Count Adam de Gurowski," *New York Times*, May 6, 1866, 4; Whitman, *Notebooks and Unpublished Prose Manuscripts*, 2:549; Horace Traubel, *With Walt Whitman in Camden*, vol. 3: *November 1, 1888–January 20, 1889* (New York: Mitchell Kennerley, 1914), 78–79, 340, 381–82.

21. "Free Love in the East," *New York Times*, Oct. 23, 1855, 4 (possibly by Oscanyan). Mohammed, "A Turkish View of Christian Churches," *Saturday Press*, Jan. 29, 1859, 1; Christopher Oscanyan, *The Sultan and His People* (New-York, Derby & Jackson, 1857).

22. Briggs, "Old and the New," 1, 5. Briggs ran the *New York Sunday Courier*. Winter, *Vagrant Memories*, 219; Maurice, "Literary Clubland," 396; Mary Gove Nichols, *Reminiscences of Edgar Allan Poe* (1863; repr., New York: Union Square Book Shop, 1931).

23. Notes dated Nov. 26, 1860, in Whitman, *Notebooks and Unpublished Prose*, 1:434; Charles Demerais Gardette, "Kino: A Mystification of the Crescent City," *Knickerbocker, or New York Monthly Magazine* 51 (May 1858): 470; and his poem, "The Riddle of Roland," *Godey's Lady's Book and Magazine* (Mar. 1877): 340. Rawson, "Bygone Bohemia," [5]. On DuSolle, see Browne, *Great Metropolis*, 156. On Charles Gardette in Philadelphia, see "The Man in the Blue Surtout," *Saturday Press*, Dec. 31, 1859, 2; Charles Gardette's poem "Au Revoir," *Saturday Press*, Dec. 8, 1860, 1. A Lippard short story was behind the anonymous poem "Independence Bell—July 4th, 1776," *Saturday Press*, July 7, 1860, 4. David S. Reynolds, *George Lippard* (Boston: Twayne, 1982) and the anthology he edited, *George Lippard, Prophet of Protest: Writings of an American Radical, 1822–1854* (New York: Peter Lang, 1986). On Harry Neal and other Philadelphians, see Parry, *Garrets and Pretenders*, 151–52, and Rawson, "Bygone Bohemia," [5, 7]. "Obituary," *New York Daily Times*, Apr. 11, 1875, 7.

24. David S. Reynolds, *Walt Whitman* (New York: Oxford Univ. Press, 2005) reflects the author's interest in figures such as Lippard and John Brown. As such, it provides some of the best connections between Whitman and contemporary radical movements. Despite its title, one should have no such expectations in approaching Jason Stacy's *Walt Whitman's Multitudes: Labor Reform and Persona in Whitman's Journalism and the First* Leaves of Grass, *1840–1855* (New York: Peter Lang, 2008), which does not mention Whitman's views on land reform, Fourierism, or even the importance of Clapp and his circle.

25. Traubel, *With Walt Whitman in Camden*, 3:116–77, 2: 457; vol. 4: *January 21–April 7, 1889*, ed. by Sculley Bradley (Philadelphia: Univ. of Pennsylvania Press, 1953), 184, 283, 328; vol. 5, *April 8–September 14, 1890*. ed. by Gertrude Traubel (Carbondale: Southern Illinois Univ. Press, 1964): 184, 420, 466.

26. Traubel, *With Walt Whitman in Camden*, 1:214, 236, 237, 4:195; Rawson, "Bygone Bohemia," [7, 10]. "Obituary," *New York Daily Times*, Apr. 11, 1875, 7.

27. Browne, *Great Metropolis*, 154–55. Maurice, "Literary Clubland," 396; "Hemstreet, "Literary Landmarks of New York," 156. "Artemus Ward, on the Celebration at Baldinsville, in Honor of the Atlantic Cable," *Saturday Press*, Aug. 19, 1865, 33.

28. Rawson, "Bygone Bohemia," [5].

29. Parry, *Garrets and Pretenders*, 45.

30. Rawson, "Bygone Bohemia," [5–7]. For notice of McElhenney's involvement in a play staged at the Metropolis, see "Things Theatrical," *Spirit of the Times*, Nov. 17, 1855, 480.

31. Rawson, "Bygone Bohemia," [6–7]; "Letter from Ada Clare," "Another Letter from 'Ada Clare,'" "Letter from Ada Clare," untitled letter, "From Ada Clare," "Letter from Ada Clare," "Our Paris Correspondence," *Spirit of the Times*, May 2, 1858, 134, Sept. 12, 1857, 362, Oct. 24, 1857, 433, Nov. 21, 1857, 488, Mar. 20, 1858, 61, May 8, 1858, 148, Aug. 28, 1858, 348, Oct. 9, 1858, 410.

32. Ada Clare, *Only a Woman's Heart* (New York: M. Doolady, 1866); Rawson, "Bygone Bohemia," [5, 6, 7]; "Literary Notices," *Ladies' Wreath*, Dec. 1, 1858, 69; "The Queen of Bohemia" [from New York Correspondence of the *Philadelphia Dispatch*], *Saturday Press*, Nov. 10, 1860, 1; and Horace Traubel, *With Walt Whitman in Camden*, vol. 8: *February 11, 1891–September 30, 1891*, ed. by. Jeanne Chapman and Robert MacIsaac (Oregon House, Calif.: W. L. Bentley, 1996), 312–13.

33. Ada Clare, "Thoughts and Things: The Many-Colored Joke," *Saturday Press*, Nov. 17, 1860, 3.

34. Odell, *Annals of the New York Stage*, 6:365, 446, 447, 454, 455, 493; Rawson, "Bygone Bohemia," [5–7]; Maurice, "Literary Clubland," 396; Freer, "In the Bookman's Mail," 117; Maurice, "Literary Snapshots," 485; "Obituary," *New York Daily Times*, Apr. 11, 1875, 7; "The Queen of Bohemia," *Saturday Press*, Nov. 10, 1860, 1; Whitman, for example, had Ada Clare's address; see his *Notebooks and Unpublished Prose Manuscripts*, 2:495. See also the anonymous poem "To Ada Clare," *Spirit of the Times*, Jan. 21, 1860, 600.

35. Gaston, *Women of Fair Hope*, 23–26, 36; Rawson, "Bygone Bohemia," [11].

36. Lewis, *Queen of the Plaza*, 105.

37. Rawson, "Bygone Bohemia," [39, 41]; Browne, *Great Metropolis*, 157. "Obituary," *New York Daily Times*, Apr. 11, 1875, 7; "Obituary," *New York Daily Times*, Apr. 11, 1875, 7; Wilson, *New York*, 2:143.

38. Hahn, *Romantic Rebels*, 21; Brown, *History of the American Stage*, 411; Browne, *Great Metropolis*, 157; Hahn, *Romantic Rebels*, 21. She was among those "not at all dead, but is frequently heard of as 'M.H.B.' the correspondent of the *St. Louis Republican*," "Obituary," Apr. 11, 1875, 7.

39. See George Lippard Barclay, *The Life and Remarkable Career of Adah Isaacs Menken: The Celebrated Actress* (Philadelphia: Barclay, 1868); Ed. James, *Biography of Adah Isaac Menken* (New York: Ed. James, 1869); Bernard Falk, *The Naked Lady: A Biography of Adah Isaacs Menken*, rev. ed. (1934; repr., London: Hutchinson, 1952); John S. Kendall, *"The World's Delight": The Story of Adah Isaacs Menken* (New Orleans: Thomas J. Moran's Sons, 1938); Allen Lesser, *Enchanting Rebel: The Secret of Adah Isaacs Menken* (1947; repr., Port Washington, N.Y.: Kennikat, 1973); Wolf Makowitz, *Mazeppa: The Lives, Loves, and Legends of Adah Isaacs Menken: A Biographical Quest* (New York: Stein and Day, 1982); Renée M. Sentilles, *Performing Menken: Adah Isaacs Menken and the Birth of American Celebrity* (Cambridge: Cambridge Univ. Press, 2003); Hahn, *Romantic Rebels*, 21–26; Brown, *History of the American Stage*, 243–44.

40. Anna Mary Freeman, "Song of the Flowers," *Knickerbocker, or New York Monthly Magazine* 31 (Apr. 1848): 242–43, and "Morning Song of the Flowers," *Union Magazine of Literature and Art* 3 (July 1848): 33; and Mary Freeman Goldbeck, "Love Song" and "Adjuration," *Galaxy* 12 (Nov. 1871): 697, and 15 (Feb. 1873), 177; Lewis, *Queen of the Plaza*, 91, 93–95, 126, 131, 215; Brown, *History of the American Stage*, 142. See also Getty Gay, "A City Sketch," "The Bore," "Waking from Illusions," and "The Royal Bohemian Supper," *Saturday Press*, Aug. 13, 1859, 1, Sept. 17, 1859, 1, Nov. 5, 1859,

1, and Dec. 31 1859, 2; Mrs. D. S. Curtiss, "Thirty-Five," *Saturday Press*, Aug. 13, 1859, 1. On Ada Clifton, see "The Town Shows," *Vanity Fair* (Nov. 29, 1862): 256, and "Ada Clifton, the Despondent Actress," *National Police Gazette* 35 (Dec. 20, 1879): 2.

41. Winter, *Old Friends*, 100. Odell, *Annals of the New York Stage*, 6:380.

42. Maretzek, *Sharps and Flats*, 17–18, 21, 13, 21–25, 37, 38, 41, 44, 45–46. See also Brown, *History of the American Stage*, 234, 352; Odell, *Annals of the New York Stage*, 7:61, 102, 113, 155, 156, 162, 196, 251, 256, 346, 396, 427; 428, 453, 512, 532, 560, 618. By the start of 1859, Strakosch "returned to the protection of the American Eagle" after recruiting in Europe. "Dramatic Feuilleton," *Saturday Press*, Oct. 1, 1859, 2.

43. On Fry, see Maretzek, *Sharps and Flats*, 41; "Editorial Department," *White Banner* 1 (1851), 152.

44. Winter, *Vagrant Memories*, 90; "Dramatic Feuilleton," *Saturday Press*, Oct. 8, 1859, 2; Browne, *Great Metropolis*, 156; "Obituary," *New York Daily Times*, Apr. 11, 1875, 7; as well as the many indexed citations in Odell, *Annals of the New York Stage*. On Kate Josephine Bateman, see Brown, *History of the American Stage*, 25.

45. Charles D. Shanly, "A Night in the Sewers," *Stories and Sketches by Our Best Authors* (Boston: Lee and Shepard, 1867), 293–307; Winter, *Vagrant Memories*, 300–301, and his *Old Friends*, 94–95; Browne, *Great Metropolis*, 153, 156; Hahn, *Romantic Rebels*, 20; Traubel, *With Walt Whitman in Camden*, 3:116–17.

46. See Winter, *Vagrant Memories*, 53, 228, 231, 415, 443; Brown, *History of the American Stage*, 90, 93; Winter, *Old Friends*, 88; Winter, *Shadows of the Stage* (Boston: L. C. Page and Company, 1892), 215–25; Odell, *Annals of the New York Stage*, 7:117, 159, 306, 307, 377, 379, 463, 481, 534; J. W. Watson, "How Artemus Ward Became a Lecturer," *North American Review* 148 (Apr. 1889): 522; Lewis, *Queen of the Plaza*, 85; Brown, *History of the American Stage*, 22, 309; "Dolly Davenport's Body Wanted" [from the *New Orleans Times*], and Charles Mathews's obituary, "The Prompter's Last Bell," and "Drop-Curtain Monographs," *New York Times*, Dec. 23, 1867, 5, June 25, 1878, 5, July 3, 1887, 16.

47. "New American Tragedy at Wallacks," *Saturday Press*, Aug. 13, 1859, 2; Winter, *Vagrant Memories*, 53, 228, 238; "Obituary" and "Funeral of William P. Davidge," *New York Times*, Aug. 8, 15, 1888, 5, 8.

48. See also the many productions cited in Odell, *Annals of the New York Stage*. On Mollenhauer, see Hahn, *Romantic Rebels*, 21. On the Hanlons—Thomas, George, William, Alfred, and Edward—see John A. McKinven, *The Hanlon Brothers: Their Amazing Acrobatics, Pantomimes, and Stage Spectacles* (Glenwood Ill.: David Meyer Magic Books, 1998); Brown, *History of the American Stage*, 160.

49. Huffman, *Yankee in Meiji Japan*, 15–20; Whitman, *Notebooks and Unpublished Prose Manuscripts*, 1:265n; Andrews, *North Reports the Civil War*, 754; Rawson, "Bygone Bohemia," [7, 11]; Browne, *Great Metropolis*, 154; Freer, "In the Bookman's Mail," 117. "Obituary," Apr. 11, 1875, 7.

50. "Art and Politics," *Saturday Press*, July 14, 1860, 2; Rawson, "Bygone Bohemia," [1–12]; Paul Johnson, *The Masters Revealed: Madame Blavatsky and the Myth of the Great White Lodge* (Albany: State Univ. of New York Press, 1994), 25–26; John Patrick

Deveney, "Nobles of the Secret Mosque: Albert L. Rawson, Abd al-Kader, George H. Felt and the Mystic Shrine," and his "The Travels of H.P. Blavatsky and the Chronology of Albert Leighton Rawson: An Unsatisfying Investigation of H.P.B.'s Whereabouts in the Early 1850s," *Theosophical History* 8 (July 2002): 250–61, and 10 (October 2004): 8–31. A. L. Rawson, "Mme. Blavatsky—A Theosophical Occult Apology," *Frank Leslie's Popular Monthly* 33 (Feb. 1892): 201; Marion Mead, *Madame Blavatsky: The Woman Behind the Myth* (New York: G. P. Putnam's Sons, 1980), 508.

51. Frank H. Norton, "Ten Years in a Public Library," *Galaxy: A Magazine of Entertaining Reading* 8 (Oct. 1869): 531; Winter, *Vagrant Memories*, 121; Winter, *Old Friends*, 317–20; "Mr. Arthur Lumley Returns to the Nast-Santa Claus Discussion," *New York Times*, June 25, 1904, BR438. Brown, *History of the American Stage*, 118.

52. Odell, *Annals of the New York Stage*, 7:683; and George Parsons Lathrop, "The Literary Movement in New York," *Harper's New Monthly Magazine* 73 (Nov. 1886): 833.

53. Traubel, *With Walt Whitman in Camden*, 5:470–71; Eugene Benson, "Eastman Johnson," *Galaxy* 6 (July 1868): 3; William Stillman, *The Acropolis of Athens, Illustrated Picturesquely and Architecturally in Photography* (London: F. S. Ellis, 1870), available at the Division of Rare and Manuscript Collections, Cornell Univ. Library, Ithaca, N.Y.; and Matthew Biagell, *Albert Bierstadt* (New York: Watson-Guptill, 1981).

54. "The Individuality of Genius," *Saturday Press*, Oct. 29, 1859, 2; and Rawson, "Bygone Bohemia," [9].

55. The group was ostensibly inspired by an 1830 musical piece "The Pilgrim Fathers"—better known as: "The Landing of the Pilgrims." See also Winter, *Old Friends*, 66, 374; Southworth, "Sculptors of New York," 5.

4. Liberty and Coercion

Epigraph from "'Sam Test' and Ada Clare," *Spirit of the Times*, Nov. 21, 1857, 488.

1. Bernard A. Weisberger, *Reporters for the Union* (Westport Conn.: Greenwood, 1953), 72–73; and Huffman, *Yankee in Meiji Japan*, 24–26. Thomas Hovenden painted the image twenty-five years later, and the tableau entered into the widely believed mythology around Brown's martyrdom. Shortly after, Ned Underhill recalled that he had passed the story from the paper from someone alleged to have been there, and other sources said that it had been Edward H. House.

2. Ned Underhill had "been in practice seventeen months." "Correspondence" and Nessung, "The Unitary Household," *Saturday Press*, Sept. 10, 1859, 2; "Practical Socialism in New-York," and Underhill letter, "The Unitary Household. Letter from Mr. Underhill in Reply to the Article in the Times," *New York Times*, June 25, 1858, 2, Sept. 26, 1860, 2.

3. Underhill letter, "The Unitary Household." The course of the experiment was followed by the *Brooklyn Daily Eagle*, as well, which offered commentary in untitled editorial items on May 15, Sept. 21, Nov. 10, 1858, all on 2.

4. "Practical Socialism in New-York," *New York Times*, June 22, 1858, 5.

5. "The Free Love System: Origin, Progress and Position of the Anti-Marriage Movement," and "The Homestead Bill," *New York Times*, Sept. 8, 1855, 2, Feb. 14, 1859, 4; as well as "Land for the Landless," *National Era*, July 14, 1859, 112.

6. "The Unitary Household. Letter from the Proprietor in Reply to the Times," "Times," and "Regaining their Senses," *New York Times*, June 25, 1858, 2, July 29, 1858, 4, Aug. 4, 1858, 4.

7. Underhill letter, "Practical Socialism in New York." Eventually, if temporarily, of its accounts of the household, the paper acknowledged that it was "by no means impossible that they may have come to us in an exaggerated form, and that isolated instances of misconduct may have been regarded and presented as characteristic of a system." *New York Times*, July 29, 1858, 4.

8. "Free Love. Expose of the Affairs of the Late 'Unitary Household,'" *New York Times*, Sept. 21, 1860, 5; "Correspondence." Nessung, "The Unitary Household," *Saturday Press*, Sept. 10, 1859, 2; "The Organs of Modern Socialism," *New York Herald*, July 14, 1858, 4.

9. "A Duel at the Phalanx," *New York Times*, July 7, 1859, 5. The excursion would have been to George Arnold's former home, whether it was to the old North American Phalanx or the Raritan Bay Union. Lucy Fir, "From the Village of 'Modern Times'" [from the *Sunday Dispatch*], *Saturday Press*, Nov. 27, 1858, 1.

10. Gaston, *Women of Fair Hope*, 32, 33, Whitman knew Mrs. Case's address; see his *Notebooks and Unpublished Prose Manuscripts*, 1:453, 2:495. On E. Howland, see Honore de Balzac, "A Treatise Upon the Life of Elegance," trans. by Edward Howland. *Saturday Press*, Oct. 13, 1860, 1, with further pieces on "Balzac," F.L.W., "Reminiscences of Balzac," in the issues of Nov. 3, 1860, 1, and Aug. 19, 1865, 37–39, 42–43.

11. Henry Clapp Jr., *Husband v. Wife; or, Nobody to Blame. With designs by A. Hoppin* (New York: Rudd & Carleton, 1858), 44. Clapp wrote a piece in the *Knickerbocker* (Nov. 1858), which was announced in Washington *National Era*, Nov. 4, 1858, 175. For an additional response to William Allen Butler's *Nothing to Wear* (New York: G. P. Putnam, 1857), see K. Barton, *Nothing to You; or, Mind Your Own Business. In Answer to "Nothings" in General, and "Nothing to Wear" in Particular. By Knot-Rab* [pseud.] *With Illustrations by J. H. Howard* (New York: Wiley & Halsted, 1857).

12. Briggs, "Old and the New," 3–4; "Workingmen's Mass Meeting. Gathering at the Broadway Tabernacle," *New York Times*, Jan. 30, 1855, 4. On Fry, see Maretzek, *Sharps and Flats*, 41.

13. "Republican Festival. Grand Celebration of the Universal Democratic Republicans," "Anniversary of the French Republic," "Celebration of the Twenty-Fifth Anniversary of the Polish Revolution," "English Republicanism in the United States," "Great German Fremont Meeting," "Celebration of the Anniversary of the Proclamation of the French Republic of 1792," "Celebration of the Anniversary of the Polish Revolution," "The European Revolutionists—Celebration of the 24th of February 1848," "Funeral of Dr. Louis Szpaczeck," *New York Times*, Feb. 25, 1854, 8;

Feb. 26, 1855, 2, Nov. 30, 1855, 8, Apr. 1, 1856, 4, Aug. 22, 1856, 1, Sept. 23, 1856, 4, Dec. 1, 1856, 6, Feb. 25, 1857, 8, Apr. 11, 4, 1859.

14. "The Sanders Dinner to the Revolutionary Exiles in London" [from Brussell's *Nation*], "The First French Republic—Anniversary by the Society of the Mountain," *New York Times*, Mar. 29, 1854 and Sept. 24, 1855, both 1; Parry, *Garrets and Pretenders*, 45. Clapp said, regarding Texas, "Paradise might well have been located there—they tickle the soil with a hoe and it laughs with a harvest." Rawson, "Bygone Bohemia," [4].

15. "The Mechanics' and Workingmen's Meeting in the Park," *New York Times*, Oct. 29, 1856, 1.

16. "A National Land-Reform Convention," "Kansas. Convention of Kansas Aid Committees at Buffalo," *New York Times*, June 27, July 11, 1856, 5, 8.

17. "Republican Organizations," "Mechanics to the Rescue," three under the heading "Free Territory for Free Labor," an untitled notice, "Huzza for the Natick Cobbler," two under "Free Labor. Senator Wilson before the Mechanics and Working-men of New-York," "Mechanics and Workingmen, to the Rescue!" *New York Times*, Mar. 27, 1856, 5, Sept. 2. 1856, 3, Sept. 11, 1856, 6, Sept. 22, 1856, 3, Sept. 30, 1856, 3, Oct. 3, 1856, 4, Oct. 4, 1856, 6, Oct. 6, 1856, 1, Oct. 11, 1856, 4, Oct. 21, 1856, 3.

18. "Free-Soil Meeting," "Meeting of the Workingmen's State Central Committee," "The Mechanics' and Workingmen's State Central Committee," and "Meetings of the Unemployed. Mayor Wood's Reception of Them. Action of the Common Council on their Petition," *New York Times*, Jan. 28 1857, 1, July 1, 1857, 1, July 2, 1857, 4, Nov. 6, 1857, 2; "Immense Gathering of Workingmen. Mass Meeting at Tompkins Square and City Hall Park," *New York Herald*, Nov. 6, 1857, 8.

19. Three articles under the title "The Land Reformers," "The Workingmen's State Convention," "The Political Campaign. Celebration of the Opposition Triumphs. Meeting of Americans and Republicans in the City Hall Park," "Cassius M. Clay on Free Labor, Slavery, Poverty and Things in General," "Distribution of the Public Lands," "The Freedom of the Public Lands—Timothy Davis, M.C., of Iowa, and the Land Reformers," *New York Times*, Jan. 29,1858, 1, Mar. 11, 1858, 4, Oct. 5, 1858, 1, Oct. 14 1858, 5, Oct. 22, 1858, 1, Dec. 27, 1858, 3, July 21, 1859, 4, Aug. 9. 1859, 3.

20. "Letter from the Editor," and "Garibalderdash," *Saturday Press*, Aug. 6, Oct. 1, 1859, both 2. See also that same paper's commentary: "Official Report of the Emperor's Address," "The Families of Bonaparte and Garibaldi" [from *Atheneum*], Aug. 13, 1859, 4, Nov. 10, 1860, 1, as well as reprints from the *Independent* of poems by: Elizabeth Barrett Browning, "Garibaldi"; John G. Whittier, "Italy"; and "Naples.—1860," Oct. 13, Dec. 1, Dec., 15, 1860, all on 1, as well as a discussion of the controversy around "Alexander Dumas and Garibaldi" [from *Philadelphia Press*], Sept. 22, 1860, 1, which had to do with the appearance of *Giuseppe Garibaldi, My Life*, trans. by Stephen Parkin (London: Hesperus, 2004); *The Memoirs of Garibaldi*, ed. by Alexandre Dumas, trans. by R. S. Garnett (New York: D. Appleton, 1931). Clapp passed on a description and picture of Garibaldi to Whitman: Clapp to Whitman, Oct. 3, 1857, in Traubel, *With Walt Whitman in Camden*, 1:267, with clipping quoted, 268–69.

21. *Memoirs and Adventures of Felice Orsini Written by Himself*, 2d ed., ed. by Ausonio Franchi (1857; repr., Turin: n.p., 1858); and Christine Lattek, *Revolutionary Refugees: German Socialism in Britain, 1840–1860* (New York: Routledge, 2006), 183–84.

22. "The Orsini and Pierri Demonstration. Grand Torchlight Procession of Frenchmen, Germans, Italians, Hungarians, and Other Foreigners. Large Gathering in the Park" and "The Memory of Humboldt," *New York Times*, Apr. 23, 1858, 1, July 12, 1859; "The World At Large," *National Magazine: Devoted to Literature, Art, and Religion* 12 (June 1858): 571.

23. The Orsini and Pierri Demonstration" *New York Times*, Apr. 23, 1858, 1; "National Reform Banquet" [from the *Cincinnati Daily Herald*], *Harbinger* 7 (June 10, 1848): 45–46. On Brisbane's continued association with Clapp, see his "The Five Senses," *Saturday Press*, Mar. 19, 1859, 1.

24. "Orsini and Pierri Meeting in Boston," Garrison quote from "Personal," "The Orsini Conspiracy in England," "Orsini Demonstration in Chicago," Detroit in "Demonstrations of the Unemployed," *New York Times*, May 1, 1858, 1, May 3, 1858, 1, 4, May 21, 1858, 2, June 8, 1858, 5.

25. For this and the following paragraph, "The Republican Celebration by the International Society," *New York Times*, June 24, 1858, 4.

26. "The Republican Celebration by the International Society," *New York Times*, June 24, 1858, 4; and "Anniversary of the French Revolution of 1792," *New York Herald*, Sept. 23, 1858, 4.

27. "Appendix 8: A Manifesto by the Central International Committee Sitting in London, June 24, 1858," from Arthur Lehning, "International Association," in his *From Buonarroti to Bakunin: Studies in International Socialism* (Boston: Brill, 1970), 241–46.

28. "The Orsini and Pierri Sympathizers," "The Moloch of Radicalism," "Practical Socialism in New York," The Republican Celebration by the International Society," *New York Times*, Apr. 14, 1858, 4, Apr. 21, 1858, 4, June 22, 1858, 4, June 24, 1858, 4. The same paper reported: "A rabid Red Republican, who has long disgusted the sensible portion of the German population by his fierce tirades in the *Pioneer,* of which paper the person in question is editor," had offered to kill Napoleon III if his expenses were paid. "Assassination by Contract," Apr. 26, 1858, 4.

29. Untitled item, "A CASE FOR THE UNDERGROUND RAILROAD.—SLAVERY OF WOMEN.—Mrs. JULIA BRANCH," *New York Times*, June 28, 1858, 4; "The Cause and Cure of Evil," *New York Times*, Sept. 2, 1858, 4; William Goodell, "The Rutland Convention," *Radical Abolitionist* 3 (July 1858): 89; "The Convention of Radicals at Rutland, Vermont," *Memphis Daily Appeal*, July 9, 1858, 1; and, for Clapp's words, the *Proceedings of the Free Convention,* 56. John B. Buescher identified Branch as a member of a "Unitary Home," surely the Unitary Household with which the bohemians in New York had become so closely identified. *The Remarkable Life of John Murray Spear: Agitator for the Spirit Land* (Notre Dame, Ind.: Univ. of Notre Dame Press, 2006), 205–6, 209.

30. *Proceedings of the Free Convention*, 10; Mark A. Lause, *The Civil War's Last Campaign: James B. Weaver, the National Greenback-Labor Party, and the Politics of Race and Section* (Lanham, Md.: Univ. Press of America, 2001), particularly the chapter on the convention, 65–88.

31. "A Second Edition of the Rutland Convention," Aug. 7, 1858, 4; "The Philanthropic Convention at Utica," "The Free-Love Convention," Untitled item "THE FREE-LOVERS AT UTICA," "Harmonial Convention," "A Variety of State Conventions," "Another Reformatory Convention," "News by Telegraph. Abolition, Free Love, Infidel and Women's Rights Convention," *New York Times*, Sept. 11, 1858, 1, Sept. 13, 1858, 1, Sept. 15, 1858, 4, Sept. 17, 1858, 4, Sept. 21, 1858, 4, Sept. 8, 1859, 4, Sept. 19, 1859, 4 "'Overcoming Evil with Good'—Convention," and "Overcoming Convention," *New York Tribune*, Sept. 11, 13, 1858, both 5; "Utica Philanthropic convention. Its organization—Few Philosophers Present," *New York Herald*, Sept. 12, 1858, 1; "First Anniversary of Philanthropic Convention," "Religious Reform Convention at Ellensville, N.Y.," *Liberator*, Aug. 12, 1859, 127, Sept. 30, 1859, 29.

32. H. L. Flash, "Haunted," on Balthazar the alchemist "Balzac," "Mesmerism and Matrimony: Or, Science versus Widow" [Knitting Work], Nessung, "Spiritualism," *Saturday Press*, Aug. 13, 1859, 4, Aug. 27, 1859, 1, Sept. 10, 1859, 1, Sept. 17, 1859, 2, as well as the letters of Judge John W. Edmonds, reprinted from the *New York Tribune* through late 1859. Early in its history, the paper listed Munson among the "Agents for the Sale of the New York Saturday Press," as in, for example, the issue of Dec. 18, 1858, 2. On Ballard, see Wunderlich, *Low Living and High Thinking*, 39.

33. Mortimer Thomson, *The Witches of New York* (New York: Rudd & Carleton, 1859). Debunking pieces include "The Haunted House in Astoria" [from the *New Jerusalem Messenger*], *Saturday Press*, Nov. 27, 1858, 1; "The Automaton Chess-Player" [from Robert Houdini Conjurer], "Tom Taylor and Hume, the Spiritualist," *Saturday Press*, Aug. 13, 1859, 1; June 30, 1860, 2.

34. "Free Love. Expose of the Affairs of the Late 'Unitary Household,'" and "Fourier and Free-Love—Note from Court Gurowski," with the letter from Thomas L. Nichols on "Free Love and Mary Lyndon," *New York Times*, Sept. 21, 1860, 5, Oct. 26, 1860, 2. Underhill frankly recounted the most scandalous development in the household. He wrote that one resident "in a drunken frenzy, in the presence of his family and servants, knocked his wife down, dealing several powerful blows, and followed up this demonstration by choking her until she was rescued from his grasp by the interference of others." "Out of sympathy for those dependent upon him," Underhill had resisted appeals to dismiss the man, but the offending individual had been the source of the lies and libels printed in the *Times*. "The Unitary Household. Letter from Mr. Underhill in Reply to the Article in the Times" with the response, "The Unitary Household and the Free Love System," Sept. 26, 1860, 2. Stedman recalled the Unitary Household as the site of as "many romances and jealousies as elsewhere." Stedman, quoted in Gaston, *Women of Fair Hope*, 32–33. The conflict was likely in reference to Marx Edgeworth Lazarus, whose history included outbreaks of violence

indicative of some instability. See also Emily Bingham, *Mordecai: An Early American Family* (New York: Hill and Wang, 2003).

35. Rawson, "Bygone Bohemia," [11]; and Browne, *Great Metropolis*, 152. Certainly, in the wake of Rutland, Clapp wrote a self-deprecating "Proposal for a New Series of Lectures," *Saturday Press*, Dec. 4, 1858, 2. These would include lectures on "Free Love" and "Passional Attraction."

36. Lalor, "Literary Bohemians," 98–100, 101–2; "Card," Untitled notice, the "*Saturday Press* building" described in "By Overland Mail. Brigham Young's Two Hours with Horace Greeley," *Saturday Press*, Jan. 29, Aug. 13, 27, 1859, all 2; Wilson, *New York*, 2:125.

37. Edward, Everett. *The Mount Vernon Papers* (New York: D. Appleton, 1860). Also, Browne, *Great Metropolis*, 152–53.

38. Winter, *Old Friends*, 60–61. William Winter, "Out in the Storm" [from *Harper's Monthly* for December], *Saturday Press*, Nov. 24, 1860, 1.

39. "To Whom It May Concern," "Book-Making in America" [from *Boston Transcript*], and "New Feature of the Atlantic Monthly," "Disreputable Journalistic Practices," "A Worthless Book," D. H. Craig, "Editorial Discipline and Deportment," "Opinions of the Press," "Obituary of a Newspaper" [from the *Evening Post*]," "The Newspaper and the Reader," *Saturday Press*, Nov. 6, 1858, 2, 4, Jan. 1, 1859, 2, Aug. 13, 1859, 1, Sept. 10, 1859, 2, Oct. 1, 1859, 1, Nov. 26, 1859, 4, June 30, 1960, 4, July 7, 1869, 2.

40. On Holmes, see L. de Loop, "Phrenology" and "Fragments from the Table of an Intellectual Epicure," both in *Saturday Press*, Aug. 20, 1859, 2, June 23, 1860, 4. Parry, *Garrets and Pretenders*, 45; "William Winter's Literary Idols and Animosities," *Current Literature* 47 (Oct. 1909): 403, and quoted, 404; and Rawson, "Bygone Bohemia," [3].

41. Parry, *Garrets and Pretenders*, 15, 16, 24–25, 39, 41, 47; Hahn, *Romantic Rebels*, 20, 28; Lalor, "Literary Bohemians," 4, 70. On George Clapp, see "Died in Bowery Lodgings," *New York Times*, Apr. 10, 1893, 3; Traubel, *With Walt Whitman in Camden*, 4:196; Winter, *Old Friends*, 57; "William Winter's Literary Idols and Animosities," 401–5. See also William Winter's works: *Vagrant Memories, Being Further Recollections of Other Days* (New York: George H. Doran, 1915), 176. Rawson, "Bygone Bohemia," [7, 10]; Hemstreet, "Literary Landmarks of New York," 156 Freer, "In the Bookman's Mail," 117; "Current Memoranda," *Potter's American Monthly* 5 (Sept. 1875): 714; Andrews, *North Reports the Civil War*, 751, 758; Maurice, "Literary Clubland," 396. See also Thomas B. Aldrich, "Piscataqua River—1860" [from Independent], *Saturday Press*, Nov. 24, 1860, 1.

42. On Greeley, see Lewis, *Queen of the Plaza*, 86. On Halleck, see Freer, "In the Bookman's Mail," 117.

43. "Mass Meeting of Germans to Organize an Independent Political Party," *New York Times*, Oct. 14, 1858, 5.

44. "Manifestation of the Solidarity of the Nations," and "City Intelligence," *New York Times*, Jan. 15, 18, 1859, both 5.

45. "'Who and What Next,'" *Saturday Evening Press*, June 9, 1860, 2.

46. "Kansas. The Insurrectionary Movement in Southern Kansas—General News,'""Obituary," *New York Times*, Jan. 18, 1859, 8, Apr. 11, 1875, 7; Jeffery Rossbach, *Ambivalent Conspirators: John Brown, the Secret Six, and a Theory of Slave Violence* (Philadelphia: Univ. of Pennsylvania Press, 1982), 200, 202; and Traubel, *With Walt Whitman in Camden*, 5:48, 40–41 "Hinton, J. R., Leavenworth, Kansas" is listed among the contributors to the first volume of the *Round Table* (June 11, 1864): 1. Thomson, *Plu-Ri-Bus-Tah*, 189. Arnold, "Why Thomas Was Discharged"; Browne, *Great Metropolis*, 155; Guarneri, *Utopian Alternative*, 322, 323–24. Maurice, "Literary Clubland," 396; Hemstreet, "Literary Landmarks of New York," 155; English, "That Club at Pfaff's," 202; Rawson, "Bygone Bohemia," [5, 7, 9, 10]. See, too, Wm. S. and Caroline A. Bailey, "Death of Our Daughter, Laura" [from *Free South*] and Augustus Wattles, "Maple Island," *Saturday Press*, Sept. 10, 24, 1859, both 1.

47. Otto Scott, *The Secret Six: John Brown and the Abolitionist Movement* (New York: n.p., 1979), 231–32, 240–41, 246–47, 248–50, 251–52, 255–56; Rossbach, *Ambivalent Conspirators*, 132, 133, 135–41, 141–44, 144–46, 146, 149, and 178; Stephen B. Oakes, *To Purge the Land with Blood: A Biography of John Brown* (New York: Harper & Row, 1970), 200–201, 211–13; W. D. H. Callendeer to Brown, July 2, 1857, Brown Papers, Kansas State Historical Society, Topeka; George M. Trevelyan, *Garibaldi and the Making of Italy* (London: Longmans, Green, 1914), 98–99; George M. Trevelyan, *Garibaldi's Defense of the Roman Republic* (London: Longmans, 1907), 349–51. W. H. Tinson at New York printed three versions of Hugh Forbes's *Manual for the Patriotic Volunteer on Active Service in Regular and Irregular War* during these years, each of which is in the collections of the Library of Congress. The one-volume edition of 1854 likely represented a manuscript put together in the wake of his Italian experience. An expanded, two-volume, second edition appeared under the same title in 1855. What Brown was discussing here was the truncated *Extracts from the Manual for the Patriotic Volunteer on Active Service in Regular and Irregular War*, printed in 1857.

48. Rossbach, *Ambivalent Conspirators*, 162n5, 171–72, 134, 160–64, 172–73, 174; Untitled items, "Garibaldi and his Former English Lieutenant," and "A Roman" letter on "Garibaldi and Colonel Forbes," *New York Times*, June 24, 1859, 2, June 28, 1859, 1; John Brown Jr. to Hugh Forbes, Jan. 15, 1858, John Brown to John Brown Jr., Feb. 9, 1858, both in Boyd B. Stutler Collection, West Virginia State Archive, Charleston, W.V.; Franklin B. Sandborn, ed. *The Life and Letters of John Brown, Liberator of Kansas and Martyr of Virginia* (Boston: Roberts Brothers, 1885), 432–33.

49. Rossbach, *Ambivalent Conspirators*, 185–86, 186–88.

50. Richard J. Hinton, "John Brown and His Men," *Frank Leslie's Popular Monthly* 29 (June 1889): 695, and, for the later New York City connection, Hinton, *John Brown and His Men*, (New York: Funk & Wagnalls, 1894), 162–63. For repetition of the persistent slanders of Forbes, see Benjamin Quarles, *Allies for Freedom: Blacks and John Brown* (Oxford: Oxford Univ. Press, 1974), 52–53; and Daniel C. Littlefield, "Blacks,

John Brown, and a Theory of Manhood," *His Soul Goes Marching On: Responses to John Brown and the Harpers Ferry Raid*, ed. by Paul Finkelman (Charlottesville: Univ. Press of Virginia, 1995), 79; David S. Reynolds, *John Brown, Abolitionist: The Man Who Killed Slavery, Sparked the Civil War, and Seeded Civil Rights* (New York: Knopf, 2005), 240, 113–14, 191, 234, 240–44, 258.

51. Augustus Saint-Gaudens, *The Reminiscences of Augustus Saint-Gaudens, edited and amplified by Homer Saint-Gaudens*, 2 vols.(New York: Century 1913), 1:17, 23; Kenneth Mackenzie thought an androgynous Egyptian order reached Europe through Jutland and northern Europe: *The Royal Masonic Cyclopedia* (London: privately printed, 1877), 43; publisher's introduction, Jacques Etienne Marconis, *The Sanctuary of Memphis* (Monroe, N.C.: Nocalone Press, 1933) 3–4; Calvin C. Burt, *Egyptian Masonry* [original title: *Egyptian and Masonic History of the Original and Unabridged Ancient and Ninety-Six Degree*] (N.p.: n.p., 1879), 203–4, 205, 206, 207, 314–17; and "The French Masonic Incident" in the history of Prince Hall masonry is discussed at www.freemasonry.org/jawalkes/page_3.htm (as of May 4, 2009, no longer online).

52. "Funeral of Harry G. Seymour," *New York Daily Times*, June 18, 1883, 8; Brown, History of the American Stage, 328. Odell, *Annals of the New York Stage* 5:594, 6:42, 140, 222, 223, 555.

53. Weisberger, *Reporters for the Union*, 68–69; and "Waifs from Washington," *Saturday Press*, Dec. 10, 1859, 2.

54. Two articles titled "Waifs from Washington" *Saturday Press*, Dec. 10, 31, 1859, both 2; and, for Clapp's quip on Brown's execution, see Rawson, "Bygone Bohemia," [4].

55. "Our Good Wishes," *Saturday Press*, Dec. 24, 1859, 2.

56. Getty Gay, "The Royal Bohemian Supper," and also "The Queen of Bohemia," *Saturday Press*, Dec. 31 1859, 2, Nov. 10, 1860, 1.

5. Representing Alienation

Epigraph from McWatters, *Knots Untied*, 509.

1. Ibid., 33; "A Chance for the Charitable," "Aid for Disabled Veterans—Interesting Correspondence," New York item under "Local News in Brief," McWatters, "Senator Wilson and the Solider," 8; McWatters's letter, "Practical Sympathy" in the "Letters to the Editor," "Death of George S. McWatters," *New York Times*, June 11, 1869, 2, Aug. 23, 1870, 2, Oct. 13, 1870, 8, June 6, 1872, July 29, 1883, 3, Apr. 8, 1886, 8; Holyoake, "Stranger in America," 365.

2. Brown, *History of the American Stage*, 66, portrait on 79. Earlier radicals would have appreciated Clapp's noting of the "curious necessity" of placing factories in pastoral settings. "S. P. Willis" letter to Home Journal, "American Watches," *Saturday Press*, Nov. 5, 1859, 4 (surely a spoof of N. P. Willis).

3. Traubel, *With Walt Whitman in Camden*, 1:237, 417. 2:375, 5:227, 3:117. See also "Correction," "Walt Whitman" by "A Woman," *Saturday Press*, June 9, 1860, 2, June 23, 1860, 3.

4. Maretzek, *Sharps and Flats*, 18–19.

5. Huffman, *Yankee in Meiji Japan*, 16–17; William Winter, "On the Death of Lawrence Barrett," obituary of March 20, 1891, in Winter's *Shadows of the Stage*, 218–19.

6. McWatters, *Knots Untied*, 625, 543. At the time, police work involved minimal forensics among the "circumstantial evidence" that had to be balanced against "the oral testimony of living witnesses, who may be prejudiced or bribed," and both involved an element of subjective perceptions seen through the prism of class.

7. Thomson, *Plu-Ri-Bus-Tah*, 196; George Cooper, "The Toiler," *Saturday Press*, June 2, 1866, 5.

8. Freer, "In the Bookman's Mail," 117.

9. The proceedings of these conventions were later published in the *Printer* 2 (Sept. 1859): 108, (Oct. 1859): 129.

10. "Actors' Protective Union," and "Meeting of the Actors' Protective Union," *New York Daily Times*, Aug. 5, 1864, 3, Aug. 19, 8, 1864.

11. Maretzek, *Sharps and Flats*, 43–44; "Musical Mutual Protective Union" under heading "Synopsis of Bills Before the Legislature," *New York Daily Times*, Mar. 13, 1864, 3, May 4, 1864; meeting announcement, *Brooklyn Daily Eagle*, May 3, 1864, 3. Max Maretzek and others of the operatic, musical, and theatrical occupations held an 1864 Christmas Eve benefit for at the Brooklyn Academy of Music for the Working Women's Protective Union, as described in a classified advertisement under "The Trades," *Brooklyn Daily Eagle*, Dec. 22, 1864, 1.

12. "Beggars," *Saturday Press*, Sept. 8, 1860, 2; "The Unemployed. Large Meeting in Hope Chapel,""Labor. Condition of the Unemployed Poor," and "Practical Socialism in New-York," *New York Daily Times*, Jan. 9, 1855, 4, Mar. 1, 1855, 2, 1855, June 22, 1858, 5.

13. Mortimer Thompson, *Nothing to Say: A Slight Slap at Mobocratic Snobbery, Which Has "Nothing to Do" with "Nothing to Wear"* (New York: Rudd & Carleton, 1857) 58, 59, 60.

14. "'Man and His Dwelling Place;'" two items on the "American Photographical Society,""Darwin's 'Origin of Species,'" *Saturday Press*, Jan. 29, 1859, 2 Aug. 13, 1859, 2, Sept. 24, 1859, 1, 1859, Feb. 25, 1860, 2; Traubel, *With Walt Whitman in Camden*, 3:499. See also James Hinton, *Man and His Dwelling Place: An Essay towards the Interpretation of Nature* (New York: Redfield, 1859).

15. Lalor, "Literary Bohemians," 70–71, 72; "The Bohemian in Government—'Read His History in a Nation's Eyes,'" "Pedagogues," and "The Harvard Historians," *Saturday Press*, July 7, 1860, 2, Oct. 20, 1860, 2, Nov. 17, 1860, 3; and Parry, *Garrets and Pretenders*, 45.

16. "Woman in the Kitchen," *Saturday Press*, July 21, 1860, 2.

17. Ada Clare, "The Home-Made Shirt," *Vanity Fair* (Dec. 31, 1859): 6.

18. Ada Clare, "A Lady's Ideas on Crinoline and Bloomers" [from *New York Leader*] *Saturday Evening Post*, Apr. 19, 1862, 4.

19. "Dramatic Feuilleton," "Artemus Ward Encounters the Octoroon," *Saturday Press*, Oct. 15, 1859, 2, July 14, 1860, 4.

20. Clapp, "The Song of the Worldling," *The Knickerbocker, or New York Monthly Magazine* 52 (Aug. 1858): 158; John Burroughs, "A Thought on Culture," *Saturday Press*, July 21, 1860, 1. Burroughs wrote: "In the conduct of life, a man should not show his knowledge, but his wisdom."

21. McWatters, *Knots Untied*, 462, 630; "The Twaddle of Business [*Willis' Musical World*]," *Saturday Press*, Aug. 6, 1859, 1; and Parry, *Garrets and Pretenders*, 45.

22. McWatters, *Knots Untied*, 626, 627, 628–29, 640–41, 639–40.

23. Ibid., 609, 606. On Commissioners of Public Charities and Corrections communication from the superintendent of Blackwell's Island southeast staircase tower of building occupied by women leaning west and south, "The Leaning Tower of New York," *Saturday Press*, May 26, 1860, 3.

24. McWatters, *Knots Untied*, 42–43; "Death of George S. McWatters," *New York Times*, Apr. 8, 1886, 8; Edward Winslow Martin [James McCabe], *The Secrets of the Great City* (Philadelphia: Jones, Brothers & Co., [1868]), 544–45; David M. Barnes, *The Draft Riots in New York. July, 1863. The Metropolitan Police: Their Services during Riot Week. Their Honorable Record* (New York: Baker & Godwin, 1863), 82.

25. "Mount Vernonism," "Extracts from Mr. Edward Everett's Life of Washington," and "The Tomb of the Washington Family in England" [from *Boston Daily Advertiser*], *Saturday Press*, Jan. 8, 1860, 2, Sept. 22, 1860, 2, Dec. 1, 1860, 4, 1860; and Thomson, *Plu-Ri-Bus-Tah*, 36.

26. Thomson, *Plu-Ri-Bus-Tah*, x, 30, 133, 45, 76, 143.

27. Ibid., 45, 41, 42, 43, 124, 84–85. From Ike Partington "The American Eagle," *Saturday Press*, Oct. 30, 1858, 4. Whitman was later visited by "three Hindu fellos" (May 26, 1889) and had himself "frequently" visited black soldiers, particularly at Culpepper hospital. Traubel, *With Walt Whitman in Camden*, 5:230, 299.

28. Thomson, *Plu-Ri-Bus-Tah*, 112–13, 119.

29. "The Song of the Worldling" from *The Knickerbocker, or New York Monthly Magazine* 52 (Aug. 1858): 158.

30. Clapp, "Modern Christianity," *Pioneer*, 40–43; *Proceedings of the Free Convention*, 60; "The Unitary Household. Letter from Mr. Underhill in Reply to the Article in the Times," *New York Times*, Sept. 26, 1860, 2; and "Letter from Ada Clare," *Spirit of the Times*, Oct. 24, 1857, 433. Clapp quipped once, "I've no prejudices. I don't think a man is ever good for much without them, but there is my misfortune." "New Portrait of Paris," Dec. 4, 1858, 2.

31. Quoted in "The Other Side," "Who and What Next," Joseph Barber, "Our Rich and Poor [from *New York Mercury*]," *Saturday Press*, Aug. 13, 1859, 2, June 9, 1860, 2, Aug. 11, 1860, 1.

32. McWatters, *Knots Untied*, 590.

33. Nathaniel Rogers, "Labor," and also his discussions of "Aristocracy," "The Poor House," *Saturday Press*, Oct. 8, 1859, 1, July 28, 1860, 2, Aug. 4, 1860, 2, Aug. 5, 1865, 3–4.

34. Fitz-Hugh Ludlow, "The Proper Use of Grandfathers," *Stories and Sketches by Our Best Authors* (Boston: Lee and Shepard, 1867), 61–76; Parry, *Garrets and*

Pretenders, 6, 55. See also, "De Quincy" [from the *London Critic*, Aug. 20], *Saturday Press*, Sept. 24, 1859, 4. Ludlow excerpts in *Decadents, Symbolists, and Aesthetes in America: Fin-de-Siècle American Poetry: an Anthology*, ed. Edward Foster (Jersey City, N.J.: Talisman, 2000), 17–21. See Traubel, *With Walt Whitman in Camden*, 1:267, 268–69. Norman A. Bergman, *Humphry Davy's Contribution to the Introduction of Anesthesia: A New Perspective* (Chicago: Univ. of Chicago Press, 1991).

35. "Important Reform among the Israelites" [from the *Baltimore Sun*], Richard D. Webb, "Quakers Again," Veritas, "Decay of Quakerism" [from *London Times*], "The Other Side," "Dr. Bellows' Statement," "Ada Clare," "Thoughts and Things," "Our Religion," "Who and What Next," "The Bohemian in Government—'Read his history in a nation's eyes,'" "Freedom *NOT* to Worship God," Thomas Bailey Aldrich, "The Crescent and the Cross," *Saturday Press*, Dec. 4 ,1858, 2, Jan. 29, 1859, 1, 2, Aug. 13, 1859, 2, Aug. 27, 1859, 1, Sept. 24, 1859, 2, Oct. 22, 1859, 2, June 9, 1860, 2, July 7, 1860, 2, Sept. 8, 1860, 2, Oct. 6, 1860, 4; Howe, *Memories of a Hostess*, 185; Hahn, *Romantic Rebels*, 29.

36. "Of the Beauty and the Necessity of Having Governors," *Saturday Press*, Dec. 11, 1858, 2.

37. Ibid.

38. Clapp quoted in an untitled article in *The Rural Repository*, Apr. 14, 1847, 58, *Proceedings of the Free Convention*, 12; "The Hanging," *Saturday Press*, July 14, 1860, 4.

39. The Ebony Idol," commentary on Mrs. G. M. Flanders, *The Ebony Idol* (New York: D. Appleton & Co., 1860); "Minor Experiences in America, 17," "'The American'" [translated by the *Anti-Slavery Standard* from the *Paris Siècle*], *Saturday Press*, , Sept. 1, 1860, 2, Dec. 15, 1860, 1, Sept. 22, 1860, 2. Mortimer Thompson, *Great Auction Sale of Slaves at Savannah, Georgia, March 2d and 3d, 1859. Reported for the Tribune* (New York: American Anti-Slavery Society, [1859]). After the demise of the *Saturday Press*, Clapp wrote for the *New York Leader* and may have visited New Orleans. Articles appearing in the *Leader* as "Scenes on the Mississippi" reported that on the lower decks of the steamboat, "there are blacks—for night turns us all to negroes." "Scenes on the Mississippi" [from the *New York Leader*], *Memphis Daily Appeal*, Mar. 10, 1861, 1.

40. "On the Death of the Temperance Movement," 2; "Profile-Sketches of Men and Things, 1," *Saturday Press*, Dec. 1, 1860, 3.

41. Howe, *Memories of a Hostess*, 185; "On the Death of the Temperance Movement," 2; "By Overland Mail. Brigham Young's Two Hours with Horace Greeley," "Mr. Greeley," "That Private Letter. Horace Greeley to William H. Seward [from the *New York Tribune*]," *Saturday Press*, Aug. 27, 1859, 2, June 9, 1860, 2, June 16, 1860, 4. In the fictional interview with Young, the Mormon leader asked Greeley if he believed in monogamous marriage, and Greeley replied, "Some of us do; and some of us don't"; when asked about indulgence in alcoholic beverages, he repeated the same answer. For the original interview, see Horace Greeley, *An Overland Journey: From New York to San Francisco in the Summer of 1859* (1860; repr. Lincoln: Univ. of Nebraska Press, 1999), 209–18.

42. "The Bohemian in Government—'Read his history in a nation's eyes,'" *Saturday Evening Press*, July 7, 1860, 2. Trying to remember a prominent figure, an Englishman asked, "Mrs.—what's a-name, in America," to which Clapp quipped "Mrs. Grundy, perhaps." Clapp, "New Portrait of Paris," Nov. 13, 1858, 1.

43. "Of the Beauty and the Necessity of Having Governors," "Mr. Greeley," and "The Political Excitement," *Saturday Press*, Dec. 11, 1858, 2, June 9, 1860, 2, Nov. 3, 1860, 2.

44. Winter, *Old Friends*, 60–61; Howe, *Memories of a Hostess*, 185; "Poetry and Politics," and untitled notice, *Saturday Press*, Aug. 4, 1860, 2, Aug. 5, 1865, 8.

45. "Who and What Next," *Saturday Evening Press*, June 9, 1860, 2.

46. "'Sam Test' and Ada Clare," *Spirit of the Times*, Nov. 21, 1857, 488.

47. Devyr, "American Section," 77.

48. Count Adam G. De Gurowski, *America and Europe*. (New York: D. Appleton and Company, 1857), vi–vii. With a characteristic eccentricity, he complains that Fourierism had been "wantonly and ignorantly confounded with what is commonly called socialism."

Conclusion

1. E. H. H. letter on "The Slavery Question," and Clapp's "Reply," *Saturday Press*, Nov. 24, 1860, 1.

2. Andrew A. Freeman, *Abraham Lincoln Goes to New York* (New York: Coward-McCann, 1960), 72, 73, 74.

3. Traubel, *With Walt Whitman in Camden*, 1:237, 239, 2:371, 375, 376, 4:196, which includes several of Clapp's letters to Whitman, May 12, 14, 27, 1860.

4. Huffman, *Yankee in Meiji Japan*, 30–34; Masao Miyoshi, *As We Saw Them: The First Japanese Embassy to the United States* (New York: Kodansha International, 1994), 28–30. "Japan and Its People" [from *English Paper*], "An Ode to the Japanese" [from the *New York Times*], "The Japanese," and "Literature in Japan," *Saturday Press*, Jan. 1, 1859, 1, May 19, 1860, 4, June 30, 4, 1860, Aug. 4, 1860, 4.

5. "The Chicago Zouaves" [from the *New York Times*] with Fitz-James O'Brien's "The Zouaves," and also "Zouaves in the Army of the Revolution," *Saturday Press*, July 28, Aug. 4, 1860, all on 4.

6. "Pedagogues," *Saturday Press*, Oct. 20, 1860, 2; Huffman, *Yankee in Meiji Japan*, 23; "Vanity Fair to the Prince of Wales," *Vanity Fair* 5 (Jan. 18, 1862): 37. Walt Whitman was not in the city at the time, and did not meet the Prince. *Notebooks and Unpublished Prose Manuscripts*, 1:443; Traubel, *With Walt Whitman in Camden*, 5:396.

7. "Mr. Smith.—The Presidency," "Presidential Candidates," and "The Political Excitement," *Saturday Press*, Sept. 24, 1859, Nov. 3, 1860, all on 2.

8. "'Honest Abe,'" and last sentence from "'Who and What Next,'" *Saturday Press*, May 26, 1860, 3, June 9, 1860, 2. (The June 9 issue, on page 3, began offering a full set of *Tribune* pamphlets.)

9. "European Correspondence," 133, and "Foreign Correspondence," 149; "History of the Peace Congresses," 188–89, which mistakenly described Clapp as being from Cincinnati. Launt Thompson segment in Southworth, " Sculptors of New York," 5; *Clapp Memorial*, 40.

10. Clapp's "Reply" to E.H.H. letter on "The Slavery Question," *Saturday Press*, Nov. 24, 1860, 1.

11. "'Who and What Next,'" "Panic in Irving Place. Downfall of the Ullmann Dynasty, and Retirement of Napoleon to St. Helena" [from *New York Herald*], *Saturday Press*, June 9, 1860, 2, Dec. 8, 1860, 1.

12. Parry, *Garrets and Pretenders*, 45; and "'Who and What Next,'" *Saturday Press*, June 9, 1860, 2.

13. E. H. H. letter on "The Slavery Question," and Clapp's "Reply," *Saturday Press*, Nov. 24, 1860, 1.

14. "Peace Movements Abroad," *Advocate of Peace and Universal Brotherhood* 1 (Dec. 1846): 280; "The Bohemian in Government—'Read His History in a Nation's Eyes,'" with "Alas! Poor 'Saturday Press'" [from *Sunday Atlas*], *Saturday Press*, July 2, 1860, 2, Nov. 17, 1860, 1.

15. Huffman, *Yankee in Meiji Japan*, 27–29, 36–38, 39. "The New Irish Dramy at Niblo's Garden" Play Written by Dion O'Bourcicolt and Edward McHouse. Signed by "Figaro," "Artemus Ward on Arrah Na Pogue," *Saturday Press*, Aug. 5, 1865, 1, 8.

16. For Joseph Howard and Thomas Aldrich, see Andrews, *North Reports the Civil War*, 755. "Literary Clubland," 396. Hemstreet, "Literary Landmarks of New York," 155; "Obituary," Apr. 11, 1875, 7; Andrews, *North Reports the Civil War*, 758; Starr, *Bohemian Brigade*, 9; Lalor, "Literary Bohemians," 4. On Aldrich, see Andrews, *North Reports the Civil War*, 751. See Browne's chapter on "The Bohemians," in *Great Metropolis*, 150–58.

17. O'Brien's "The Seventh" in "Poetry, Rumors and Incidents," 17–18, and his "The Seventh Regiment" in "Documents and Narratives," in *The Rebellion Record: a Diary of American Events, with Documents, Narratives, Illustrative Incidents, Poetry, etc*. ed. by Frank Moore, 6 vols. (New York, G. P. Putnam, 1861–1863; D. Van Nostrand, 1864–68), 1:148–54; George L. Wood, *The Seventh Regiment: A Record* (New York: James Miller, 1865), 89–90.

18. McWatters, *Knots Untied*, 34, 36–37, 49; Barnes, *The Draft Riots in New York*, 82; and "Death of George S. McWatters," *New York Times*, Apr. 8, 1886, 8. See also "The Unlicensed Driver," *New York Herald*, Oct. 21, 1865, 5.

19. "Obituary," and Clemenceau is mentioned in "Death of Charles I. Pfaff" under "In and About the City," *New York Daily Times*, Apr. 11, 1875, 7, Apr. 26, 1890, 2; Winter, *Old Friends*, 61, 62.

20. "The Origin of 'Hail Columbia'" [from Recollections of Washington], *Saturday Press*, July 7, 1860, 4. See also Alice Fahs, *The Imagined Civil War: Popular Literature of the North and South, 1861–1865* (Chapel Hill: Univ. of North Carolina Press, 2001), 74, 75–76.

21. "The War in Italy," "Affairs in Italy," "Our War Correspondance," *Vanity Fair* 2 (Nov. 24, Dec. 8, 1860): 265, 281, 3 (Feb. 16, May 18, 25, 1861): 181, 237, 244, 7 (July 4, 1863): 151; Fahs, *Imagined Civil War*, 204–11.

22. Swinton to Whitman, June 1861, and following comment, 416. O'Connor to Whitman, Aug. 13, 1864, in Traubel, *With Walt Whitman in Camden*, 3:338–39; Traubel, *With Walt Whitman in Camden*, 5:36; and Whitman, *Notebooks and Unpublished Prose Manuscripts*, 2:479. Later, though, Whitman was fired from the Bureau of Indian Affairs, when superiors deemed a revised edition of *Leaves of Grass* to be indecent.

23. Sentilles, *Performing Menken*, 88–89.

24. Lewis, *Queen of the Plaza*, 10–11.

25. Ibid., 19–20.

26. Ibid., 20–23; Browne, *Great Metropolis*, 157; and Rawson, "Bygone Bohemia," [7–8], who said "The ill-fated Adah Menken, also went to Pfaff's occasionally," but gave Rawson a copy of *Infelicia* (Philadelphia: Lippincott, 1868).

27. J. W. Watson, "How Artemus Ward Became a Lecturer," *North American Review* 148 (Apr. 1889): 521–22; and Parry, *Garrets and Pretenders*, 45. Ward was noted for such one-liners as "I have already given two cousins to the war and I stand ready to sacrifice my wife's brother."

28. Sentilles, *Performing Menken*, 178, 189–90.

29. Maretzek, *Sharps and Flats*, 26–36, 41, 47–48, 49–81; Whitman, *Notebooks and Unpublished Prose Manuscripts*, 1:453, 2:495; and Stoddard, "Reminiscences of Bayard Taylor," 251.

30. "An Aged Journalist Declining," *New York Times*, Aug. 9, 1884, 8. Browne, *Great Metropolis*, 156; "Obituary," *New York Daily Times*, Apr. 11, 1875, 7; and Parry, *Garrets and Pretenders*, 41, 46, 49, 77.

31. Hemstreet, "Literary Landmarks of New York," 156; Starr, *Bohemian Brigade*, 9, 312. For more on those who gathered at Pfaff's, see Maurice, "Literary Clubland," 396; Mark Twain, "A Strange Dream," *Saturday Press*, June 2, 1866, 1–2.

32. An untitled printing of the graffiti, as well as *New York World*'s "A Disorderly Crowd" on saving of the *Saturday Press*, to which Clapp responded with "What the World Says," *Saturday Press*, Aug. 5, 12, 1865, 8, 24; Quoted in Winter, *Old Friends*, 62, Hahn, *Romantic Rebels*, 29; and Lalor, "Literary Bohemians," 105, 106–7, 127. The revived *Saturday Press* regularly published lists of who wouldn't be contributors as well as phony foreign agents of the paper.

33. George Arnold, "Beer," *Saturday Press*, Aug. 12, 1865, 22; Browne, *Great Metropolis*, 155; Guarneri, *Utopian Alternative*, 322, 323–24. For examples of writings of those who gathered at Pfaff's, see Maurice, "Literary Clubland," 396. Hemstreet, "Literary Landmarks of New York," 155; English, "That Club at Pfaff's," 202; "Obituary," Apr. 11, 1875, 7; Brown, *History of the American Stage*, 309.

34. Rawson, "Bygone Bohemia," [7, 9, 10], "Letter to 'Gurowski,'" *Saturday Press*, Jan. 1, 1859, 1; "Count Adam de Gurowski," *New York Times*, May 6, 1866, 4; J. W. Watson,

"How Artemus Ward Became a Lecturer," *North American Review* 148 (Apr. 1889), 521–22; Brown, *History of the American Stage*, 160; Winter, *Old Friends*, 312–13, 310.

35. Whitman, *Notebooks and Unpublished Prose Manuscripts*, 2:825. Clapp lived in the household of James Warren, a thirty-seven-year-old farmer, according to the 1870 U.S. Census. Atlantic Township, Monmouth County, New Jersey, 17. Though erroneous in giving his age at fifty-seven, the individual gave his occupation as editor and state of birth as Massachusetts. Rawson, "Bygone Bohemia," [3]; Traubel, *With Walt Whitman in Camden*, 8:312–13; Parry, *Garrets and Pretenders*, 47; "Obituary," Apr. 11, 1875, 7; "Queries and Answers in All Branches of Literature," 134; Howe, *Memories of a Hostess*, 185; Winter, *Old Friends*, 62.

36. John W. Crowly and William L. White, *Drunkard's Refuge: The Lesson of the New York State Inebriate Asylum* (Amherst: Univ. of Massachusetts Press, 2004), 29–31. A sympathetic officeholder named Hall got Clapp into the asylum, though his full name is variously given as Mayor Abraham Oakley Hall of New York City and Mayor George Hall of Brooklyn, the latter probably being correct, by virtue of his having been a printer.

37. Traubel, *With Walt Whitman in Camden*, 3:499; Howe, *Memories of a Hostess*, 185; "Miscellaneous News Items" and "Personal," *Brooklyn Daily Eagle*, Aug. 31, 1867, 1, Dec.11, 1868, 3.

38. Howe, *Memories of a Hostess*, 185; Lalor, "Literary Bohemians," 119nn74, 128; and "How Dickens Unwittingly Started the First Woman's Club Here," *New York Times*, Feb. 4, 1912, magazine section, 3.

39. Browne, *Great Metropolis*, 157; Traubel, *With Walt Whitman in Camden*, 8:313.

40. "Obituary," "Queries and Answers in All Branches of Literature," *New York Daily Times*, Apr. 11, 1875, 7, Mar. 9, 1913, 134; Parry, *Garrets and Pretenders*, 47, 48; "Editor's Historical Record," *Harper's New Monthly Magazine* 51 (June 1875), 155; Lalor, "Literary Bohemians," 70; Winter, *Old Friends*, 62–63. On the committee to arrange for Clapp's reburial in Nantucket with a monument, see "Current Memoranda," *Potter's American Monthly* 5 (Sept. 1875): 714.

41. "The Election Frauds," "Drop-Curtain Monographs," "An Aged Journalist Declining," *New York Times*, Dec. 28, 1876, 2, July 3, 1887, 16, Aug. 9, 1884, 8.

42. "General City News," New York item under "Local News in Brief," "Death of George S. McWatters," *New York Times*, July 15, 1866, 5, Oct. 13, 1870, 8; Apr. 8, 1886, 8; McWatters, *Knots Untied*, 33; Holyoake, "Stranger in America," 365.

43. Rawson, "Bygone Bohemia," [10]. The meeting included Hugh McGregor and John Ennis. "Society of the Solidarity," *New York Daily Times*, Mar. 19, 1868, 8. Ray Reynolds, *Cat's Paw Utopia* (El Cajon, Calif.: privately printed, 1972).

44. Sotheran was alleged to be a denizen of Pfaff's with English, but he denied knowing the latter. See also English, "That Club at Pfaff's," 202. Before her marriage to Von Racowitz, Helen Von Donniges had been courted by the socialist Ferdinand LaSalle, who was killed in a duel over her.

45. "Review of the Week," Philadelphia *American Publishers' Circular and Literary Gazette*, May 17, 1856, 290; Parry, *Garrets and Pretenders*, 44–45. The most accessible edition is probably the 1972 reprint of *The Social Destiny of Man; or, Theory of the Four Movements, by Charles Fourier. Translated by Henry Clapp, Jr. with a Treatise on the Functions of the Human Passions. And An Outline of Fourier's System of Social Science. By Albert Brisbane* (1857; repr., New York: Gordon Press, 1972).

46. Lalor, "Literary Bohemians," 8, 358, 359.

47. "A SOCIALIST INSTITUTE BROKEN UP," "Police," Brooklyn *Daily Eagle*, Feb. 13, 1861, 3.

48. See the untitled notice on the Unitary Household in the *Richmond Daily Dispatch*, Sept. 29, 1860, 1.

49. Editorial, "THE INDUSTRIAL CONGRESS," *New York Herald*, Nov. 23, 1860, 4.

50. Norton, "Ten Years in a Public Library," 531. For a detailed description of plans for opening of the Cooper Union in 1860, see "Cooper Union for the Advancement of Science and Art," *Saturday Press*, Oct. 8, 1859, 1. David Harvey argues that the sociological imagination has spatial expressions in "The Sociological and Geographical Imaginations," *International Journal of Politics, Culture, and Society* 18 (Spring–Summer 2005): 211–55.

51. Philip Green Wright, *Elizur Wright: The Father of Life Insurance* (Chicago: Univ. of Chicago Press, 1937); and Lawrence B. Goodheart, *Abolitionist, Actuary, Atheist: Elizur Wright and the Reform Impulse* (Kent, Ohio: Kent State Univ. Press, 1990).

52. MacDonald, *Fifty Years of Freethought*, 1:207–8. Edward Fitch Underhill *Handbook of Instruction for the Type-Writer* (New York: privately printed, 1880).

53. Nast and Arthur Lumbley both worked for Sol Eytinge on the *New York Illustrated News*, of which Aldrich was the editor. He contested claims on the illustration of Saint Nicholas, but Nast is widely credited as having established the modern Santa Claus character as a toy maker with his annual Christmas illustrations. "Mr. Arthur Lumbley Returns to the Nast–Santa Claus Discussion," *New York Times*, June 25, 1904, Saturday Review of Books, 38. Charles Gayler, "Christmas Eve," and Allen D. Vorce, "Christmas," *Saturday Press*, Dec. 24, 1859, 2, "A Gush From Brady," *Saturday Press*, Oct. 27, 1860, 2.

54. Browne, *Great Metropolis*, 157–58. It is interesting that Walt Whitman wrote in his notebook that "no Nation, once enslaved, ever fully recovered its liberty." After thinking better of it, he added "fully" before "enslaved." Whitman, *Notebooks and Unpublished Prose Manuscripts*, 1:267.

55. "'Who and What Next,'" *Saturday Press*, June 9, 1860, 2. On Jackson, Clapp wrote,

> The last President that we had who was good for anything was Andrew Jackson, and he was a tyrant. The best tyrant out. Just such a tyrant as we need now. ... He brooked no interference. When a delegation of New York merchants

called upon him to protest against one of his measures, he told them to go home and mind their own business. And he talked to Congress in the same way. The Whigs said he was more despotic than any sovereign in Europe. And so he was: or Asia either. And the people liked him for it; if he had been a Whig instead of a man, the Whigs would have liked him for it. But he had too much sense to be a Whig, or for that matter, a Democrat either.

56. Clapp, "New Portrait of Paris," Dec. 4, 1858, 2; Clapp, "Dramatic Feuilleton," *Saturday Press*, Oct. 8, 1859, 2, which also says "the world is too sensible by half."

Selected Bibliography

Primary Sources
Newspapers and Periodicals

Boston. *Liberator*
Brooklyn. *Brooklyn Daily Eagle*
London. *Standard of Freedom*
New York City. *New York Harbinger*
 Herald
 Knickerbocker, or New York Monthly Magazine
 Times
 Printer
 Radical Abolitionist
 Saturday Press
 Scientific American
 Spirit of the Times
 Spiritual Telegraph, published, or *Spiritual Telegraph Papers*
Washington, D.C. *National Era*
Worcester, Mass. *Advocate of Peace and Universal Brotherhood*

Select Works by Bohemians

Andrews, Stephen Pearl, ed. *Love, Marriage, and Divorce and the Sovereignty of the Individual: A Discussion Between Henry James, Horace Greeley, and Stephen Pearl Andrews: Including the Final Replies of Mr. Andrews, Rejected by the Tribune*. 1853. Reprint, Boston: B. R. Tucker, 1889.

Arnold, George. "Why Thomas Was Discharged." *Atlantic Tales: A Collection of Stories*. 2d ed. 162–79. Boston: Ticknor and Fields, 1866.

Briggs, Charles F. "The Old and the New," *Putnam's Magazine* 1 (January 1868): 1–5.

Brisbane, Albert, ed. *The Social Destiny of Man; Or, Theory of the Four Movements*, by Charles Fourier. Translated by Henry Clapp, Jr. with a Treatise on the Functions of the Human Passions. And An Outline of Fourier's System of Social Science. 1857. Reprint, New York: Gordon, 1972.

Clapp, Henry, Jr. *Husband v. Wife; or Nobody to Blame*. With designs by A. Hoppin. New York: Rudd & Carleton, 1858.

———. "New Portrait of Paris: Painted from Life," *Saturday Press*, November 13, 1858, 1.

———. *The Pioneer: or, Leaves from an Editor's Portfolio*. Lynn, Mass.: J. B. Tolman, 1846.

Clapp, Theodore. *Autobiographical Sketches and Recollections: During a Thirty-Five Years' Residence at New Orleans*. Boston: Phillips, Sampson & Company, 1858.

Gayler, Charles. *Fritz, the Emigrant*. New York: F. Leslie's Publishing House, 1876.

———. *The Love of a Prince: Or, The Court of Prussia*. New York: S. French, [c1857].

———. *Out of the Streets: A Story of New York Life*. New York: Robert M. DeWitt, Publishers, 1869.

———. *Sleepy Hollow; or, The Headless Horseman: A Comic Pastoral Opera in Three Acts, Music by Max Maretzek, Words by Charles Gayler*. New York: [F. Rullman], 1879.

———. *The Son of the Night: A Drama, in Three Days: And a Prologue*. New York: S. French [186–].

Gurowski, Count Adam G. De. *America and Europe*. New York: D. Appleton, 1857.

House, Edward H. "Anecdotes of Charles Reade." *Atlantic Monthly* 60 (October 1887): 525–39.

———. "Hints to Visitors to Paris." *Galaxy* 3 (Mar. 1, 1867): 508–17.

James, Ed. *Biography of Adah Isaac Menken*. New York: Ed James, 1869.

Love vs. Marriage. Part 1. New York: Fowler and Wells, 1852. Reprinted in "History of Women" microfilm series. New Haven, Conn.: Research Publications, 1975.

Ludlow, Fitz-Hugh. "The Proper Use of Grandfathers." 61–76. *Stories and Sketches by Our Best Authors*. Boston: Lee and Shepard, 1867.

Maretzek, Max. *Sharps and Flats: A Sequel to "Crotchets and Quavers."* Vol. 1. New York: American Musician Publishing, 1890.

McWatters, George S. *Knots Untied; or, Ways and By-Ways in the Hidden Life of American Detectives*. Hartford, Conn.: J. B. Burr and Hyde, 1871.

Menken, Adah. *Infelicia*. Philadelphia: Lippincott, 1868.

North, William. *The Slave of the Lamp: A Posthumous Novel*. New York: H. Long & Brother, 1855.

Oscanyan, Christopher. *The Sultan and His People*. Cincinnati: H. W. Derby & Co., 1857.

Rawson, Albert L. "A Bygone Bohemia," *Frank Leslie's Popular Monthly* 41 (January 1896): [1–14].

———. "Mme. Blavatsky—A Theosophical Occult Apology." *Frank Leslie's Popular Monthly* 33 (February 1892): 201.

Seymour, Charles B. *Self-Made Men*. New York: Harper & Brothers, 1858.

Shanly, Charles D. "A Night in the Sewers." *Stories and Sketches by Our Best Authors*. 293–307. Boston: Lee and Shepard, 1867.

Stoddard, R. H. "Reminiscences of Bayard Taylor." *Atlantic Monthly* 43 (February 1879): 245–46, 251.

Taylor, Bayard. "Friend Eli's Daughter." *Atlantic Tales: A Collection of Stories.* 367–98. 2d ed. Boston: Ticknor and Fields, 1866.

Thompson, Mortimer. *Great Auction Sale of Slaves at Savannah, Georgia, March 2d and 3d, 1859. Reported for the Tribune.* New York: American Anti-Slavery Society, [1859].

———. *Nothing to Say: A Slight Slap at Mobocratic Snobbery, Which Has "Nothing to Do" with "Nothing to Wear."* New York: Rudd & Carleton, 1857.

———. *The Witches of New York.* New York: Rudd & Carleton, 1859.

——— [as Q.K. Philander Doesticks, P.B.]. *Plu-Ri-Bus-Tah: A Song That's by No Author.* New York: Livermore & Rudd, 1856.

Traubel, Horace. *With Walt Whitman in Camden.* Vol. 1, *March 28–July 14, 1888.* Boston: Small, Maynard & Company, 1906.

———. *With Walt Whitman in Camden.* Vol. 2, *July 16, 1888–October 31, 1888.* New York: D. Appleton, 1908.

———. *With Walt Whitman in Camden.* Vol. 3, *November 1, 1888–January 20, 1889.* New York: Mitchell Kennerley, 1914.

———. *With Walt Whitman in Camden.* Vol. 4, *January 21–April 7, 1889.* Ed. by Sculley Bradley. Philadelphia: University of Pennsylvania Press, 1953.

———. *With Walt Whitman in Camden.* Vol. 5, *April 8–September 14, 1890.* Ed. by Gertrude Traubel. Carbondale: Southern Illinois University Press, 1964.

———. *With Walt Whitman in Camden.* Vol. 6, *September 15, 1889–July 6, 1890.* Ed. by Gertrude Traubel and William White. Carbondale: Southern Illinois University Press, 1982.

———. *With Walt Whitman in Camden.* Vol. 7, *July 7, 1890–February 10, 1891.* Edited by Jeanne Chapman and Robert MacIsaac. Carbondale: Southern Illinois University Press, 1992.

———. *With Walt Whitman in Camden.* Vol. 8, *February 11, 1891–September 30, 1891.* Edited by Jeanne Chapman and Robert MacIsaac. Oregon House, Calif.: W. L. Bentley, 1996.

———. *With Walt Whitman in Camden.* Vol. 9, *October 1, 1891–April 3, 1892.* Edited by Jeanne Chapman and Robert MacIsaac. Oregon House, Calif.: W. L. Bentley, 1996.

Underhill, Edward Fitch. *Handbook of Instruction for the Type-Writer.* New York: privately printed, 1880.

Warren, Josiah. *Practical Details in Equitable Commerce: Showing the Workings, in Actual Experiment, During a Series of Years, of the Social Principles Expounded in the Work Called "Equitable Commerce," by the Author of This, and "The Science of Society," by Stephen Pearl Andrews.* New York: Fowler and Wells, 1852.

Whitman, Walt. *Notebooks and Unpublished Prose Manuscripts.* Edited by Edward F. Grier. 6 vols. New York: New York University Press, 1984.

Winter, William. *Old Friends: Being Literary Recollections of Other Days.* New York: Moffat, Yard, 1909.

———. *Shadows of the Stage.* Boston: L. C. Page, 1892.

———. *Vagrant Memories, Being Further Recollections of Other Days.* New York: George H. Doran, 1915.

Works by Observers and Contemporaries

"American Literature." In *The Penguin Companion to World Literature.* Ed. by Malcolm Bradbury, Eric Mottram, and Jean Franco. New York: McGraw-Hill, 1971.

Armstrong, Thomas. *A Memoir.* Edited by L. M. Lamont. London: Martin Secier, 1912.

Barnes, David M. *The Draft Riots in New York, July 1863. The Metropolitan Police: Their Services during Riot Week. Their Honorable Record.* New York: Baker & Godwin, 1863.

Barton, K. *Nothing to You; or, Mind Your Own Business. In Answer to "Nothings" in General, and "Nothing to Wear" in Particular. By Knot-Rab [pseud.] With illustrations by J. H. Howard.* New York: Wiley & Halsted, 1857.

Bell, Charles H. *The Bench and Bar of New Hampshire.* Boston: Houghton, Mifflin, 1894.

Brisbane, Redelia *Albert Brisbane: A Mental Biography.* Boston: Arena, 1893.

Brown, Thomas Alston. *History of the American Stage. Containing Biographical Sketches of Nearly Every Member of the Profession that Has Appeared on the American Stage, from 1733 to 1870.* New York: Benjamin Blom, 1870.

Browne, Junius Henri. *The Great Metropolis: A Mirror of New York.* Hartford, Conn.: American Publishing Company, 1869.

Burt, Calvin C. *Egyptian Masonry.* N.p.: n.p., 1879.

Butler, William Allen. *Nothing to Wear.* New York: G. P. Putnam, 1857.

Chase, Warren B. *Forty Years on the Spiritual Rostrum.* Boston: Colby & Rich, 1888.

Clapp, Ebenezer, comp. *The Clapp Memorial. Record of the Clapp Family in America,* Boston: David Clapp & Son, 1876.

Congdon, Charles T. *Reminiscences of a Journalist.* Boston: J. R. Osgood, 1880.

"Current Memoranda," *Potter's American Monthly* 5 (September 1875).

Custis, George Washington Parke. *Recollections and Private Memoirs of Washington.* Washington, D.C.: W. H. Moore, 1859.

Devyr, Thomas Ainge. *The Odd Book of the Nineteenth Century; or, "Chivalry" in Modern Days: A Personal Record of Reform—Chiefly* LAND REFORM, *for the Last Fifty Years.* Greenpoint, N.Y.: privately printed, 1882.

Duffy, John, ed. *Parson Clapp of the Strangers' Church of New Orleans.* Baton Rouge: Louisiana State University Press, 1957.

English, Thomas Dunn. "That Club at Pfaff's." *Literary World* 17 (June 12, 1886): 202.

Everett, Edward. *The Mount Vernon Papers.* New York: D. Appleton, 1860.

Forbes, Hugh. *Forbes's Answer to Archbishop Hughes.* 2d ed. Boston: privately printed, 1850.

———. *Manual for the Patriotic Volunteer on Active Service in Regular and Irregular War: Being the Arts and Science of Obtaining and Maintaining Liberty and Independence.* 2d ed. 2 vols. New York: W. H. Tinson, printer, 1855.

Freer, Dink. "In the Bookman's Mail." *Bookman* 64 (September 1926): 117.
Garrison, William Lloyd. *The Letters of William Lloyd Garrison*. Vol. 3, *No Union with Slaveholders*. Ed. by Walter M. Merrill. Cambridge, Mass.: Belknap Press of Harvard University Press, 1973.
Giuseppe Garibaldi, My Life. Trans. by Stephen Parkin. London: Hesperus, 2004.
Goodell, William. "The Rutland Convention." *Radical Abolitionist* 3 (July 1858): 89.
Greeley, Horace. *An Overland Journey: From New York to San Francisco in the Summer of 1859*. 1860. Reprint, Lincoln: University of Nebraska Press, 1999.
———. *Recollections of a Busy Life, Including Reminiscences of American Politics and Politicians, from the Opening of the Missouri Contest to the Downfall of Slavery*. New York: J. B. Ford & Co., 1868.
Hemstreet, Charles. "The Literary Landmarks of New York." *Critic* 421 (August 1903): 155–56.
Higginson, Thomas Wentworth. *Cheerful Yesterdays*. Boston: Houghton, Mifflin, 1898.
Hinton, Richard J. *John Brown and His Men*. New York: Funk & Wagnalls, [1894].
Holyoake, George Jacob. "A Stranger in America." *Littell's Living Age* 31 (August 7, 1880): 354–67.
Howe, Mark Anthony DeWolfe. *Memories of a Hostess: A Chronicle of Eminent Friendships Drawn Chiefly from the Diaries of Mrs. James T. Fields*. Boston: Atlantic Monthly Press, 1922.
Ingalls, Joshua K. *Reminiscences of an Octogenarian in the Field of Industrial and Social Reform*. New York: M. L. Holbrook, 1897.
Kilbourn, Dwight C. *The Bench and Bar of Litchfield County, Connecticut 1709–1909. Biographical Sketches of Members History and Catalogue of the Litchfield Law School Historical Notes*. Litchfield, Conn.: privately printed, 1909.
Laurens, J. Wayne. *The Crisis: Or, the Enemies of America Unmasked*. Philadelphia: G. D. Miller, 1855.
Lippard, George. *George Lippard, Prophet of Protest: Writings of an American Radical, 1822–1854*. Ed. by David S. Reynolds. New York: Peter Lang, 1986.
MacDonald, George E. *Fifty Years of Freethought, Being the Story of the Truth Seeker, with the Natural History of Its Third Editor*. 2 vols. New York: Truth Seeker Company, 1929, 1931.
Mackenzie, Kenneth. *The Royal Masonic Cyclopedia*. London: privately printed, 1877.
Marconis, Jacques Etienne. *Lecture of a Chapter, Senate, and Council: According to the Forms of the Antient and Primitive Rite, but Embracing All Systems of High Grade Masonry*. London: John Hogg, 1882.
Maurice, Arthur Bartlett. "Literary Clubland." *Bookman* 21 (June 1905): 396.
———. "Literary Snapshots," *Bookman* 54 (January 1922): 485.
Martin, Edward Winslow [James McCabe], *The Secrets of the Great City: a Work descriptive of the Virtues and the Vices, the Mysteries, Miseries and Crimes of New York City*. Philadelphia: Jones, Brothers & Co., [1868].

Mayhew, Henry. *London Labour and the London Poor: The Condition and Earnings of Those That Will Work, Cannot Work, and Will Not Work.* 4 vols. London: C. Griffin, [1861–62].

The Memoirs of Garibaldi. Ed. by Alexandre Dumas. Trans. by R. S. Garnett. New York: D. Appleton, 1931.

Moore, Frank, ed. *The Rebellion Record: A Diary of American Events, with Documents, Narratives, Illustrative Incidents, Poetry, etc.* 6 vols. New York, G. P. Putnam, 1861–63; D. Van Nostrand, 1864–68.

"Mrs. Mary S. Gove." *Water Cure Journal* 1 (January 1, 1846): 38–39.

Nell, William Cooper. *William Cooper Nell: Selected Writings 1832–1874.* Ed. by Dorothy Porter Wesley and Constance Porter Uzelac. Baltimore: Black Classic, 2003.

Nichols, Mary Gove. *Mary Lyndon; or, Revelations of a Life. An Autobiography.* New York: Stinger and Townsend, 1855.

———. *Reminiscences of Edgar Allan Poe.* 1863. Reprint, New York: Union Square Book Shop, 1931.

Nichols, Thomas Low. *Esoteric Anthropology.* London: Nichols & Co. 1853.

———. *Forty Years of American Life, 1821–1861.* 1864. Reprint, New York: Stackpole Sons, 1937.

———. *Woman, in All Ages and Nations.* New York, Fowler and Wells, [1849].

Nichols, Thomas Low, and Mrs. Mary S. Nichols. *Marriage: Its History, Character, and Results.* Cincinnati, V. Nicholson & Co. [1854]. Odell, George C. *Annals of the New York Stage,* 15 vols. New York: Columbia University Press, 1929–49.

Orsini, Felice. *Memoirs and Adventures of Felice Orsini, Written by Himself.* 2d ed. Ed. by Ausonio Franchi. 1857. Reprint, Turin: n.p., 1858. Penington, James W. C. *The Fugitive Blacksmith; or, Events in the History of James W. C. Pennington.* London: Charles Gilpen, 1849.

Picton, Thomas. "Memoir." In *Life and Writings of Frank Forester.* Ed. by David W. Judd. 2 vols. New York: Orange Judd, 1882.

Proceedings of the Free Convention Held at Rutland, Vt., June 25th, 26th, 27th, 1858. Boston: J. R. Yerrinton & Son, 1858.

Rogers, Nathaniel P. *A Collection from the Newspaper Writings of Nathaniel Peabody Rogers.* Concord: John R. French, 1847.

Saint-Gaudens, Augustus. *The Reminiscences of Augustus Saint-Gaudens, edited and amplified by Homer Saint-Gaudens.* 2 vols. New York: Century, 1913.

Sanborn, Franklin B., ed. *The Life and Letters of John Brown: Liberator of Kansas and Martyr of Virginia.* Boston: Roberts Brothers, 1885.

Southworth, Alvan S. "The Sculptors of New York." *Frank Leslie's Popular Monthly* 25 (February 1888): 1–14.

Stearns, Ezra S. *History of Plymouth, New Hampshire.* 1906. Reprint, Somersworth, N.H.: New England History Press, in collaboration with the Plymouth Historical Society, 1987.

Thackeray, William Makepeace. *The Paris Sketch Book*. London: Smith, Elder, 1870.
Watson, J. W. "How Artemus Ward Became a Lecturer." *North American Review* 148 (April 1889): 521–22.
Wilson, Rufus Rockwell. *New York: Old and New; Its Story, Streets, and Landmarks*. 2d ed. 2 vols. Philadelphia: J. B. Lippincott, 1903.
Wood, George L. *The Seventh Regiment: A Record*. New York: James Miller, 1865.
"The World at Large." *National Magazine: Devoted to Literature, Art, and Religion* 12 (June 1858): 571.
"The World's Convention." *Nichols Journal of Health, Water-Cure and Human Progress* 1 (October 1853): 55.

Secondary Sources

Ackroyd, Peter. *London: The Biography*. New York: Anchor, 2000.
Andrews, J. Cutler. *The North Reports the Civil War*. Pittsburgh: University of Pittsburgh Press, 1955.
Bairoch, Paul. *Cities and Economic Development: From the Dawn of History to the Present*. Trans. by Christopher Braider. Chicago: University of Chicago Press, 1991.
Barclay, George Lippard. *The Life and Remarkable Career of Adah Isaacs Menken: The Celebrated Actress*. Philadelphia: Barclay, 1868.
Bergman, Norman A. *Humphry Davy's Contribution to the Introduction of Anesthesia: A New Perspective*. Chicago: University of Chicago Press, 1991.
Billington, James H. *Fire in the Minds of Men: The Origins of the Revolutionary Faith*. New York: Basic, 1980.
Bridges, Amy. *City in the Republic: Antebellum New York and the Origins of Machine Politics*. Cambridge: Cambridge University Press, 1984.
Burke, W. J., and Will D. Howe. *American Authors and Books: 1640 to the Present Day*. Ed. by Irving Weiss and Anne Weiss. 3d rev. ed. New York: Crown, 1972.
Casteras, Susan P. and Alicia Craig Faxon, eds. *Pre-Raphaelite Art in Its European Context*. Madison, N.J.: Fairleigh Dickinson Univ. Press, 1995.
Chandler, Tertius. *Four Thousand Years of Urban Growth: An Historical Census*. Lewiston, N.Y.: Edwin Mellen, 1987.
Churchill, Allen. *The Improper Bohemians*. New York: E. P. Dutton, 1959.
Crowly, John W., and William L. White. *Drunkard's Refuge: The Lesson of the New York State Inebriate Asylum*. Amherst: University of Massachusetts Press, 2004.
Darnton, Robert. *The Literary Underground of the Old Regime*. Cambridge, Mass.: Harvard Univ. Press, 1982.
Easton, Malcolm. *Artists and Writers in Paris: The Bohemian Idea, 1805–1867*. London: Edward Arnold, 1964.

Fahs, Alice. *The Imagined Civil War: Popular Literature of the North & South, 1861–1865*. Chapel Hill: University of North Carolina Press, 2001.
Falk, Bernard. *The Naked Lady: A Biography of Adah Isaacs Menken*. 1934. Rev. ed. London: Hutchinson, 1952.
Farrison, William E. *William Wells Brown: Author and Reformer*. Chicago: University of Chicago Press, 1969.
Fleming, Gordon. *The Young Whistler, 1834–44*. London: Allen & Unwin, 1978.
Foster, Edward, ed. *Decadents, Symbolists, and Aesthetes in America: Fin-de-Siècle American Poetry: An Anthology*. Jersey City, N.J.: Talisman, 2000.
Freeman, Andrew A. *Abraham Lincoln Goes to New York*. New York: Coward-McCann, 1960.
Gaston, Paul M. *Women of Fair Hope*. Athens: University of Georgia Press, 1984.
Gilfoyle, Timothy J. *City of Eros: New York City, Prostitution, and the Commercialization of Sex, 1790–1920*. New York: Norton, 1992.
Gilfoyle, Timothy J., Patricia Cline Cohen, and Helen Lefkowitz Horowitz. *The Flash Press: Porting Male Weeklies in 1840s New York*. Chicago: University of Chicago Press, 2008.
Goodheart, Lawrence B. *Abolitionist, Actuary, Atheist: Elizur Wright and the Reform Impulse*. Kent, Ohio: Kent State University Press, 1990.
Graña, César. *Bohemian versus Bourgeois: French Society and the French Man of Letters in the Nineteenth Century*. New York: Basic, 1964.
Graña, César, and Marigay Graña. *On Bohemia: The Code of the Self-Exiled*. New Brunswick, N.J.: Transaction, 1990.
Guarneri, Carl J. *The Utopian Alternative: Fourierism in Nineteenth-Century America*. Ithaca, N.Y.: Cornell University Press, 1991.
Hahn, Emily. *Romantic Rebels: An Informal History of Bohemia*. Boston: Houghton Mifflin, 1967.
Haine, W. Scott. *The World of the Paris Café: Sociability among the French Working Class, 1789–1914*. Baltimore: Johns Hopkins University Press, 1996.
Harsin, Jill. *Barricades: The War of the Streets in Revolutionary Paris, 1830–1848*. New York: Palgrave, 2002.
Hart, James D. *The Oxford Companion to American Literature*. 6th ed. New York: Oxford University Press, 1995.
Harvey, David. "The Sociological and Geographical Imaginations." *International Journal of Politics, Culture, and Society* 18 (Spring–Summer 2005): 211–55.
Hibbert, Christopher. *Garibaldi and His Enemies: The Clash of Arms and Personalities in the Making of Italy*. Boston: Little, Brown, 1965.
Hilton, Timothy. *The Pre-Raphaelites*. London: Thames and Hudson, 1970.
Huffman, James L. *A Yankee in Meiji Japan: The Crusading Journalist Edward H. House*. Lanham Md.: Rowman & Littlefield, 2003.
Hunt, William S. *Frank Forester: A Tragedy in Exile*. Newark, N.J.: Carteret Book Club, 1933.
Hutton, Patrick H. *The Cult of the Revolutionary Tradition: The Blanquists in French Politics, 1864–1893*. Berkeley: University of California Press, 1981.

Inwood, Stephen. *A History of London*. London; Macmillan, 1998.
Kendall, John S. *"The World's Delight": The Story of Adah Isaacs Menken*. New Orleans: Thomas J. Moran's Sons, 1938.
Klein, Marcus. *Easterns, Westerns, and Private Eyes: American Matters, 1870–1900*. Madison: University of Wisconsin Press, 1994.
Kunit, Stanley J., and Howard Haycraft, eds. *American Authors, 1600–1900: A Biographical Dictionary of American Literature*. New York: H. W. Wilson, 1938.
Lalor, Eugene T. "The Literary Bohemians of New York City in the Mid-Nineteenth Century." Ph.D. dissertation, St. John's University, New York, 1976.
Lattek, Christine. *Revolutionary Refugees: German Socialism in Britain, 1840–1860*. New York: Routledge, 2006.
Lause, Mark A. "American Radicals and Organized Marxism: the Initial Experience, 1868–1874," *Labor History* 33 (Winter 1992): 55–80.
———. *The Civil War's Last Campaign: James B. Weaver, the National Greenback-Labor Party, and the Politics of Race and Section*. Lanham, Md.: University Press of America, 2001.
———. *Young America: Land, Labor, and The Republican Community*. Urbana: University of Illinois Press, 2005.
Lehning, Arthur. "International Association." In *From Buonarroti to Bakunin: Studies in International Socialism*. 241–46. Boston: Brill, 1970,
Lesser, Allen. *Enchanting Rebel: The Secret of Adah Isaacs Menken*. 1947. Reprint, Port Washington, N.Y.: Kennikat, 1973.
Levine, Bruce. *The Spirit of 1848: German Immigrants, Labor Conflict, and the Coming of the Civil War*. Urbana: University of Illinois Press, 1992.
Lewis, Paul. *Queen of the Plaza: A Biography of Adah Isaacs Menken*. New York: Funk & Wagnalls, 1964.
Libby, Jean, ed. *John Brown Mysteries: Allies for Freedom*. Missoula, Mont.: Pictorial Histories, 1999.
Littlefield, Daniel C. "Blacks, John Brown, and a Theory of Manhood," *His Soul Goes Marching On: Responses to John Brown and the Harpers Ferry Raid*. Ed. by Paul Finkelman, 67–97. Charlottesville: University Press of Virginia, 1995.
Makowitz, Wolf. *Mazeppa: The Lives, Loves, and Legends of Adah Isaacs Menken: A Biographical Quest*. New York: Stein and Day, 1982.
McConachie, Bruce A. "'The Theatre of the Mob': Apocalyptic Melodrama and Preindustrial Riots in Antebellum New York." In *Theatre for Working-Class Audiences in the United States, 1830–1880*. Ed. by Bruce A. McConachie and Daniel Friedman, 17–46. Westport, Conn: Greenwood, 1985.
McKinven, John A. *The Hanlon Brothers: Their Amazing Acrobatics, Pantomimes, and Stage Spectacles*. Glenwood Ill.: David Meyer Magic Books, 1998.
Mead, Marion. *Madame Blavatsky: The Woman Behind the Myth*. New York: G. P. Putnam's Sons, 1980.
Miyoshi, Masao. *As We Saw Them: The First Japanese Embassy to the United States*. New York: Kodansha International, 1994.

Mushkat, Jerome. *Fernando Wood: A Political Biography*. Kent, Ohio: Kent State University Press, 1990.
The National Cyclopaedia of American Biography. 50 vols. New York: James T. White & Co., 1899.
Nicolaevsky, Boris I. "Secret Societies and the First International." In *The Revolutionary Internationals, 1864–1943*. Ed. by Milorad M. Drachkovitch, 36–56. Stanford, Calif.: Stanford University Press for the Hoover Institution on War, Revolution, and Peace, 1966.
Oakes, Stephen B. *To Purge the Land with Blood: A Biography of John Brown*. New York: Harper & Row, 1970.
Parry, Albert, *Garrets and Pretenders: A History of Bohemianism in America*. New York: Covici, Friede, 1933.
Picard, Liza. *Victorian London: The Talk of a City, 1840–1870*. New York: St. Martin's Griffin, 2005.
Powers, Madelon. *Faces along the Bar: Lore and Order in the Workingman's Saloon, 1870–1920*. Chicago: University of Chicago Press, 1998.
Prescott, Andrew. "'The Cause of Humanity': Charles Bradlaugh and Freemasonry." *Ars Quatuor Coronatorum* 116 (2003): 15–64.
Quarles, Benjamin. *Allies for Freedom: Blacks and John Brown*. Oxford: Oxford University Press, 1974.
Reynolds, David S. *George Lippard*. Boston: Twayne, 1982.
———. *John Brown, Abolitionist: The Man Who Killed Slavery, Sparked the Civil War, and Seeded Civil Rights*. New York: Knopf, 2005.
———. *Walt Whitman*. New York: Oxford University Press, 2005.
Reynolds, Ray. *Cat's Paw Utopia*. El Cajon, Calif.: privately printed, 1972.
Roberts, J. H. *The Mythology of the Secret Societies*. London: London: Secker and Warburg, 1972.
Rossbach, Jeffery. *Ambivalent Conspirators: John Brown, the Secret Six, and a Theory of Slave Violence*. Philadelphia: University of Pennsylvania Press, 1982.
Scott, Otto. *The Secret Six: John Brown and the Abolitionist Movement*. New York: n.p., 1979.
Seigel, Jerrold E. *Bohemian Paris: Culture, Politics, and the Boundaries of Bourgeois Life, 1830–1930*. New York: Viking, 1986.
Sentilles, Renée M. *Performing Menken: Adah Isaacs Menken and the Birth of American Celebrity*. Cambridge: Cambridge University Press, 2003.
Silver-Isenstadt, Jean L. *Shameless: The Visionary Life of Mary Gove Nichols*. Baltimore: Johns Hopkins University Press, 2002.
Stacy, Jason. *Walt Whitman's Multitudes: Labor Reform and Persona in Whitman's Journalism and the First Leaves of Grass, 1840–1855*. New York: Peter Lang, 2008.
Starr, Louis M. *Bohemian Brigade: Civil War Newsmen in Action*. New York: Alfred A. Knopf, 1954.
Stoehr, Taylor, ed. *Free Love in America: A Documentary History*. New York: AMS Press, 1979.

Stott, Richard B. *Workers in the Metropolis: Class, Ethnicity, and Youth in Antebellum New York City.* Ithaca, N.Y.: Cornell University Press, 1990.

Thompson, E. P. *William Morris: Romantic and Revolutionary.* 2d. ed. Stanford, Calif.: Stanford University Press, 1976.

Trevelyan, G. M. *Garibaldi's Defense of the Roman Republic.* London: Longmans, 1907.

Uhl, Robert. "Masters of the Merchant Marine," *American Heritage Magazine* 34 (April–May 1983): 68–77.

Weisberger, Bernard A. *Reporters for the Union.* Westport, Conn.: Greenwood, 1953.

Wilson, Elizabeth. "Bohemians, Grisettes and Demi-Mondaines." In *Violetta and Her Sisters: The Lady of the Camellias: Responses to the Myth.* Ed. by Nicholas John. Boston: Faber, 1994.

———. *Bohemians: The Glamorous Outcasts.* New York: I. B. Tauris, 2000.

Wilson's Business Directory of New York City. New York: John F. Trow, 1859.

Winick, Charles, and Paul M. Kinsie. *The Lively Commerce: Prostitution in the United States.* Chicago: Quadrangle, 1971.

Wolle, Francis. *Fitz-James O'Brien: A Literary Bohemian of the Eighteen-Fifties.* Boulder: University of Colorado Press, 1944.

Wright, Lyle H. *American Fiction, 1774–1850.* San Marino, Calif.: Huntington Library, 1965.

Wright, Philip Green. *Elizur Wright: The Father of Life Insurance.* Chicago: University of Chicago Press, 1937.

Wunderlich, Roger. *Low Living and High Thinking at Modern Times, New York.* Syracuse, N.Y.: Syracuse University Press, 1992.

Index

abolitionists, 19, 22, 69, 70, 72, 74, 82, 104, 109, 119, 122; internal conflicts, 4–5, 7–9
Academy of Music, 20, 59, 60, 67, 106
Actors Protective Union, 88
African American freemasonry, 82–83
agrarianism. *See* land reform and land reformers
alcohol, 15, 16, 50
Aldrich, Thomas Bailey, 62, 79, 109, 110
Allen, John, 72, 74
American Party, 26
Andrews, Stephen Pearl, 25, 42, 49, 55, 66, 74, 77, 123, 124, 126; and the League, 31–33, 36–37, 68, 122; and Modern Times community, 27–28, 30; and Unitary Household, 66
Arbeiterbund, 24, 80
Arnold, George, 50, 52, 53, 67, 81, 115, 116, 124; and McArone, 111–12
Aubrey. *See* Clare, Aubrey

Baker, Charles, 62
Ballard, Anna, 56, 57
Ballard, H. W., 76
Balzac, Honoré de, 13, 15
Banks, A. F., 110
Barrett, Lawrence P. *See* Brannigan, Larry
Barrière, Theodore, 15
Barstow, Elizabeth Drew. *See* Stoddard, Elizabeth
Bateman, Hezekiah Linthicum, 47, 59, 60
Bateman, Kate Josephine, 59, 60
Beeson, John, 74
Bellew, Francis Henry Temple, 47, 48, 49

Bennett, James Gordon, 29, 37, 123
Benton brothers (Joel and Myron), 78
Béranger, Pierre Jean, 9
Bierstadt, Albert, 62
Blanqui, Auguste, 23
Blavetsky, Helena Petrovich, 57, 61
Bleecker Street, 1, 47, 105
bohemianism, vii–ix, 11–17; anticapitalism of, 92–93, 93–94; antislavery of, 98–99; cooptation of, 124–26; iconoclastic view of American civilization, 93–95; later, 119–20; social origins of, 86–89; utopianism of, 123
—cultural approach of, toward: race, 92, 93; traditional Christian moralism, 95–96; women's rights, 91–92
—skepticism of, toward: class analysis, 89–90; institutional republicanism, 100, 101–2; institutions, 90–91, 96–102; movements, 99–100
Booth, John Wilkes, 115
Booth, Edwin, 110, 113
Boston, 2, 3, 5, 9, 10, 12, 25, 33, 48, 61, 73, 74, 78, 80, 87, 105, 120
Boucicault, Dion, 61, 89, 110
Boughton, George Henry, 62, 114
Bradlaugh, Charles, 71
Branch, Julia, 74, 75, 148n29
Brannigan, Larry (Lawrence P. Barrett), 60, 110
Breckenridge, John C., 71
Brentwood, 27
Briggs, Charles F., 52, 68
Bright, John, 9, 17

Brisbane, Albert, 28–29, 68, 69, 136–37n25; and the League, 31, 36–41, 68, 122; leader of American Fourieriests, 26, 72, 120; social activities of, 28–29, 49; Unitary Household and, 66, 67
Brook Farm, 5, 27, 67, 77
Brotherhood of the Union, 26, 27, 89; Nazarene Circle, 27; Ouvrier Circle, 27, 89. *See also* internationalist coalitions at New York
Brougham, John, 59, 61
Brown, John, 50, 65, 81–82, 83–84, 105, 142n24, 145n1
Browne, Charles Farrar (Artemus Ward), 21, 54, 92, 110, 111, 115, 116; as lecturer, 113–14
Browne, Junius Henri, 18, 77, 110, 125
Buchanan, James, 66, 70, 126
Bull, Ole, 59
Bulwer-Lytton, Edward George Earl, 101
Bund der Gerechten, 23
Buonarotti, Filippe Michele, 23
Burritt, Elihu, 8, 9, 48
Butler, George, 62, 118

Cafferty, James H., 62
California, 28, 114, 117
capital punishment, 98
Case, Lyman Whiting, 33, 56, 68, 73, 74
Case, Marie. *See* Stevens, Marie (Case Howland)
Ceresco, 32
Chanfrau, Frank S., 44, 60, 83, 86
Chartist, 80
Chartists, 23, 28
Chase, Salmon P., 102
Chase, Warren B., 23, 32, 70
Church, William Conant, 110
Civil War, 109–12
Clancy, John, 111
Clapp, George G., 78, 105
Clapp, Harriet, 107
Clapp, Henry, 47, 50, 61, 114, 119, 124, 125; abroad, 8–17, 71; assimilation of bohemian standards, 15–18; Christian ethical concerns of, 95–97; early life, 2–4, 128n5; as editor of *Saturday Press*, 64–65, 77–79, 115–16; establishes circle at Pfaff's, 47, 49–50; and the Free Convention (Rutland 1858), 74–75; friends, 28, 51, 53, 58–59; introduction of bohemianism into America, vii, 1, 18–20; last years of, 116–18; and the League, 21, 30, 31–35, 37, 38, 41–42, 68, 122; life of, in Paris, 12–15, 137n47, 172n1; on movements, 99–100; on politicians, 126, 160–61n55; on the 1860 elections, 101; on women and women's rights, 54, 68, 87; radical politics of, 4–8, 22, 23, 26, 48, 64, 69, 84, 92, 98, 120; skepticism about American politics, 80, 84, 90–91, 93–95, 97, 100–102, 104–12, 126; and Unitary Household, 66, 68
Clapp, Henry, Sr., 2
Clapp, Rebecca Coffin (mother of Henry Clapp), 2
Clapp, Theodore, 3, 4
Clare, Ada, 53, 64, 93, 107, 111, 117–18; as female bohemian figure, 56, 91; background, 54–55, 86; commentary of, 55–56, 77, 95, 97, 102; home of, as site of bohemian gatherings, 1, 63, 84; theatre and, 56, 60, 113, 114, 117
Clare, Aubrey, 55, 117, 118
class consciousness, ix, 86–89
Clay, James A., 27
Clemenceau, Georges, 111
Clemens, Samuel L. (Mark Twain), 115
Clymer, Ella M., 117
Cobden, Richard, 9
Cockefair, Isaac, 38, 39, 40
Codman, Charles, 27
coffee, 16
Coffin School, 2
Coffin, Rebecca. *See* Clapp, Rebecca Coffin
Coffin, Sir Isaac, 2
Commerford, Charles C., 46
Commerford, John, 46, 71
Congdon, Charles T., 4
Corneille, Pierre, 12
Croly, David G., 117
Croly, Jane, 117
Cuba, 3, 23, 69
Cuban Athenaeum, 25
Cuban radicals. *See* internationalist coalitions at New York
Curtis, George Washington, 68, 157n20

Dana, Charles A., 69
Danforth, Jenny, 57
Dartmouth, 4
Davidge, William Pleater, 60, 88
Davis, Ira B.: and politics 30–31, 69–70; as cooperationist, 27, 68; as internationalist, 89
Dayton, William L., 70
de Balzac, Honoré. *See* Balzac, Honoré de
de Calonne, Alphonse, 15
Dejacques, Joseph, 69
Deland, Anne, 57, 60
Devyr, Thomas Ainge, 102
DeWalden, Thomas Blades, 60
Dickens, Charles, 11, 19, 55, 117
Disraeli, Benjamin, 17, 101
Dodge, Ossian Euclin, 110
Douai, Adolph, 69
Douglas, Stephen A., 79, 107
DuSolle, John S., 53

Edgar, Henry and Millicent, 27
Edward VII of England, 10, 87, 91, 106
Elliott, Charles I., 62, 63
Ellsworth, Elmer, 106, 109
Emerson, Ralph Waldo, 78, 85, 119
Engels, Friedrich, 23, 24
Eytinge, Sol, 62

Fairhope Single Tax Colony, 119
Fisher, Charles, 60
Flanders, Mrs. G. M., 98
Forbes, Hugh, 25–26, 31, 81, 82, 83, 111; *Manual for the Patriotic Volunteer*, 25, 151n47
Fourier, Charles, ix, 5, 17, 31, 36, 63, 99, 102, 120
Fourierism and Fourierists, 17, 19, 31, 32, 59, 99, 120, 123; as an antebellum socialist and cooperative movement, 5–6, 26–27, 63, 66, 81, 102, 116, 122; and newspaper writers, 68; and women's rights, ix, 28, 36, 76
Fox, Mary, 57, 60
France, 14, 17, 18, 22–25, 55, 71, 106, 111
Free Convention (1858) at Rutland, Vermont, 74, 77, 98
Free Democrats, 23, 25–26. *See also* republicanism
Free Love League. *See* League, The
Free labor, ix. *See also* republicanism

Free Soil Party, 22. *See also* republicanism
Freeman Goldbeck, Mary, 53, 58, 61
freemasons, 82; African American freemasonry, 82–83; Egyptian variations, 27, 82, 83
Fremont, John C., 70
French radicals. *See* internationalist coalitions at New York
Fry, William Henry, 59, 68

Gardette, Charles Demerais, 52, 54
Garibaldi, Giuseppe, 25, 71, 81, 112
Garrison, William Lloyd, 4–10, 16, 22, 78; and Red Republicanism, 72–73
Gay, Getty, 58, 60
Gayler, Charles, 44, 58
German radicals. *See* internationalist coalitions at New York
Germany, 22
Glasgow, 9
Godwin, Parke, 68
Gottschalk, Louis, 55
Gove, Hiram, 28
Gove, Mary S. *See* Neal Gove Nichols, Mary Sargent
Grand Order of Justice. *See* League, The
Grand Order of recreation. *See* League, The
Grand Order of the Social relations. *See* League, The
Grant, Ulysses S., 91
Grau, Jacob, 59
Graves, Joseph Muzzey, 61
Greeley, Horace, 16, 41, 99–100, 113, 122–23, 155n41; eccentricities of, 17; as proprietor of the *New York Tribune*, 9, 35–37, 45, 67, 68, 77; as radical, 23–24, 29, 76, 79, 126
Greenbackism, 27, 75
Greene, William Batchelder, 24, 27
Gurowski, Adam, 51, 52, 77, 102, 109, 112, 116

Hale, John P., 23, 25
Hall, George Henry, 62
Halleck, Fitz-Greene, 79, 88
Halpine, Charles G. (Miles O'Reilly), 111
Hanlon, Thomas, 116, and brothers (Alfred, Edward, George, William) 61
Hannay, James, 12
Hawthorne, Nathaniel, 78

Hayne, Paul H., 54
Hayne, Roberty Y., 54
Hazard, James W., 107
Heenan, John C., 58, 110, 112
Henderson, Donald Campbell, 122
Henderson brothers, 38, 39
Herbert, Henry W. (Frank Forrester), 48, 116
Higginson, Thomas Wentworth, 5, 81, 82
Hinton, Richard Josiah, 80, 81, 82, 83, 90, 114
Holyoake, George Jacob, 85, 119
Homer, Winslow, 62
Homestead Bill, 70, 71
Hôtel Corneille, Paris, 12–13
House, Edward Howard, 61, 89, 105, 106, 108, 109, 110, 145n1; antislavery and Republican partisan, 64, 83, 104–5, 106, 108, 109; background of, 61, 87
Howard, Joseph, Jr., 41, 110
Howells, William Dean, 78, 115
Howland, Edward, 66, 68, 77, 86, 107, 114
Howland, Marie. *See* Stevens, Marie (Case Howland)
Hoyt, Adolphus Davenport (Dolly Davenport), 60
Hurlbert, William Henry, 9, 108

Ingalls, Joshua King, 34, 36, 70
Ingraham, Duncan N., 23
Inness, George, 62
internationalist coalitions at New York, 22–26, 68–69, 71–72; call for new national republican party, 79–80; and International Association, 72–74; and International Workingmen's Association, 119
Irish, 10, 11, 48, 57, 59, 63, 66, 110
Italian Democratic Society, 25
Italian radicals. *See* internationalist coalitions at New York
Italy, 22, 25, 79, 111

James, Ed, 49, 58
James, Hannah, 58
Japanese, 105
Jefferson, Joseph, 60
Jews, 3, 11, 75
Johnson, Eastman, 62

Joyce, James, 13
Judson, Edward Zane Carroll (Ned Buntline), 107

Kansas, 25, 26, 51, 65, 66, 70, 79–81, 84, 110
Kean, Edmund, 110
Keene, Laura, 28, 44, 46, 61, 107, 115
Kellogg, Edward N., 27, 92
Kerr, Orpheus C. *See* Newell, Robert H.
Kissner, David, 38, 40
Know Nothings, 30
Kommunist Bund, 23
Koszta, Martin, 23

Lamartine, Alphonse de, 9
land reform and land reformers, 6, 26–27, 69–70, 72, 122
Lander, Frederick W., 110
Lazarus, Marx Edgeworth, 28, 36, 66
Le Montagne, 5, 24, 25
League, The, 21–22, 30, 31–33, 34–35, 122; in controversy, 35–41; meaning, 41–42
League of Universal Brotherhood, 9
Leland, Charles Godfrey, 52, 53
Leland, Theron C., 29
Liberty Party, 4–7, 22
Lincoln, Abraham, 80, 84, 105, 107, 109; assassination of, 114–15
Lincoln, Mary Todd, 114–15
Lippard, George, 52, 53, 54, 142n24
London, 5, 17, 28, 48, 55, 60, 110; bohemianism in, viii, 2, 12, 42–43, 86; Clapp in, 8–12; radicalism in, 24, 69, 73–74
London Times, 106
Longfellow, Henry Wadsworth, 94
Longley, Elias, 124, 126
Lowell, James Russell, 61
Ludlow, Fitz-Hugh, 97
Lynn Pioneer, 6, 7, 8, 9, 20

Mackerel Brigade, 112
Marconis, Jacques Etienne, 24, 82
Maretzek, Max, 59, 87, 89, 93, 114, 153n11
Martin, Homer Dodge, 62
Martineau, Harriet, 71
Marx, Karl, and Marxism, ix, 11, 23, 24, 31, 46
Matsell, George W., 39
Mayhew, Augustus, 13

Mayhew, Henry, 13
McArone. *See* Arnold, George
McElhenney, Jane, 1, 54–55, 114. *See also* Clare, Ada
McWatters, George S., 2, 28, 42, 85, 87, 92–93, 96, 110–11, 118–19
Melville, Herman, 29
Menken, Adah Isaacs, 57–58, 60, 79, 107, 112, 113, 116; and Mazeppa, 112–13
Mercer Street, 34, 36, 38, 113
Mexican-American War, 8, 22
Mexico, 119
Mill, John Stuart, 71
Mobile, 83, 107
Modern Times, 27–28, 29–31, 34, 64, 67, 76, 92, 120, 122, 124
Mollenhauer, Edouard, 60–61, 73
monetary policy, 92–93
Morris, George P., 101
Morris, William, 12
Mrs. Grundy (fictional character), 10, 34, 54, 109, 122–23, 126
Mürger, Henri, 15
Mullen, Edward F. "Ned," 62, 124
Munson, Samuel T., 75
Musical Mutual Protective Union, 89
mutualism, 27, 36

Nantucket, 2, 4, 124
Nast, Thomas, 62, 118, 125, 160n53
National Reform Association. *See* land reform and land reformers
Neal Gove Nichols, Mary Sargent, 28–29, 52
New England Workingmen's Association, 7
New Harmony, 67
New Jersey Phalanx, 67
New Orleans, 3, 4, 16, 55, 57, 60, 69, 74, 83, 107
New York Herald, 29, 35, 41, 123
New York Times, 48, 50, 80, 119; on Clapp, 1, 118; hostility to radicalism, 21, 40, 41, 74; rivalry with the *Tribune*, 45, 66–67
New York Tribune, 5, 9, 17, 45, 64, 68, 83
Newberry, Edward, 27
Newell, Robert H. (Orpheus C. Kerr), 111, 112, 113
Nichols, Mary Gove. *See* Neal Gove Nichols, Mary Sargent

Nichols, Thomas Low, 3, 16, 23, 27, 29, 36, 41, 42, 43, 77
North American Phalanx, 27, 50
North, William, 12, 48, 116
Noyes, Frank, 117

O'Brien, Fitz-James, 51, 60, 113, 124; background, 47–48; discovery of Pfaff's, 47, 49–50; military interests of, 106, 110, 115, 116, 125–26; Poe and, 52, 76
O'Connor, William D., 52, 112, 117
O'Reilly, John Boyle, 120
Ornithorhynchus Club, 47–49
Orsini, Felice, 71–74, 76, 80, 84, 114
Oscanyan, Christopher, 52
Ottarson, Franklin J., 41, 49, 86, 88, 117, 118
Our American Cousin, 44, 107, 114
Owen, Robert, 5

Page, J. August, 107
Paine, Thomas, 35
Palmer, Erastus Dow, 63
Paris, 2, 27, 42, 51, 55, 59, 87, 108, 116; and bohemianism, viii, 15–16, 86; Clapp in, vii, 12–15, 17–18; revolutionary experience of, 14, 20, 23–25, 71, 81
Peel, Sir Robert, 11
Pennington, J. W. C., 9
Pfaff, Charles, 49, 115
Pfaff's, 1, 84, 86–87, 111, 112, 116, 119, 120–21, 126; acrobats, 60–61; exotic figures, 51–52; location, 45–47; menu at, 79; musicians, 60; opera, 58; and *Saturday Press*, 77; sculptors, 63; subsequent lives of customers, 113–14, 115–19; theatre, 44, 58–61, 83, 112–13, 114; utopia and, 124–25; visual artists, 61–63; women, 54–58; writers of, 47–51, 52–54, 78–79, 81, 88, 109–10, 115, 120
Philadelphia, 28, 80
Phillips, Wendell, 78
phonography, 33, 124
phrenology, 4, 33, 78
Pierce, Franklin, 66, 126
Poe, Edgar Allan, 29, 47, 48, 52, 54, 76
Polish Democratic society, 25
Polish radicals. *See* internationalist coalitions at New York

Polk, James Knox, 22
Pre-Raphaelite, 12, 13, 37
Presbyterian, 3, 4, 50, 107
Prince Albert Edward of Wales. *See* Edward VII of England
Protective Union, 26–27, 31, 88–89, 124
Progressive Union Club. *See* League, The
Proudhon, Pierre-Joseph, 24, 31, 69, 123

Queens, Frank, 58

Radical Abolitionist Party, 108
Raritan Bay Union, 50
Rawson, Albert Leighton, 18, 48, 54, 61, 62, 84, 110, 113, 115, 116
Raymond, Henry, 35, 37, 41, 45, 74
red flag, 23, 24, 25, 69
republicanism, 14; bohemianism critiques of, 96–97, 100–102; "red republicanism," ix, 26, 69, 71–73; and the revolutions of 1848–49, 14, 20, 22, 31
Republican Party, vii–ix, 84, 89, 96, 121–23; ambivalence of leadership on race, 94, 98–99; charges of radicalism, 24, 35–36, 74; and 1860 elections, 105, 107–9; local peculiarities of, 22, 30, 45, 65–66, 69, 79–81; radical and labor associations of, 32, 41, 42, 70–71, 85–86, 119
Reynolds, William H., 60, 116
Ripley, George, 68
Ritter, Kathering Louis Marie (Ada Clifton), 58, 60
Robert-Houdin, Jean Eugéne, 76
Rogers, Nathaniel Peabody, 4–8, 10, 96
Rose, William J., 24
Rosemont, Franklin, x
Round Table, 81, 114
Rutland, Vermont, convention. *See* Free Convention

Saint-Gaudens, Bernard Paul Ernest "Honeste," 69, 82
Sanders, George N., proslavery version of Red Republicanism, 69
Santa Claus, 160n53
Saturday Press, x, 53–54, 84, 90, 94, 107, 109, 114; appearance and character of, 77–78;

association with Pfaff's, 44, 78–79; attempt to revive, 115–16; failures of, 105, 116; origins of, 64–65; radicalism in, 80–81, 88–89, 97–99; views of spiritualism, 75–76
Secret Society. *See* League, The
Seneca Falls, 30
Seward, William Henry, 61
Seymour, Charles B., 41, 48, 49, 116
Seymour, Harry J., 83
Shanly, Charles Dawson, 60, 115
Shattuck, Aaron Draper, 62
Shaw, Dora, 57, 60
Shaw, Henry W. "Josh Billings," 115
Sheppard, Daisy, 57
Shevitch, Segei, 120
Sickles, Daniel, 46
Smith, Gerrit, 23, 70
Smith, James McCune, 82
Socialistic Labor Party, 75
Social Reform Association, 24
Sorge, Friedrich Albert, 73
Sotheran, Charles, 120
Southworth, Dorothy Eliza Nevitte, 56
Spirit of the Times, 20, 46, 55, 58, 78
Spiritualism, 75–76
Spring, Marcus, 50
Stedman, Edmund Clarence, 53, 79, 102, 110, 112
Stevens, Marie (Case Howland), 60, 66, 68, 86, 118, 86; background and the League, 33; and Pfaff's 56
Stillman, William James, 62
Stoddard, Elizabeth, 51, 52, 58, 60
Stoddard, Richard Henry, 51, 52, 53, 58, 86, 114
Strakosch, Maurice, 59, 89, 114
Sumner, Charles, 81
Swedenborgian, 29, 62
Swinton, John, 50, 51, 52, 112, 119
Swinton, William, 50, 51, 52, 110

Taylor, Bayard, 51, 52, 114
Théâtre de l'Odéon, 12
Thompson, Jerome B., 62
Thomson, Mortimer (Q. K. Philander Doesticks, P. B.), 62, 68, 89, 110; on

American history, 88, 94; collaboration with Underhill, 34, 48–49, 96; and slavery, 98–99; and spiritualism, 76
Thoreau, Henry David, 6, 78
Tocqueville, Alexis de, 9
Topolobampo, Mexico, 119
Turnbull, Charles S., 38, 39, 40
Tweed, William Marcy, 118
Typographical Union, 46, 88

Ullmann, Bernard, 20, 59, 89, 114
Underhill, Edward Fitch "Ned," 2, 34, 48–49, 86, 89, 96, 123–26, 145n1; background, 29–30; and drugs, 97; and the League, 39, 41; and Unitary Household, 65–67
Union Socialiste, 23
Unitary household, 65–68, 74, 76–77, 106, 122, 146n7, 148n29, 149n34
Universal Democratic Republicans. *See* internationalist coalitions at New York

Van Beest, Albert, 62
Van Buren, Martin, 22
Vanity Fair, 53–54, 111, 113, 116
Von Racowitza, Helena, 120

Wade, Benjamin F., 71
Wainwright, D. Wadsworth, 59, 60
Ward, Artemus. *See* Browne, Charles Farrar

Warren, Josiah, 27, 31, 42, 70
Webb, Charles Henry, 110
Webster, Daniel, 63, 78
Webster, John W., 61
Weiss, Ehrich (Harry Houdini), 76
Weitling, Wilhelm, 24
Welsh, Alexander "Sandy," 47, 49, 52
Weydemeyer, Joseph, 24
Whistler, James McNeill, 13
Whitman, Walt, 88, 102, 105, 112, 113, 115, 119, 154n27; importance of bohemian circles to, 18–19, 53, 61; on Pfaff and the Pfaffians, 49–52, 59–60, 80–81, 87, 116–18; radicalism and, 142n24
Wilkes, George, 20, 46, 55, 58
Wilkins, Edward "Ned" G. P., 19, 53, 59, 60, 84
Wilmot, David, 22
Wilson, Henry, 81, 85
Winter, William, 53, 60, 77, 79, 87, 118
Wood, Fernando, 39, 45, 66, 70, 79, 110, 118, 121; clash with radicals over the League, 30–31, 34–36, 41–42
Wood, Frank, 59–60, 124
Woodhull, Victoria, 119

Young, Brigham, 99, 155n41
Young, John Russell, 41

Zouaves, 106, 112